JOHN VARVATOS

ROCK IN FASHION

Rock on!!!

ZZ TOP
DIMO
2013

JOHN VARVATOS
ROCK IN FASHION

JOHN VARVATOS WITH HOLLY GEORGE-WARREN

HARPER
DESIGN

An Imprint of HarperCollinsPublishers

TO MY FAMILY, JOYCE, JOHN, LYNDSEY, AND THEA,
FOR PUTTING UP WITH MY ROCK & ROLL OBSESSION,
AND TO JIMI HENDRIX, MC5, IGGY AND THE STOOGES,
LED ZEPPELIN, AND ALL THE OTHER ROCKERS WHO
GAVE ME MY PASSION FOR ROCK IN FASHION

CONTENTS

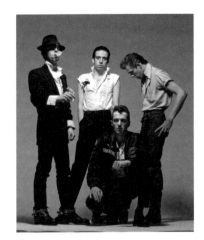
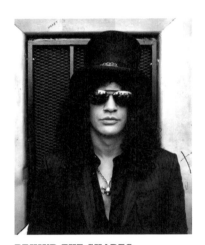
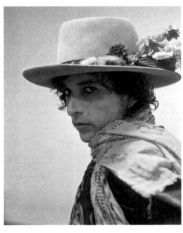

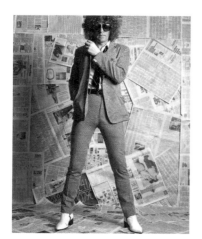

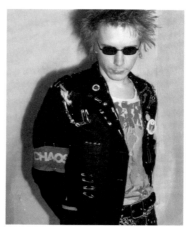

A shot from the Spring/Summer 2007 John Varvatos/Converse advertising campaign. *Photograph by Cass Bird.*

INTRODUCTION.

"Rock & roll never forgets."

Those lyrics from my hometown hero Bob Seger's song by the same name summarize how influential rock & roll has been on my life and career. I wouldn't be where I am today if not for the music I discovered growing up in Detroit in the late 1960s and 1970s.

I came of age in Motor City, surrounded by the sounds— and look—of rock & roll. From the soul/pop of Motown to such local rockers as the Stooges, MC5, Ted Nugent, Grand Funk Railroad, and Bob Seger, and touring bands like the Who and Led Zeppelin, the music enveloped me. Looking back at those days, I realize I wouldn't have become a fashion designer if not for the music in my life. There are traces of it in the way I dress and the look of my menswear collections over the past dozen years.

In this book of photographs, you will see some of the same images that caught my eye as a kid and have stayed with me, as well as newer photos that continue to inspire me. In effect, thumbing through these pages, you'll find my personal note-book of the rock style ideas and influences that have made an impact on my work. A common thread links these images through the generations—and that's what this book documents: musicians from the 1960s to the present who've taken various styles and made them their own. Like the evolution of rock, once a genre's there, you have to find a way to put your own stamp on it. Each of the artists here grew up listening to the music that came before—just as I, too, watched my favorite artists and noticed the way they dressed.

My first musical memories date to *The Ed Sullivan Show*, when I was nine or ten. That's where I discovered the British Invasion, which gave me my initial perspective on fashion as well: it was unique and novel, just like the music. The Beatles' matching outfits weren't very exciting, but I loved the Cuban-heeled boots they wore. The Stones seemed like the bad boys, refusing to dress alike. They—and their clothes—had attitude. What struck me the most was that Mick, Keith, Brian, Charlie, and Bill each had his own individual style—yet the band as a whole had a cohesive look.

Around the same time, I got hooked on the radio. We had both the Detroit and Canadian stations. Right across the bor-der, ten minutes away in Windsor, Ontario, there was a music director on the AM radio station CKLW named Rosalie Trombley. She selected so much fantastic music that Seger wrote a song about her, "Rosalie," which was later covered and amped up by Thin Lizzy. If your record was chosen by Rosalie, you'd get played around the country. She turned me on to a lot of great stuff. Some of my favorites were "You Really Got Me" by the Kinks and "I Can See for Miles" by the Who. I bought those bands' records for the music, but I quickly noticed how cool the Kinks and the Who looked as well as sounded.

When I was twelve, I went to my first concert, a small local event. Immediately, the live experience made me want to be a rock star. Detroit was brimming with bands back then. We had outdoor concerts at fairgrounds and parks where some of Detroit's best groups got started: MC5, the Stooges, and Ted Nugent's Amboy Dukes, whose "Journey to the Center of Your

Mind" was one of the first psychedelic records I ever heard. Another favorite band was the Rationals, who blended rock and soul on a song called "Guitar Army" and their version of Aretha Franklin's "Respect." Other Michigan groups, including Frijid Pink, SRC, and the Frost, would later play my high school. At the Michigan State Fair, held in Detroit, I'd catch the Battle of the Bands, watching the entire roster of groups compete.

Live rock & roll wasn't just about hearing the music, though. It was the show—being sucked into the whole visual aspect of the way the bands dressed, their aggression onstage. All the artists I liked had a unique style. In Detroit, a lot of bands emulated the stage presence originally created at Motown. They didn't do the dance moves, but they knew there was more to performance than just getting up onstage and playing; you had to give a lot more. Like the Rolling Stones, each guy in the Stooges and MC5, for example, had individual style, but as a group, they looked like a band of brothers, an army.

I briefly played in a band when I was in junior high. My cousin Tim got a drum kit and started a group called the Golden Sound and asked me to join. We did a wedding and some school gigs, but we weren't any good. We played covers like "Little Bit O' Soul," "Time Won't Let Me," "In the Midnight Hour," "Satisfaction." I sang and played trumpet. We did "Touch Me" by the Doors because it had a horn in it. My uncle Gus was our manager and he thought we were going to hit the big time. It was exciting to hear people clapping afterward and telling you how great you sounded, but all of that was short-lived. I eventually bought a used sunburst, hollow-body electric guitar and learned a few chords, but I knew I'd never be a great player. I've continued to play for fun—and once, when Cheap Trick performed at an event my company threw in Las Vegas, Rick Nielsen handed me a plugged-in guitar. Next thing I knew I was onstage playing "Surrender" with them. I could never have imagined doing that when I was fifteen. Back then, I realized I didn't have the voice or chops to make it. Yet somehow I knew that rock & roll was going to remain an important part of my life.

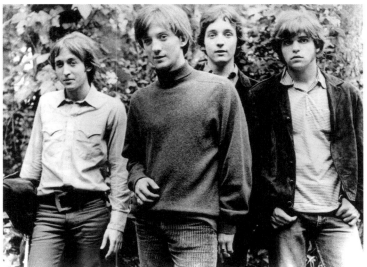

TOP
BOB SEGER.
Photograph by Robert Alford.

BOTTOM
THE RATIONALS.
Photograph courtesy of Robert Matheu Collection.

By 1969, I was seeking out Detroit's rock scene however I could, including reading about it in *Creem* magazine. In the suburb of brick houses called Allen Park where I grew up, I'd go to a record store called Sam's and buy *Creem*, founded that year in Detroit. *Creem* was my bible. Sitting on the floor and flipping through its pages made me feel like I was in the front row at a concert. I'd read the articles and stare at the pictures and ads—the photographs by Mick Rock, Robert Alford, Bob Gruen, and Robert Matheu fascinated me. Then I'd spend the three dollars I'd saved from my paper route or cutting lawns to buy an album based on a *Creem* review. (The only time the magazine let me down was when it trashed Grand Funk's 1970 album, *Closer to Home*, which I bought nonetheless.)

At home, I kept my headphones on, which helped me transcend our crowded household filled with five kids. Since I shared a bedroom with my two brothers, the records I bought took me to my own little world. Soon, though, my money started going elsewhere. I wanted to look like my favorite musicians, so I tried to find rock & roll clothes. I'd take the bus downtown to a block that was Detroit's version of Haight-Ashbury. Because my parents weren't into rock music—they thought it was a bad influence—I had to sneak over to that part of town. That area was where hippies and bands hung out at places like the Psychedelic Shop, and there were little handmade clothing boutiques and a record store, too. Once I found a navy-blue crewneck sweater with a red star on it. The first day I wore it to school, my big crush told me she loved it. After that, I wanted to wear something cool every day.

Fortunately, thanks to some friends, I caught on to the local scene. One pal's brother was in a hot Detroit band called the Unrelated Segments, and another friend's brother was in a hard-rock band, the Früt. These groups played downtown at the Grande Ballroom, our version of the Fillmore. The Grande, a big band dance hall in the 1940s, had started putting on rock shows in 1966. The Jimi Hendrix Experience, Janis Joplin with Big Brother and the Holding Company, and Jefferson Airplane performed there—all before my time. British bands used to kick off their US tours by playing Detroit, where they'd get a real rock & roll audience, giving the tour a shot in the arm. Robert Plant says Detroit's one of the places he always liked to play first when Led Zeppelin came to America. Cream played the Grande several times, too—and the band's name ultimately inspired that of the magazine.

Before I ever set foot inside the Grande, I'd dreamed about going to shows there. When I was about thirteen, my friend's brother, who played in the Unrelated Segments, gave me the venue's psychedelic hand-drawn-and-lettered posters and handbills, which I collected and taped to my bedroom door. I've continued to collect these and other 1960s posters, which today hang in my New York offices.

Finally, a friend's brother took us to a show in September 1968, and somehow I pulled it off without my parents finding out. His band, the Up, one of Detroit's freakiest groups, was on a bill with MC5 and the Stooges. This concert changed my life. I didn't smoke pot, but I was tripping on the whole scene—the light show, the music, what people were wearing.

After that I became obsessed with going to concerts and did anything I could to attend them. Back in those days, you could mail cash or a money order for tickets. If I saw an ad in the Sunday paper that said tickets went on sale on Monday, I'd get on my bike and make the hour-long trip to the main post office in downtown Detroit so that my ticket order would be delivered first thing on Monday. My strategy worked: I'd get amazing seats, sometimes in the first few rows.

Those concerts marked the beginning of a lifelong passion. I've seen literally thousands of concerts since my teens. Even so, some of those early ones, like the MC5 gigs, still stand out. The band was an absolute powerhouse. They moved around onstage like dervishes, and each guy dazzled me with his own look. There was Wayne Kramer in a fitted spangled jacket and flared pants playing his red, white, and blue guitar like it was a machine gun; singer Rob Tyner with his hippie 'fro and striped bell-bottoms and long matching vest; Fred "Sonic" Smith in a black western shirt with white fringe, looking and sounding

like a gunslinger; and drummer Dennis Thompson and bassist Michael Davis, lean and mean in tight T's drenched with sweat. Together, they were part of something bigger than themselves, like a gang. Decades later, after becoming friendly with Wayne, I found out that the band's girlfriends designed and created much of their stage wear.

Led Zeppelin was another band whose musical and style influences are with me to this day. I first saw Zeppelin on June 6, 1972, at Cobo Arena, in downtown Detroit. That was life changing. The concert was the opening night of Zeppelin's North American tour—and I was in the second balcony. I took my little portable tape recorder with me (no one searched you back then), and I still have the cassette that documented that explosive set: "Immigrant Song," "Heartbreaker," "Black Dog," "Since I've Been Loving You," "Stairway to Heaven," "Going to California," "That's the Way," "Bron-Y-Aur Stomp," "Dazed and Confused," "What Is and What Should Never Be," "Moby Dick," and "Whole Lotta Love." I took that cheap recorder everywhere, including to concerts by Black Sabbath, Yes, Edgar Winter's White Trash, Brownsville Station, Wishbone Ash, and many others.

Led Zeppelin's clothing made a huge impact on me. Like the Stooges and MC5, their stage wear had a cool rock & roll vibe—both masculine and feminine rolled into one. The guys in Led Zeppelin wore flared pants and scarves. Robert Plant sometimes sported an unbuttoned, way-too-small girl's blouse. Jimmy Page's most spectacular outfit was his dragon suit, which he had custom made in both a black and a white version, with the fire-breathing creature and ZoSo and zodiac symbols embroidered on the jacket and pant leg. Seeing it made me more conscious of how important rock was to fashion—and vice versa. Of course, I didn't have a clue that I'd be a fashion designer one day, but it got me thinking about just what fashion represented to the music: the sounds stayed with you, and so did the look; the visuals and sonics became intertwined.

Though I'd managed to see the Stooges live at the Grande, it was their photographs on album covers that really struck a

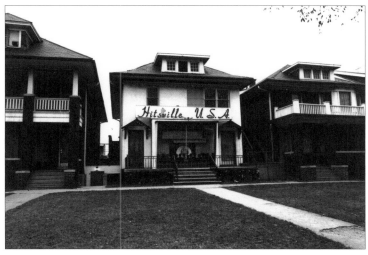

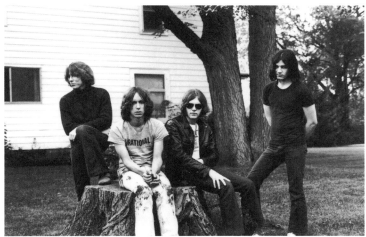

TOP

HITSVILLE. Motown headquarters in 1972.
Photograph by Robert Matheu.

BOTTOM

THE STOOGES—(from left) Dave Alexander, Iggy Pop, Ron Asheton, Scott Asheton—at the Stooge Manor, later renamed the Fun House by fans, Ann Arbor, Michigan, 1969.
Photograph by Ron Richardson/Robert Matheu Collection.

chord with me. On their 1969 self-titled debut, the tight shot of the band showed them wearing narrow-cut leather racing jackets. Their next record, 1970's *Funhouse*, was *it*—the personification of rock & roll. You opened the cover to find a gatefold photo of the band sprawled out on a Persian rug wearing tight jeans with flares and simple T-shirts, with sneakers or Beatle boots. Guitarist Ron Asheton had on a black leather jacket over his cartoon-graphic T. This was the album, and this was the look, for me. It stayed with me and remains relevant today—simple clothes that fit the guys really well, showing off their physiques. That shot, taken in 1970, could just as easily have been taken today, whereas when you go back and view most bands' old pictures, they look dated. Some forty years after *Funhouse*, when Iggy participated in my company's advertising campaign wearing one of my suits, I told him how much he and the band had influenced my fashion sense. He just laughed.

At sixteen, in order to feed my own rock-fashion habit, I got a job at Hughes and Hatcher, a men's store in Dearborn, Michigan. There I worked my way up from the layaway department to salesclerk. The chain mainly stocked suits, dress shirts, and neckwear. But as the counterculture encroached on straight America, the store added bell-bottoms, embroidered shirts, and a few other rock-style clothes. I earned enough cash on my commissions to put together my own look, beginning with a streamlined, tight-fitting red, white, and blue corduroy jean jacket trimmed with stars and epaulets. Then I got myself a leather jacket at a local motorcycle shop. It became my prized possession. Today it's all beat up but I still wear it; it's the one piece I would never give up.

I kept my job at Hughes and Hatcher after I went to college in 1973, first at Eastern Michigan University, and then at the University of Michigan. H&H had a store in Ann Arbor, so I worked my way through school there. Living in Ann Arbor kept me in the middle of the Michigan music scene. Ann Arbor was a hippie town, with several well-stocked new and used record stores, and there were concerts nearly every night of the week.

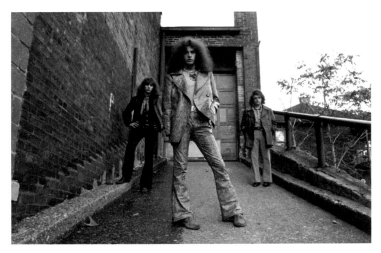

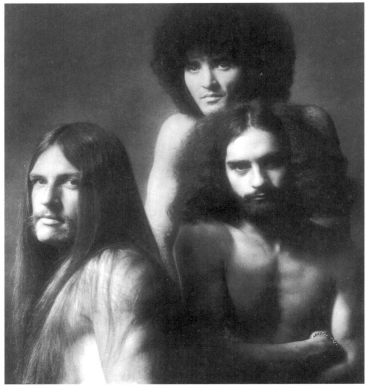

TOP
TED NUGENT AND THE AMBOY DUKES.
Photograph by Robert Matheu.

BOTTOM
GRAND FUNK RAILROAD.
Photograph by Michael Ochs Archives/Getty Images.

During my college years, I wanted to document rock & roll style, so I carried around a 35mm camera and photographed people whose looks interested me—much the way that Bill Cunningham does for the *New York Times* Sunday Styles section today. Snapping pictures in clubs and at concerts, I tried to capture all the looks happening then. Observing the music scene, I curated my favorite style elements, crafting a look all my own: flared jeans, boots, a cool shirt, and my favorite motorcycle jacket. I still harbored no ambitions of becoming a designer.

After I graduated college with a degree in education, I didn't have a plan but tried to find my way while continuing to work in fashion retail. In 1980, I partnered in a unique new store called Fitzgerald's in Grand Rapids. We carried Ralph Lauren before it became a household name. The management at Ralph Lauren/Polo took a liking to me, so when they were looking for a regional sales manager based in Chicago, I jumped at the opportunity. Within a year and a half, I was asked to move to New York City to become vice president of sales and merchandising. It was in my day-to-day contact with the design team that I realized I wanted to become a designer. At age twenty-nine, I set out on a new chapter in my life. While continuing to work at Ralph Lauren, I pushed myself into every fashion meeting and fitting possible, and I took design classes. I soaked up every bit of information that would help me become a designer.

In 1990, I landed at Calvin Klein as president of men's design. Calvin gave me a chance to do something a bit closer to my personal sense of style. He had a brand for men called Calvin Klein Sport, a line that was a bit like Polo, and he wanted to shut it down and reinvent his menswear business. We started the Calvin Klein Collection for men, and we launched the CK brand to create something more accessible in terms of design and price. Over the next four years, we rebuilt the Calvin Klein underwear brand into a huge business, we incorporated the jeans line into the CK brand, and we significantly grew the Calvin Klein Collection for men.

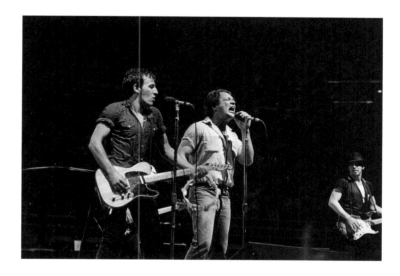

BRUCE SPRINGSTEEN and **MITCH RYDER** (center).
Photograph by Robert Alford.

In 1995, I was offered the opportunity to head up men's design at Ralph Lauren, which I did until I started my own brand in 2000. At Ralph Lauren, I learned it was important for designers to be true to who they are and stay their path, and that establishing a label means creating a style that reflects your personality, but in a way that speaks to the public, too. That's when I decided I had my own ideas about menswear—and I wanted to explore them. When I told Ralph I wanted to go out on my own, he said that if I really had something new to say, then I should do it. The most important thing I learned from Ralph is to always raise the bar, and to always elevate the brand. So from the beginning of starting my business, I launched a complete line for men that included tailored clothing, sportswear, outerwear, accessories, and shoes.

Since then, my love of rock & roll and my love of fashion have merged. There wasn't that much rock & roll in the brand when I started out, but there was some element in the line every season that had roots in my youth. Initially, I didn't realize music would become such an important part of my company. But my passion for it is endless. If I don't have music playing, I don't work well. For me, music has always been about the excitement of discovery, and it remains that way.

Then I discovered that musicians loved my clothes. So in 2005, I began collaborating with artists in our marketing campaigns, starting with Ryan Adams, then Joe Perry, Chris Cornell, and, in fall 2006, my hometown hero Iggy Pop. Iggy was the first of my Detroit icons to come on board; since then, I've worked with Alice Cooper and Wayne Kramer. All in all these collaborations have been lovefests, culminating in my tenth anniversary campaign in 2010, which, in addition to the guys I've just mentioned also featured Jimmy Page, Robert Plant, ZZ Top, Cheap Trick, Franz Ferdinand, Velvet

Revolver, Citizen Cope, Ian Hunter, David Johansen, Lenny Kravitz, Richard Manitoba, Peter Frampton, Dave Stewart, Perry Farrell, Jesse Malin, Clem Burke, and Dave Navarro, among others. Recently, Dave Matthews, the Roots, Green Day, and Paul Weller have participated in my ad campaigns.

All these artists have played an important role in my creative process. This book—my design notebook—demonstrates how rock & roll has influenced fashion, but its major focus is on the styles and artists who have inspired me in terms of their music and image. Looking at photographs not only of musicians like Jimi Hendrix, the Rolling Stones, MC5, and the Who from the late 1960s but also of current artists such as Kings of Leon, Jack White, the Strokes, the Libertines, and Interpol, you'll see timeless images, regardless of whether they were taken fifty years ago or today. You'll recognize how the Stooges and MC5 influenced the punk movement and notice elements of glam that still exist. Every generation takes from what came before, then makes it their own by embracing and respecting it, and then taking it someplace further.

I've organized the photographs in my notebook into different sections based on the ideas they've generated in my own work: scarves, footwear, leather jackets, shades, hats, denim pants, coats, tailored suits, and so on. You'll also see groupings devoted to particular styles. Over time, I've been collecting photography that has influenced me and continues to inspire me; in fact, many of the images here are ones that are always in my mind when I design. Overall, this book is a collection of visuals that have been meaningful to me and have made a lasting impression on my work. You'll also see that many of the fashion concepts created by rock & rollers have made their way into the wardrobes of the general public.

As the Stones say, "It's only rock & roll, but I like it!"

BAND ON THE RUN.

CHAPTER 1: THE WELL-DRESSED GROUP

Over the past four decades, a handful of artists have continually created a consistently cool look. They're not "chameleons" who every five or ten years come up with a new style, depending on the latest trend. Of course, some of the groups that come to mind no longer exist, so their image is frozen in that kind of "live fast, die young" way.

What's notable about these groups is that the individual members developed their own look, while the band's persona maintained an identity with a mutual history and musical personality. Some of those in my list of exceptional-looking groups are the Stooges, MC5, the Faces, the Clash, the Ramones, the Pretenders, Aerosmith, the Band, Blondie, Kings of Leon, Led Zeppelin, Bruce Springsteen and the E Street Band, the Strokes,

Pink Floyd, the Yardbirds, Velvet Revolver, and the Rolling Stones. Their styles have been a major influence on me. You can see many varied looks among these bands and in this book, but there are elements in all of them that have inspired my design thought process.

As far as rock fashion and personal style goes, the guiding principle for me is this: to create an individual look that draws influences from numerous sources yet never tries to simply imitate or duplicate them. Instead, style is all about taking snippets of inspiration and creating a unique personality and look that feels inherently right. That's what I try to do when I design my clothing collection as well.

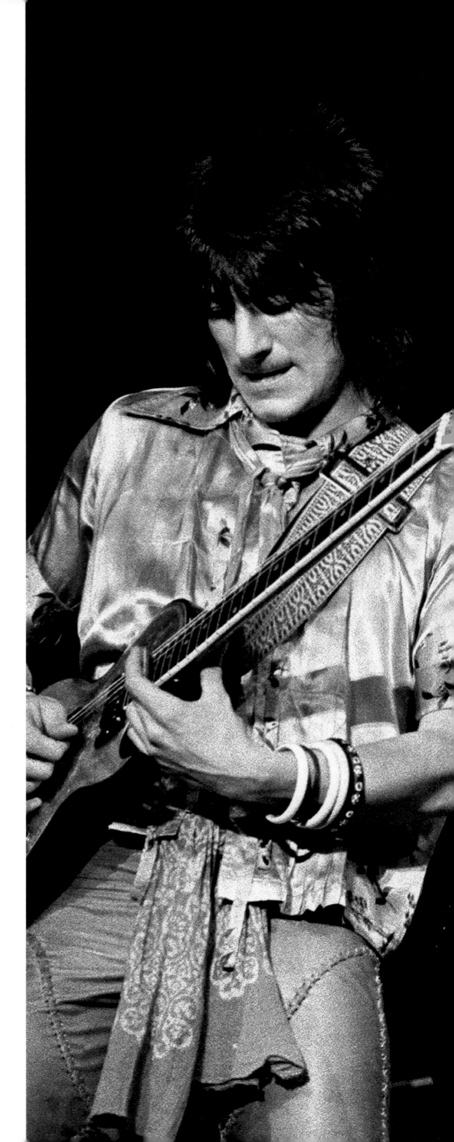

"The irony is that [former manager Andrew Loog] Oldham, at the start the great architect of the Stones' public persona, thought it was a disadvantage for us to be considered long-haired and dirty and rude...the whole idea of the Beatles and the uniforms, keeping everything uniform, still made sense to Andrew. We had those damn houndstooth, dogtooth checker jackets on *Thank Your Lucky Stars*, but we just dumped them immediately and kept the leather waistcoats he'd got us from Charing Cross Road....And he did cotton on real quick to the fact that he'd have to go with it. What are you going to do? The Beatles are all over the place like a fucking bag of fleas, right? And you've got another good band. The thing is not to try and regurgitate the Beatles. So we're going to have to be the anti-Beatles....And then Andrew started to play that to the hilt....It was actually Andrew that disintegrated the way you can represent yourself—do everything wrong, at least from a showbiz, Fleet Street point of view."

—Keith Richards, from *Life*, 2010

Photographed here with **BILLY PRESTON**, the **ROLLING STONES** mix American western style, including leather pants, with their definitively English scarves. *Photograph by Ron Pownall.*

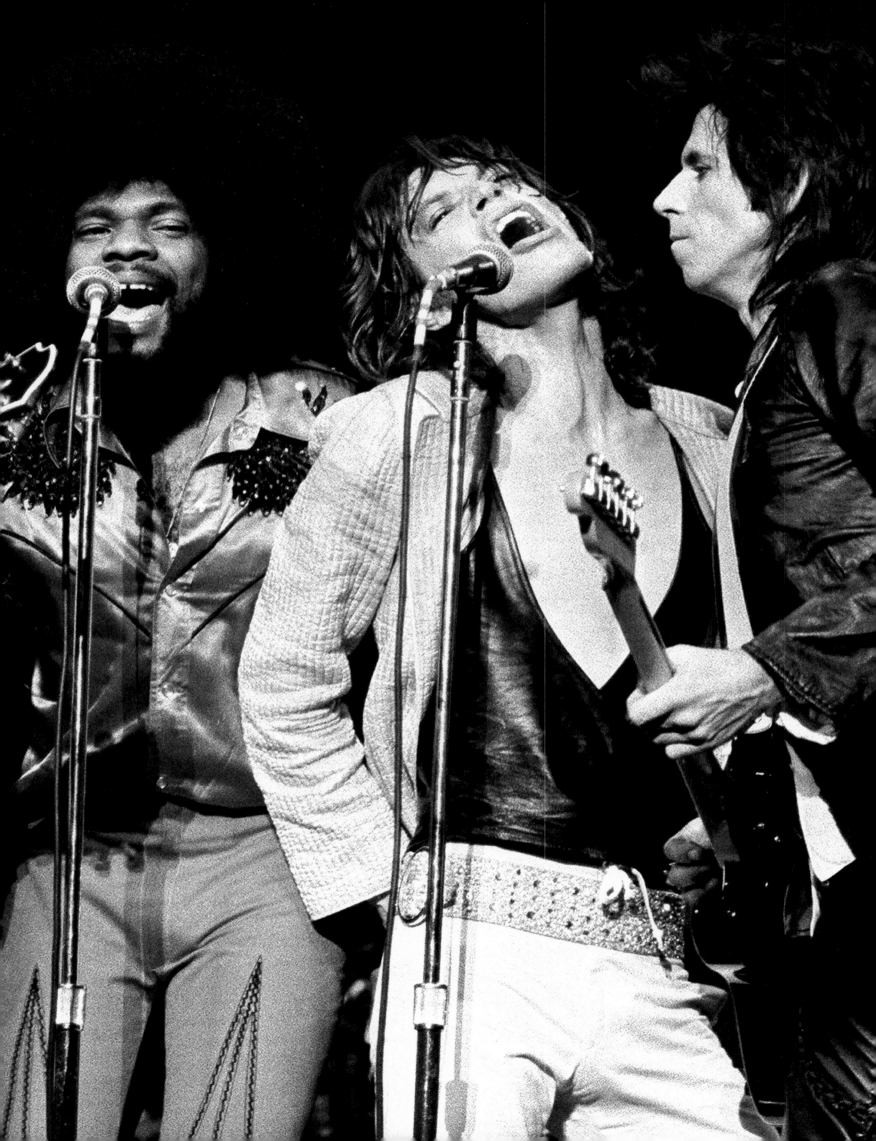

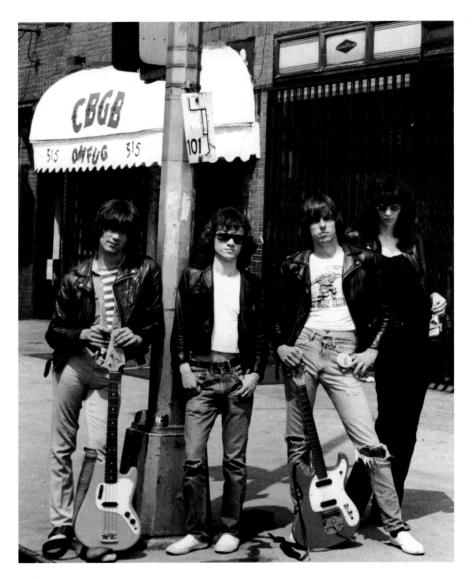

"We were still evolving into the image we became known for. But it was trial and error at first. I give Tommy [Ramone] a lot of credit for our look. He explained to me that Middle America wasn't going to look good in glitter. Glitter is fine if you're the perfect size for clothes like that. But if you're even five pounds overweight, it looks ridiculous, so it wouldn't be something everyone could relate to. It was a slow process. Over a period of six months or so. But we got the uniform defined. We figured out it would be jeans, T-shirts, leather jackets, and the tennis shoes, Keds. We wanted every kid to be able to identify with our image."

—Johnny Ramone, from *Commando*, 2012

THE RAMONES borrowed attitude from the Stooges, but they definitely had their own look—which was copied by millions.
Photograph by Bob Gruen.

OPPOSITE

With Jimmy Page and Jeff Beck in the same band, style would have to be a huge part of **THE YARDBIRDS'** essence. Page's double-breasted military coat, Keith Relf's suede jacket, and the others' coats were all part of the look brought to America by the British Invasion.
Photograph by Gered Mankowitz.

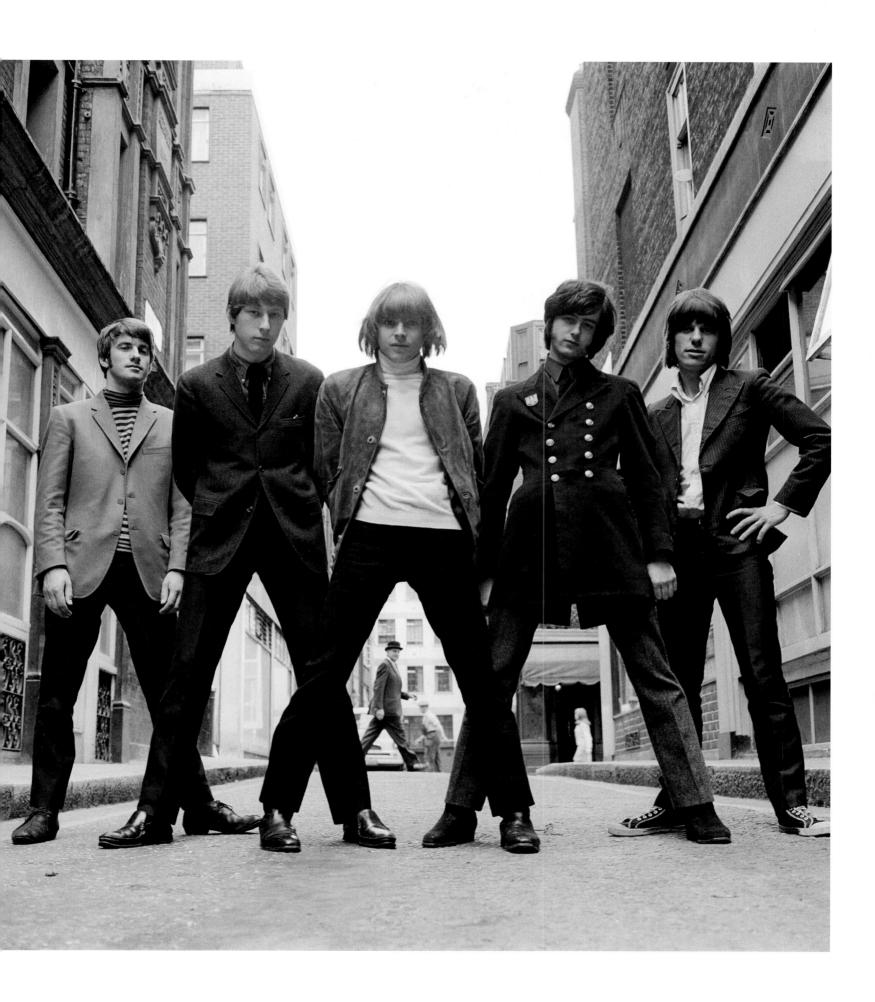

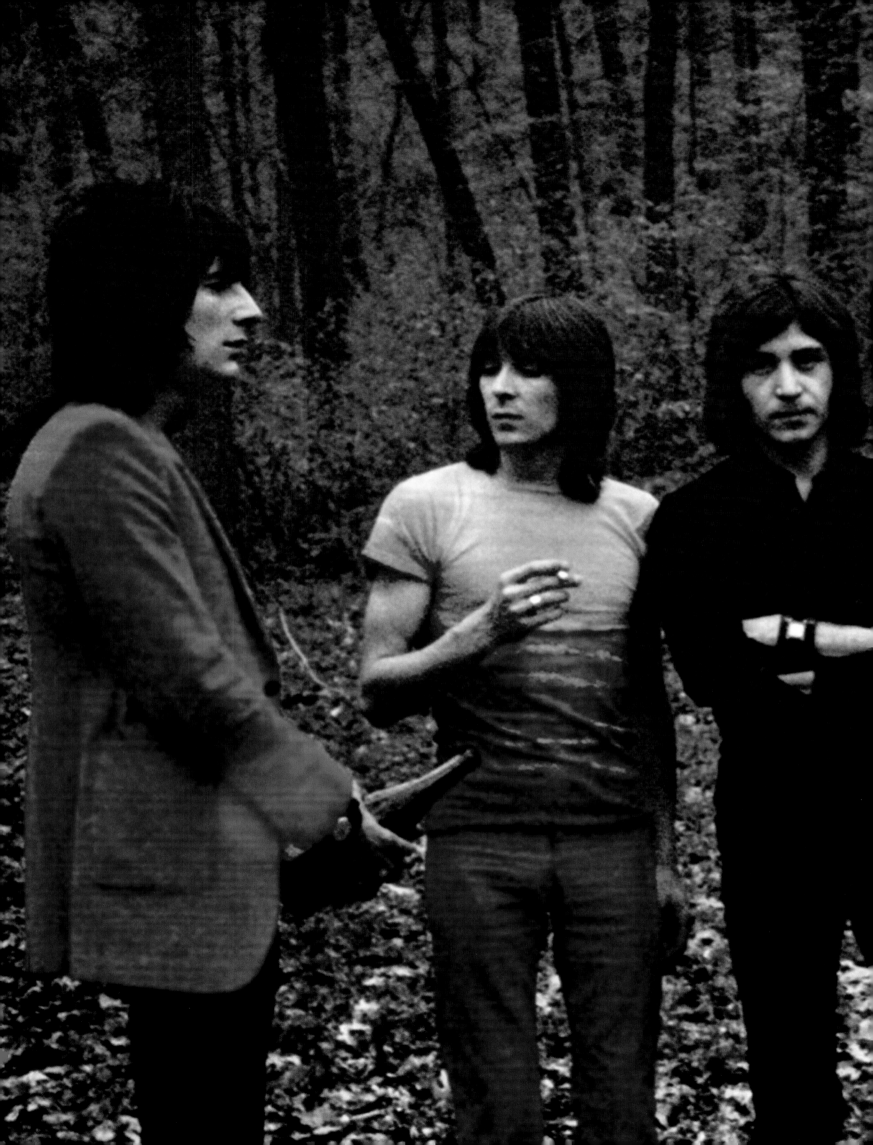

PAGES 24-25
In the 1970s, **THE FACES** were one of
the most stylish bands in rock. Seeing
them live was an experience every time.
Photograph by Tom Wright.

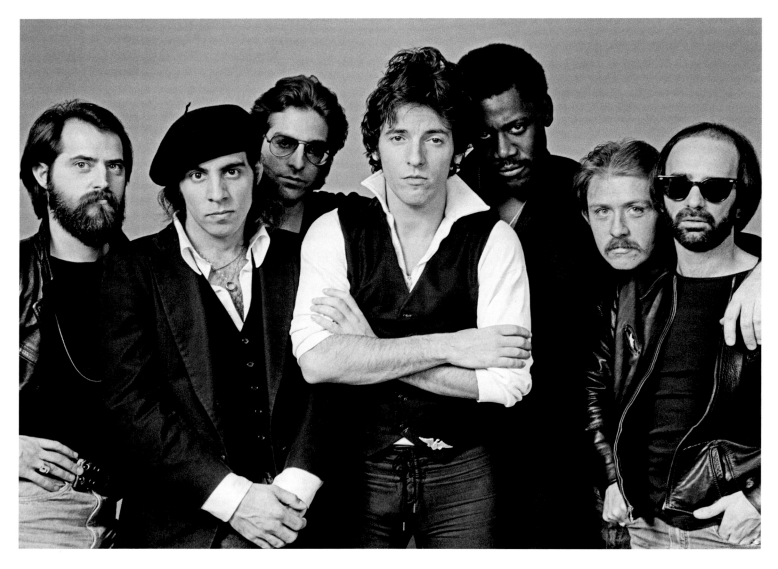

**BRUCE SPRINGSTEEN AND THE
E STREET BAND** had that gang feel
with style.
Photograph by Lynn Goldsmith.

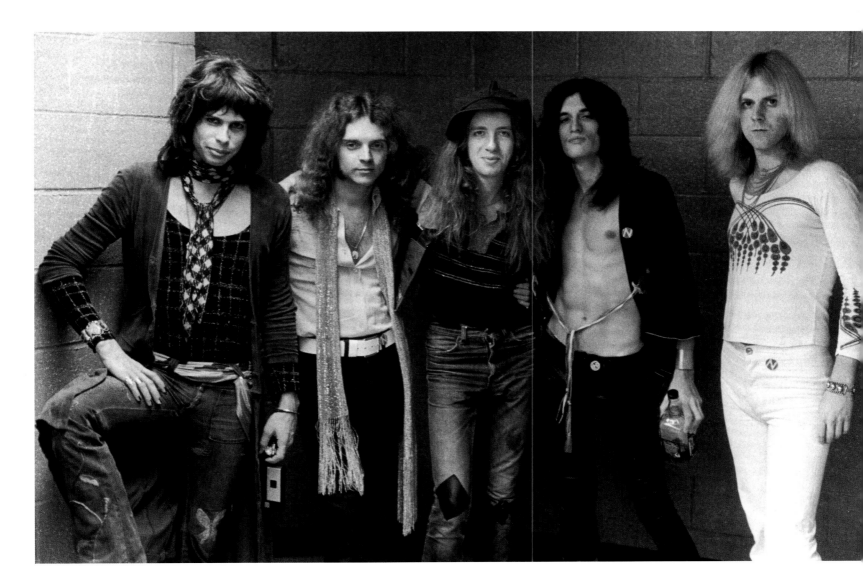

"Steven [Tyler] and I had an eye
toward the British bands, but we
wanted to create our own look.
The more it evolved, the more
we focused on it."

—Joe Perry, Aerosmith, 2012

AEROSMITH, seen here in 1973, is
the American version of the Stones,
but ever so cool! They are a little bit
glam—especially bassist Tom Hamilton
(far right)—but have a lot of swagger.
Aerosmith was the first American group
to make scarves a big part of their look.
Photograph by Bob Gruen.

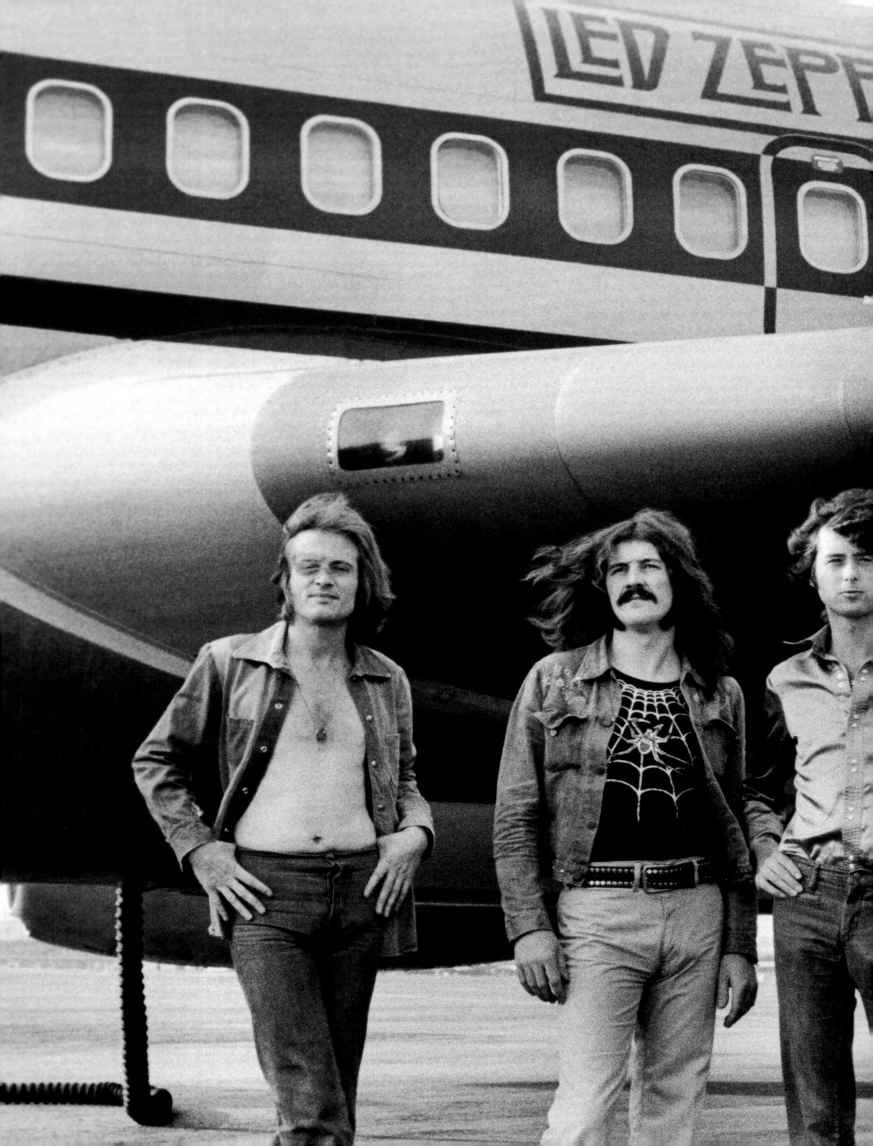

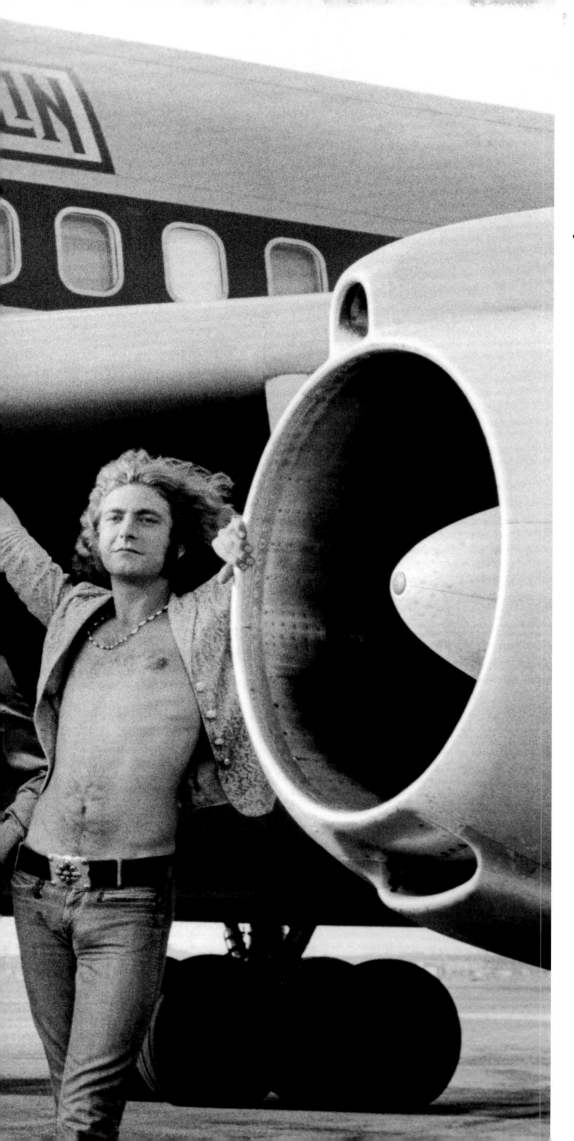

"We each did our own thing with our clothes. Somehow it all worked together."

—Robert Plant, 2012

What can I say? It's
LED ZEPPELIN, circa 1973.
Photograph by Bob Gruen.

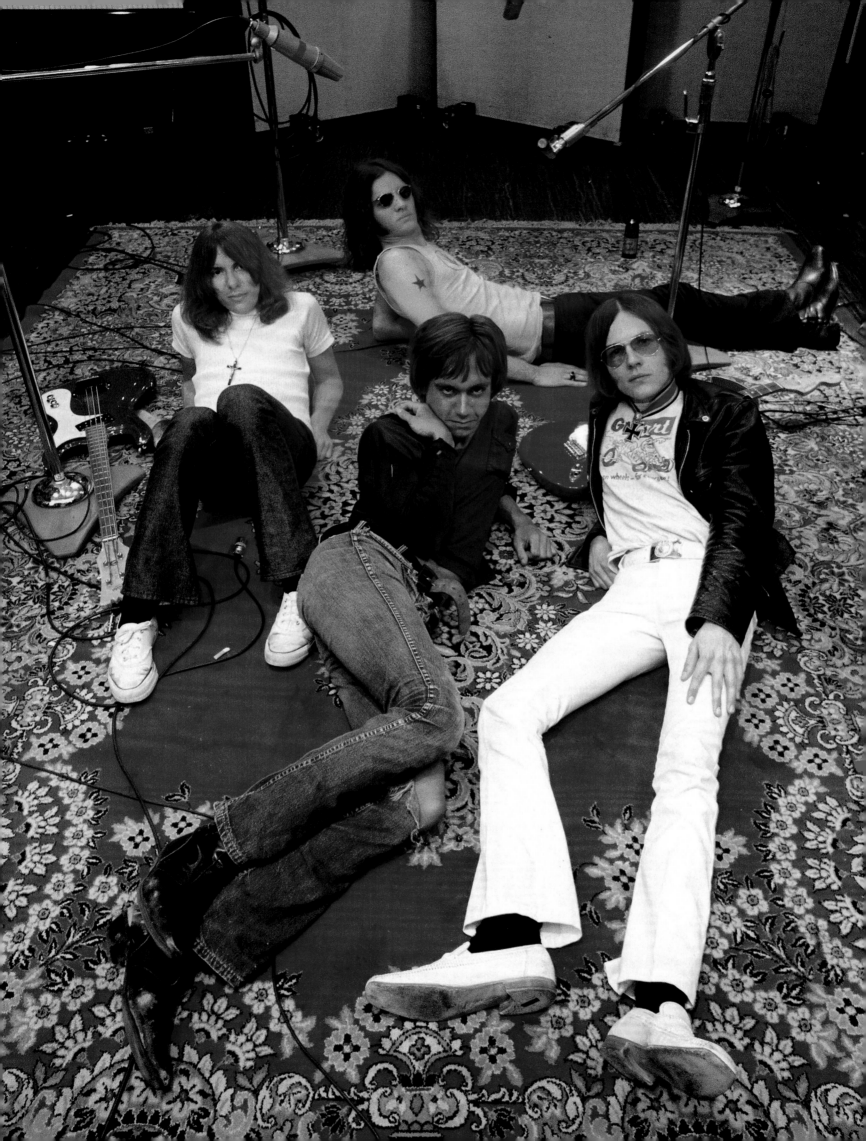

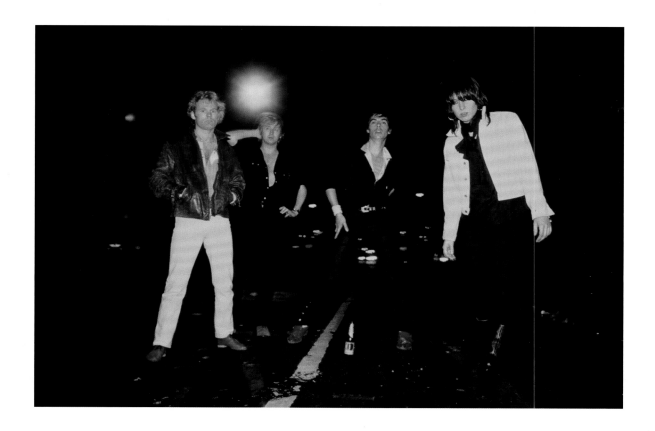

The Pretenders' **CHRISSIE HYNDE** looked every bit as tough in her jacket and boots as did the guys in her band: (from left) drummer Martin Chambers, guitarist James Honeyman-Scott, and bassist Pete Farndon. Love the red shoes! *Photograph by Lynn Goldsmith.*

BLONDIE was one of the most stylish bands of the late 1970s and early 1980s. The guys—(from left) Jimmy Destri, Clem Burke, Gary Valentine, and Chris Stein—popularized early 1960s suits with skinny lapels, sometimes pairing them with bold graphic shirts. Debbie Harry, whether going with the guys' look shown here in 1976, or as a sexy bad girl, became a huge influence on fashionable club gals. *Photograph by Bob Gruen.*

THE STOOGES were my icons growing up. The *Funhouse* album photographs will be forever ingrained in my mind. From Iggy's ripped jeans to the Asheton brothers' T-shirts, the image screams rock & roll. Ron Asheton's leather racing jacket was particularly inspirational to me. *Photographed by Ed Caraeff.*

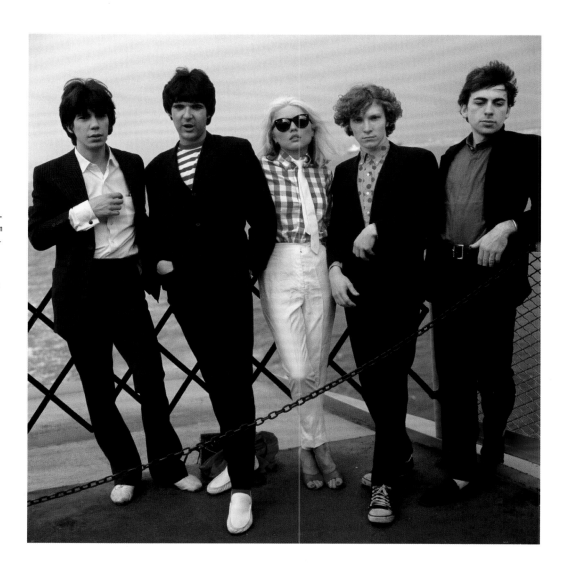

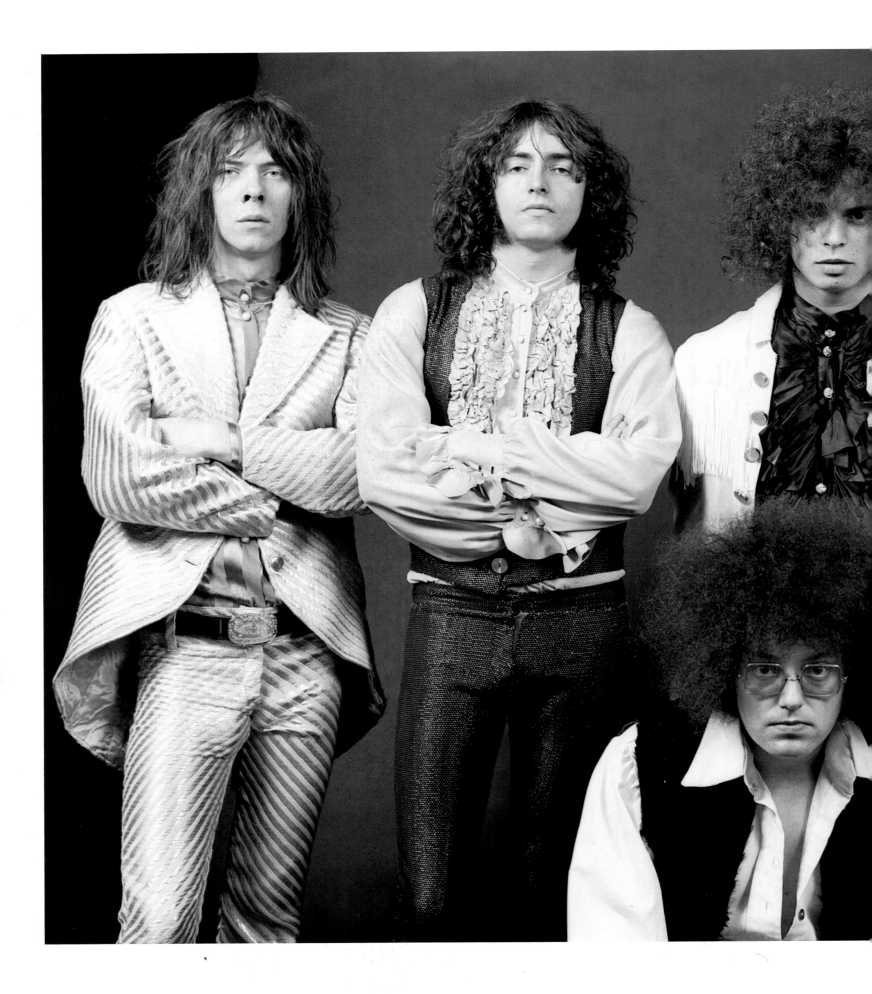

"A confluence of ideas determined the MC5's style sense. One was the bright, shiny, sharkskin stage outfits of my beloved Motown and other great R&B artists. Another was the faux-Elizabethan look of the British bands so popular in the '60s. We loved their look and adopted it for regular day-to-day wear. The Black Panthers were another big influence and an important component of our statement: the black leather jacket; sport, or car, coat length; and the long coat were all worn by the MC5 and our crew. You knew where we stood when you saw us coming. But the most important element was acid. LSD could produce tremendously vibrant, colorful hallucinations, and I wanted to reproduce these colors with the band's clothing. That's why I loved lamé and sequins. I wanted the stage lights to reflect off our clothes and dazzle the audience. My goal was to make the band look like we had arrived from another dimension. The other aspect is the boundless creativity of our singer, Rob Tyner. He designed all his own clothes and was light-years ahead of everyone. He was doing things with fur and bright colors, with stripes and metallic materials and even glitter in his Afro. He actually wore a miniskirt once. He was brilliant and remains to this day one of my art and style heroes."

—Wayne Kramer, 2012

My Detroit heroes, **MC5**, had it all in music, attitude, swagger, and style but were too far ahead of their time to be successful. Seen here in 1969, from left: Fred "Sonic" Smith, Michael Davis, Wayne Kramer, Dennis Thompson, and (front) Rob Tyner.
Photograph by Raeanne Rubenstein.

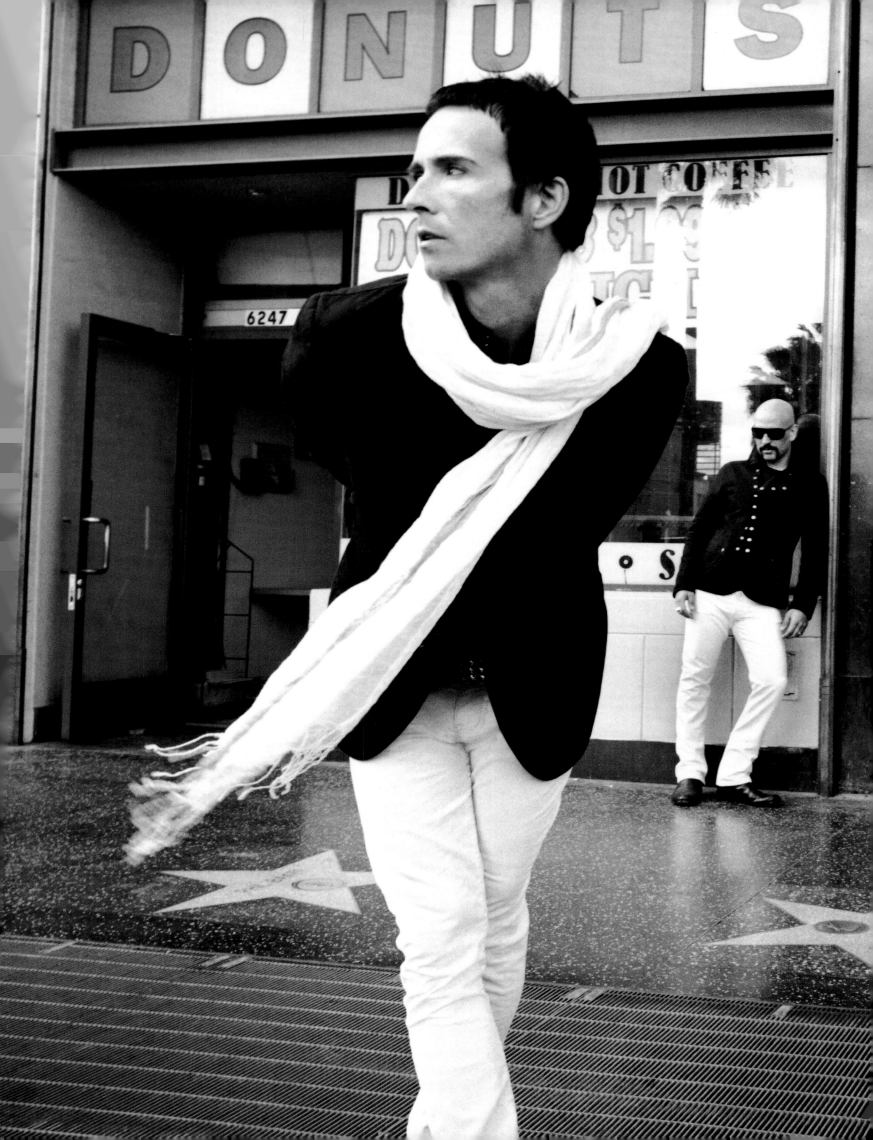

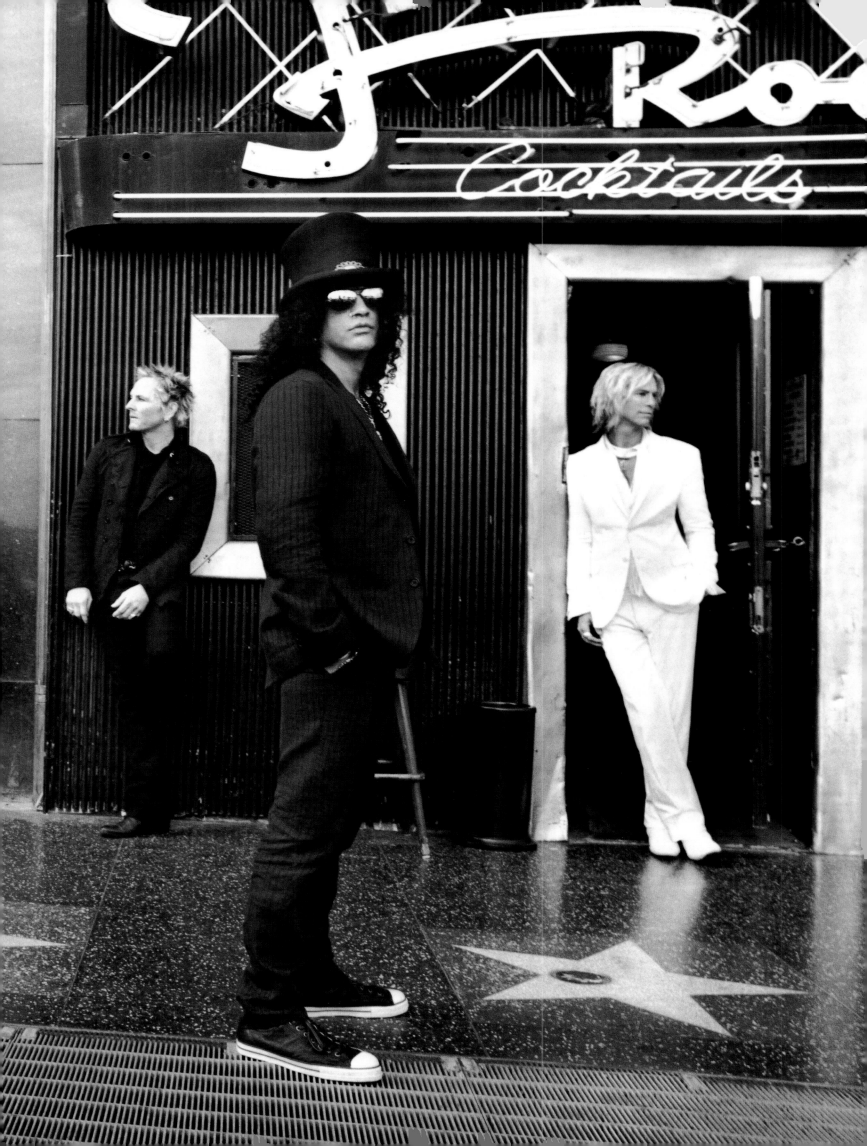

PAGES 34-35
VELVET REVOLVER, from
the John Varvatos Fall 2007
advertising campaign.
Photograph by Danny Clinch.

KINGS OF LEON is one of the coolest
bands on the planet. Their clothes are
simple but show attitude—with ease—
just like the Stooges' look did forty-
something years earlier.
Photograph by Danny Clinch.

"These guys looked like characters from the Hole in the Wall Gang."

—Eric Clapton on the Band,
 Rolling Stone, **1991**

Pictures of **THE BAND** from
this session in Woodstock, New York,
stylistically represent some of my
favorites. In this shot, from left:
Richard Manuel, Levon Helm, Rick Danko,
Garth Hudson, and Robbie Robertson
are each wearing a different style
of jacket, but still they look like
a gang—of outlaws. Elliott Landy's
photos of the Band all have a
timeless quality.
Photograph by Elliott Landy.

HAIR.

CHAPTER 2: THE ROOT OF THE STORY

What's the first thing about a person that says rock & roll? Hair.

It was like that from the beginning: In the 1950s, Elvis shocked parents and wowed kids with his sideburns and jet-black hair, long on top and slicked into a pompadour. That kicked off what became known as the rockabilly look, which has continued to pop up every few years. When the Beatles first started, they emulated that "greaser" look, but by 1963, they'd come up with their own style, which blew everyone away. Their "mop tops" started a craze that was probably as revolutionary as their music. From there, hair kept getting longer. The Rolling Stones let theirs look unkempt, like they'd just gotten out of bed. Kurt Cobain and others in the early 1990s Seattle scene made the bed-head look ubiquitous for a while.

The mix of blond and brunette made an exciting visual statement onstage and on album covers: think of the contrast between Brian Jones and Keith Richards, and between Robert Plant and Jimmy Page.

By the late 1960s, you could tell how cool someone was by the length of their hair. As Jimi Hendrix wrote in "If 6 Was 9," "I'm gonna wave my freak flag high." The Jimi Hendrix Experience's Afros were their freak flags, just like David Crosby's mane was his: "I want to let my freak flag fly," he seconded Jimi in "Almost Cut My Hair." Big Afros became a political statement, as black men went natural, forgoing the "process."

Long or wild hair epitomized an antiestablishment, outside-the-mainstream attitude, and identified the wearer as part of the rock & roll counterculture. In the 2000s, when Red Hot Chili Pepper Anthony Kiedis attacked the stage bare-chested, his very long, straight brown hair flying around him, it reminded me of seeing Mark Farner of Grand Funk Railroad at Cobo Hall in Detroit back in 1972.

In the 1970s, different hair "tribes" evolved as rock splintered into subgenres. Glam rockers took the mod look, hair back-combed up and spiky, to an extreme with the "rooster" or shag. Ushering in reggae, Bob Marley also inspired artists to let their hair dread up—dreadlocks appeared not only on Jamaicans but on artists like Perry Farrell, Adam Duritz, and Lenny Kravitz. Punk, a reaction to 1970s mainstream rock, produced shorn, spiky locks and crazy Mohawks. Green Day has kept that look going in various ways.

In this chapter are images of artists sporting styles that have had a particular influence on me as a designer—that's why I haven't included women's hairstyles here. These are the looks I think of when styling the guys for our runway shows, or as I work with musicians who appear in our ad campaigns. Most of these looks have a timeless quality to them that says "rock & roll," whether it's 1969 or today.

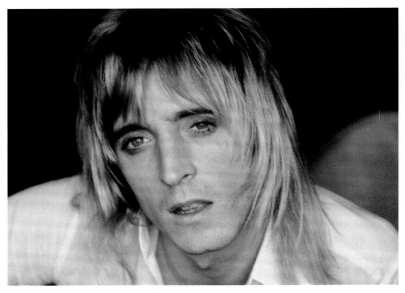

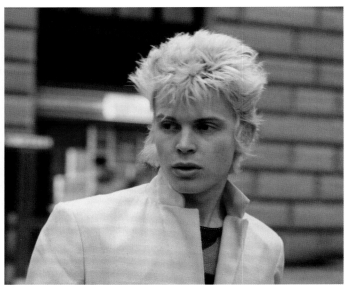

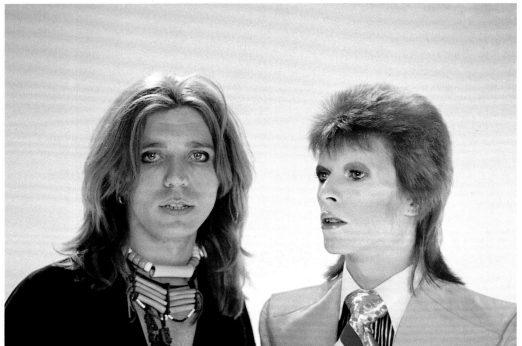

CLOCKWISE FROM TOP LEFT

MICK RONSON, the Spider from Mars. Mick's blond-streaked shag influenced men's and women's hairstyles in the 1970s, probably more than Bowie's Ziggy Stardust did, although glam fans emulated Bowie's look at the time. *Photograph by Mick Rock.*

BILLY IDOL in his Generation X days with his trademark bleached-blond locks. His spiky platinum hair inspired countless punks. *Photograph by Roberta Bayley.*

PETER GABRIEL and **DAVID BOWIE**, two of my favorite artists, showing off their glam style and hair in 1972. Bowie's blue eye shadow is a nice complement to his red 'do. Gabriel also wore heavy makeup during early shows with Genesis. *Photograph by Mick Rock.*

OPPOSITE

FREDDIE MERCURY sported a glam shag. *Photograph by Mick Rock.*

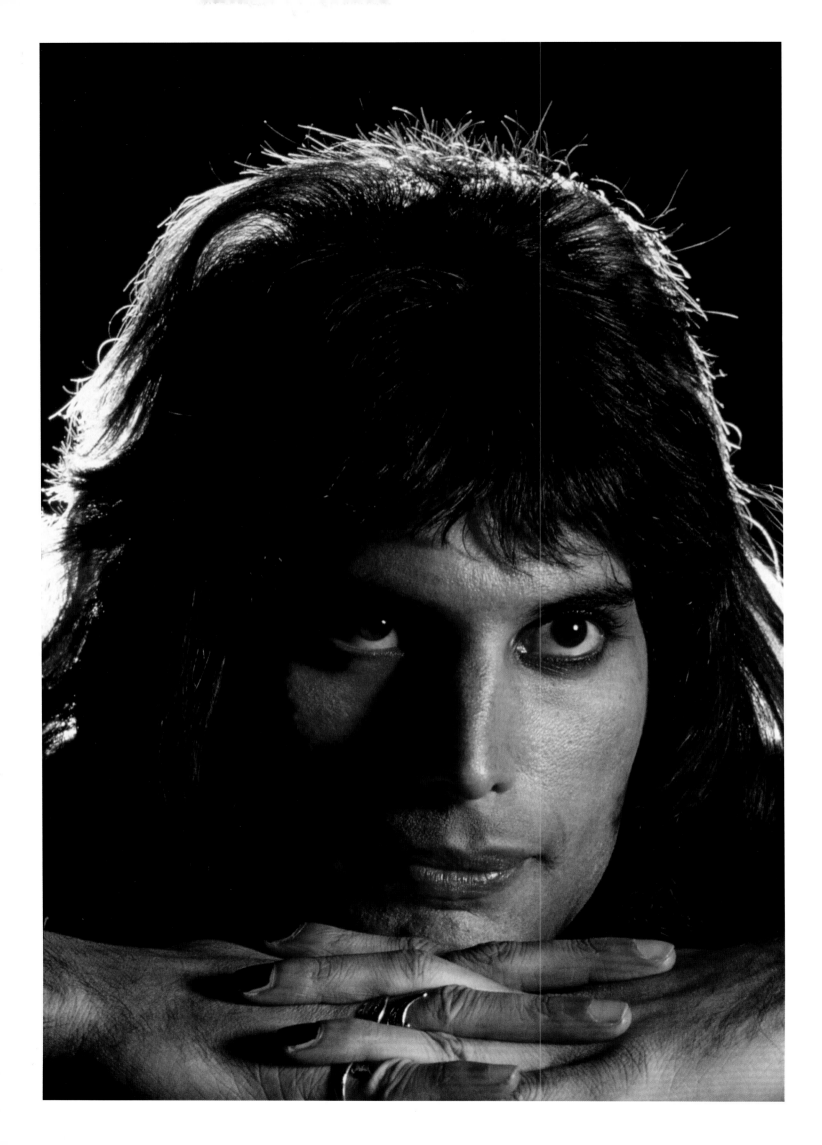

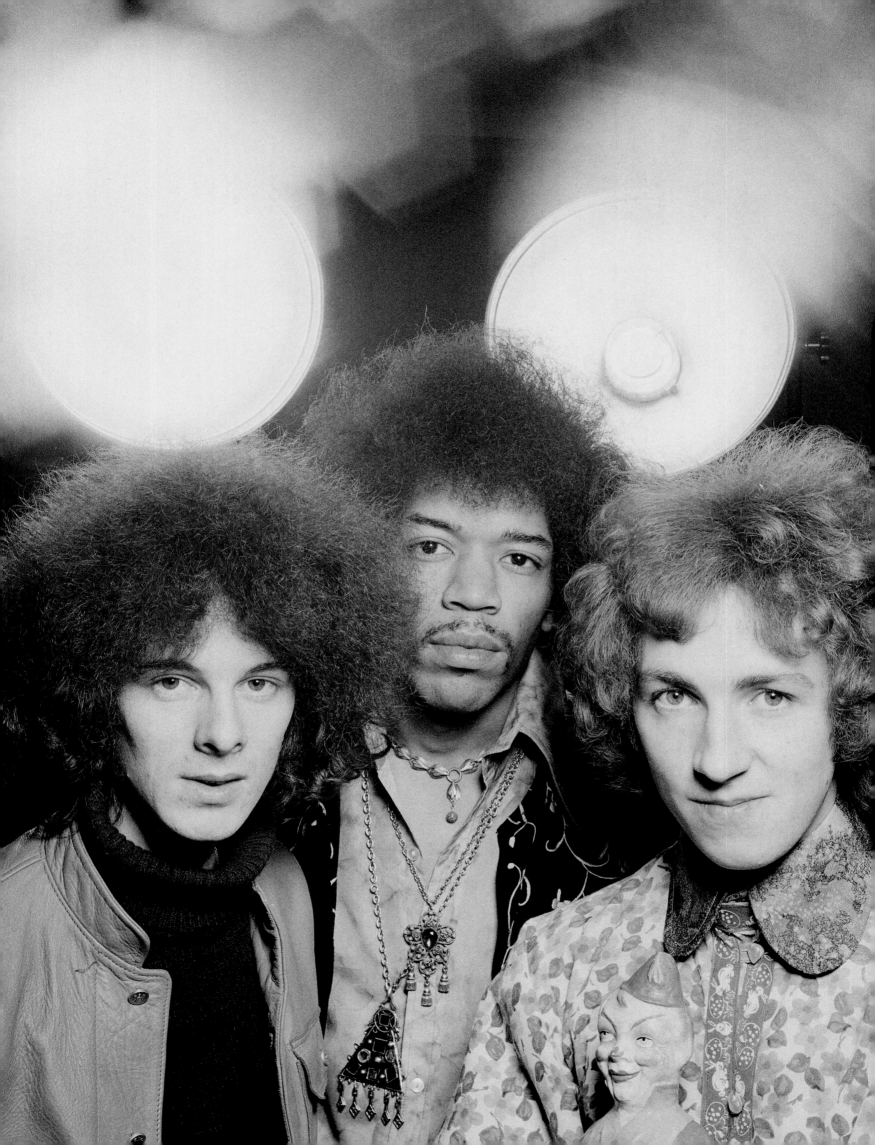

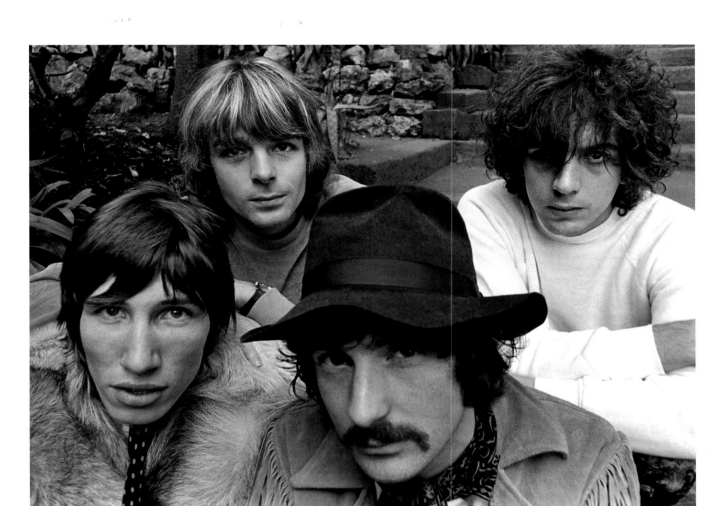

ABOVE

PINK FLOYD, during their Syd Barrett days, had a trippy style, which was characterized by clothing with lots of texture—fringe and fur—and psychedelic prints. *Photograph by Baron Wolman.*

RIGHT

JOE PERRY and **STEVEN TYLER** have always known that their hair is an important part of Aerosmith's persona. Here, the similarity in the duo's hairstyles is not unlike that of the Glimmer Twins, Mick and Keith. *Photograph by Deborah Feingold.*

OPPOSITE

I'd never seen or heard a group like the **JIMI HENDRIX EXPERIENCE**—ever! The band made the Afro an aspect of rock & roll style for both white and black artists. *Photograph by Gered Mankowitz.*

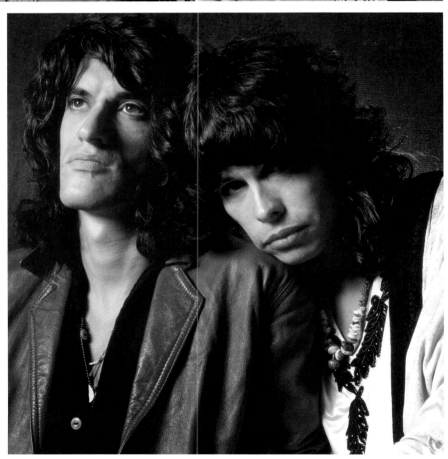

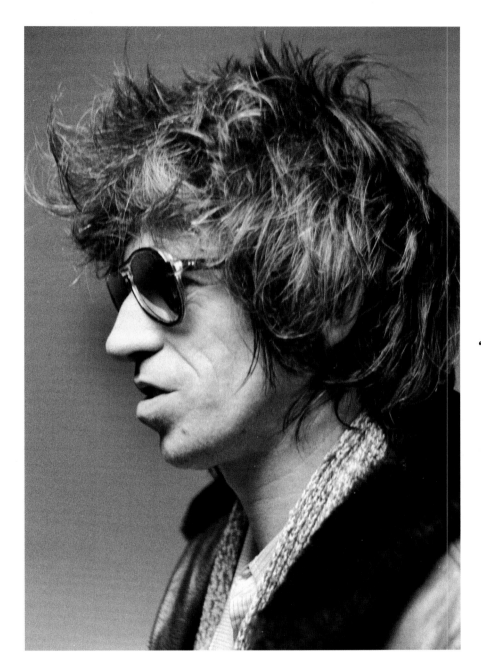

"I cut out all the pictures I could find of Keith Richards. I studied them for a while and took up my scissors, machete-ing my way out of the folk era...my Keith Richards haircut was a real discourse magnet."

—Patti Smith, from *Just Kids*, 2010

KEITH RICHARDS's just-rolled-out-of-bed hairstyle is copied by male and female rockers to this day. *Photograph by Peter Simon.*

OPPOSITE

SLY STONE had great hair and style. His Afro was both a political and a style statement. *Photograph by Stephen Paley.*

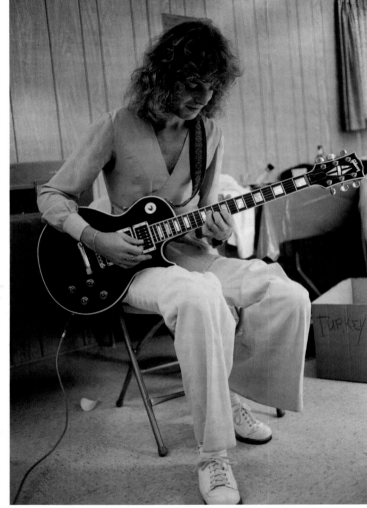

CLOCKWISE FROM TOP LEFT

ROGER DALTREY exuded raw sexuality with his slightly unkempt golden curls.
Photograph by Baron Wolman.

PETER FRAMPTON and his signature blond curls were equally famous in the 1970s.
Photograph by Michael Zagaris.

JACK WHITE is so cool! As drummer of the Dead Weather, he lets his freak flag fly.
Photograph by Jérôme Brunet.

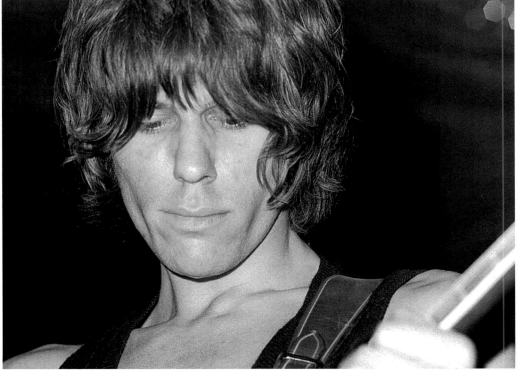

ABOVE

CALEB FOLLOWILL of Kings of Leon capturing a wonderful shaggy 1970s look.
Photograph by Danny Clinch.

LEFT

JEFF BECK's early shag. His look really hasn't changed much at all over the years.
Photograph by Robert Knight.

"My hair had a mind of its own. I shaped it with my hands—constantly."

—Robert Plant, 2012

Simply beautiful. **ROBERT PLANT** had no problem throwing on a woman's blouse to amp up his sex appeal; conversely, many women wished they had his hair!
Photograph by Bob Gruen.

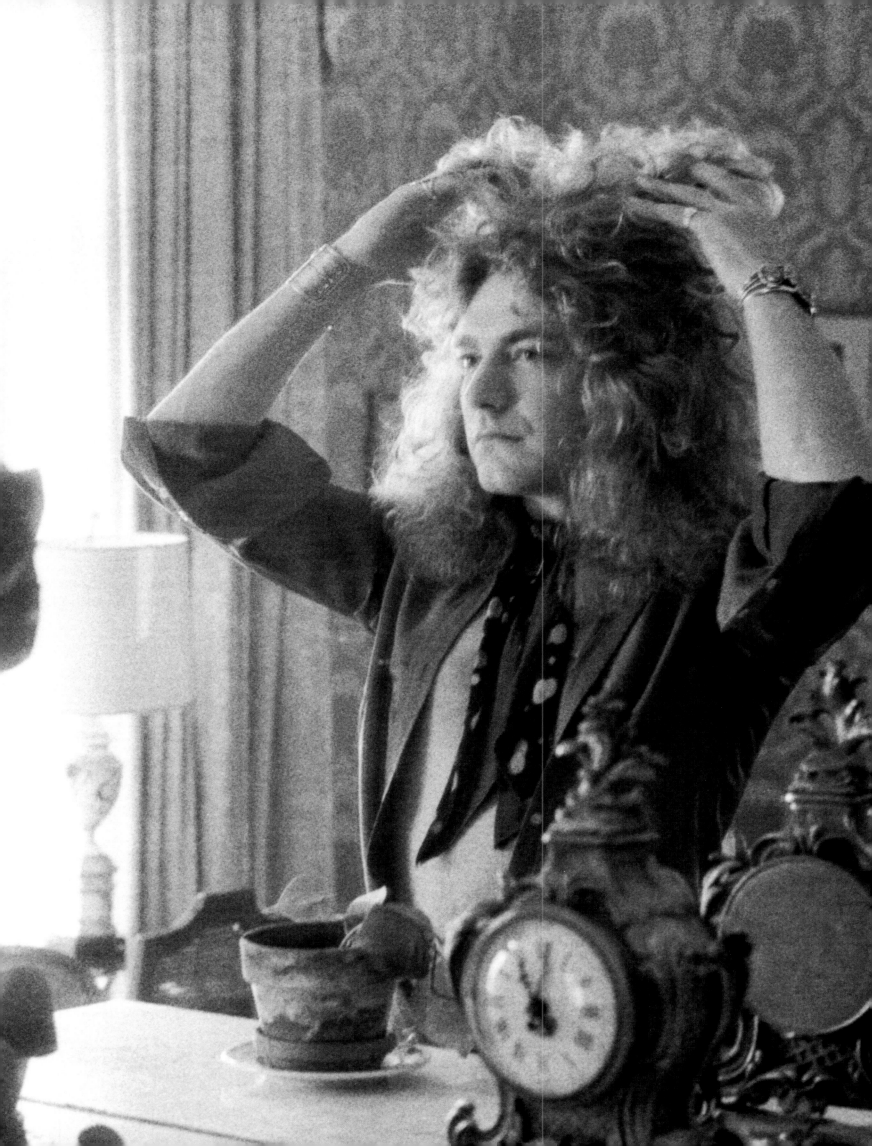

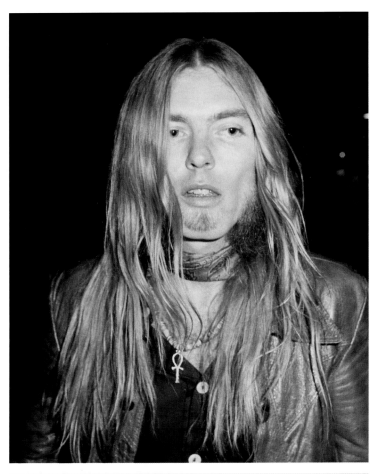

"I had blond hair down to my elbows, and I weighed a rockin' 160 pounds."

—Gregg Allman, from *My Cross to Bear*, 2012

GREGG ALLMAN's locks inspired many men to go for very long hair in the 1970s. Gregg still sports a blond ponytail today.
Photograph by Bob Gruen.

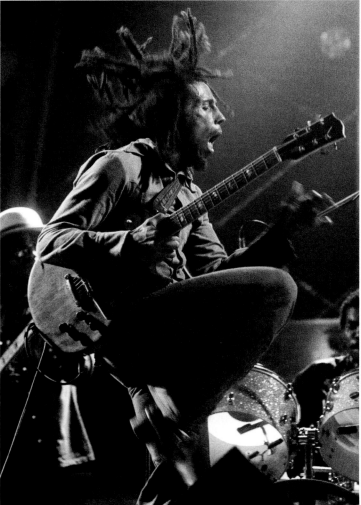

LEFT

BOB MARLEY represents my first real connection with dreadlocks. He introduced the Jamaican hairstyle to rock & rollers in England and the United States.
Photograph by Ian Dickson.

OPPOSITE

LENNY KRAVITZ is one of the most stylish rockers in history. From his Hendrix look during his "Are You Gonna Go My Way" video to his ever-changing hair, he has always intrigued me from a fashion point of view.
Photograph by Lynn Goldsmith.

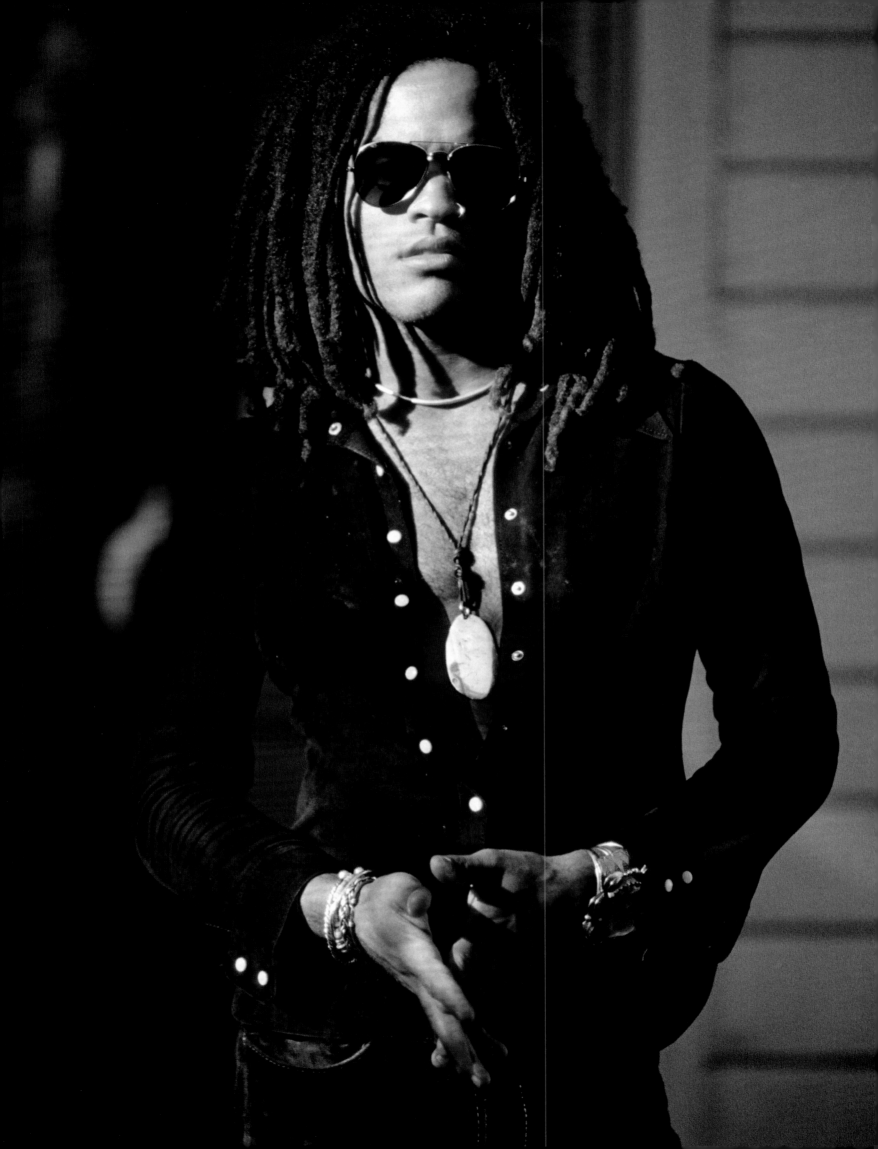

BEHIND THE SHADES.

CHAPTER 3: SUNGLASSES

Outlaws wore masks and rock & rollers wear shades. James Dean and Roy Orbison started the look in their black Ray-Bans back in the 1950s. Dylan picked up a pair of Wayfarers in the 1960s, and then Patti Smith and Debbie Harry brought them back via the punk scene in the 1970s. Other styles of shades, from the tinted granny glasses favored by John Lennon and the Byrds' Roger McGuinn to aviators to oversized white rimmed frames, have come in and out of fashion since then. Of course, beginning in the 1970s, Elton John became synonymous with eyewear.

Through the years, rockers have taken to all kinds of styles—as long as the glasses keep the eyes hidden. Why?

Because wearing shades is like wearing a mask: people can't see your full face, so they can't tell what you're thinking. This wall creates mystery, which can be alluring. For some, those dark shades add edge to what otherwise could be a straightforward look. Eyeglasses help to create a persona, like Bono's Fly, or Elvis Costello's homage to Buddy Holly. Or for those living the rock & roll lifestyle, after a long night, shades are downright practical—a good way to hide out. Just ask Slash.

OPPOSITE

SLASH, from the John Varvatos Spring 2007 advertising campaign. *Photograph by Danny Clinch.*

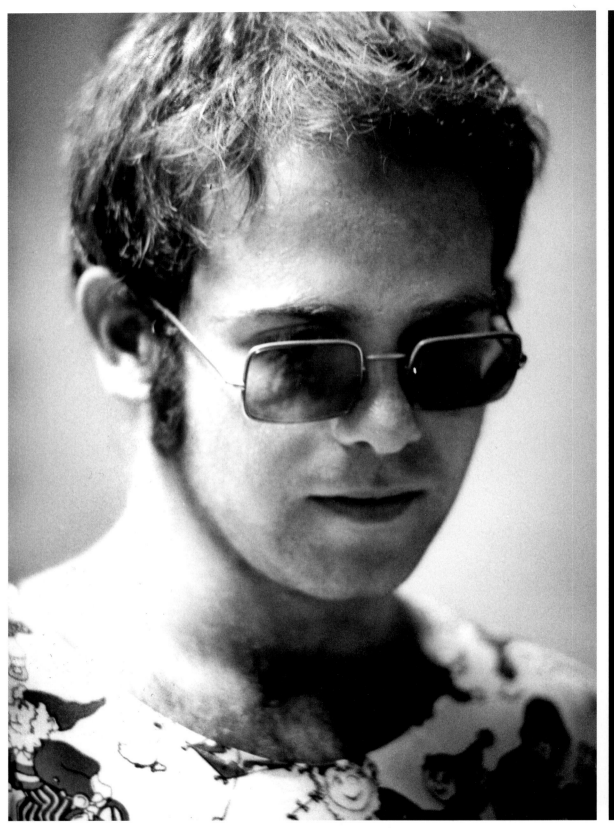

For **ELTON JOHN**, performing wasn't
about the show in his early career,
just the music. He moved on from
understated to outrageous eyewear.
Photograph by Robert Altman.

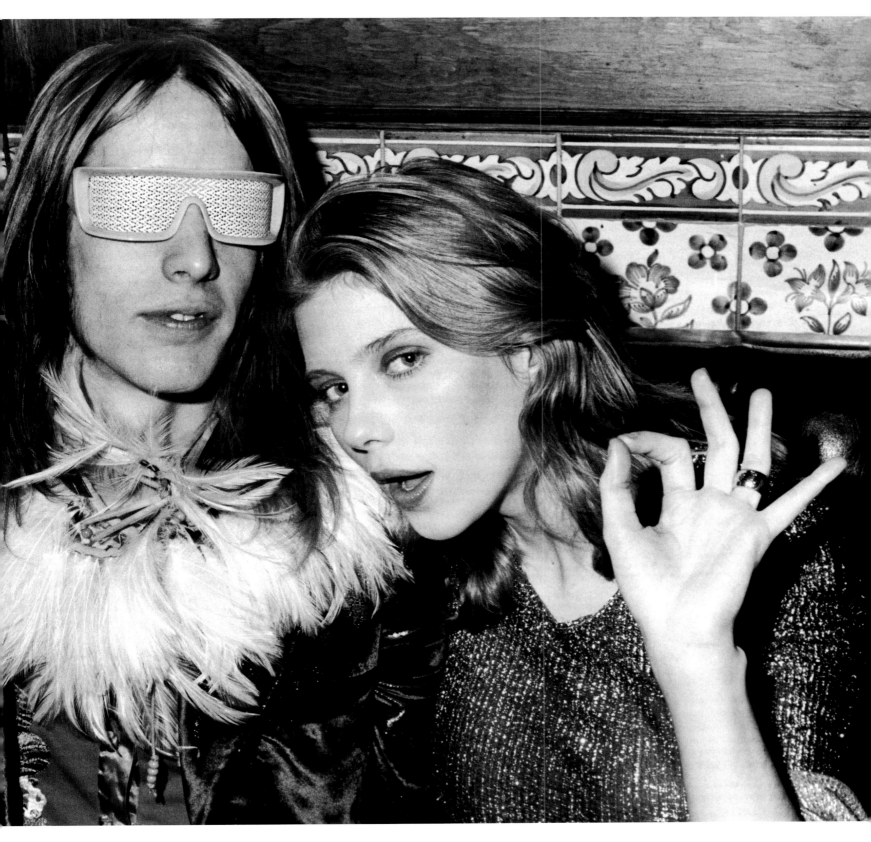

TODD RUNDGREN (with Bebe Buell) found a pair of tripped-out sci-fi shades to go with his 1970s glam boa. *Photograph by Bob Gruen.*

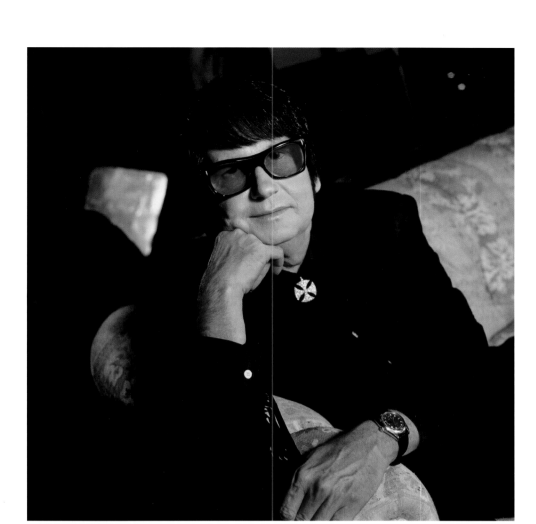

TOP, RIGHT

ROY ORBISON is nearly as famous
for his overall look, including
the signature dark Wayfarers, as
he is for his music.
Photograph by Timothy White.

RIGHT

WAYNE COYNE of the Flaming Lips
often changes up his onstage personality
by wearing different glasses.
Photograph by Mick Rock.

OPPOSITE

DAVID JOHANSEN (right) and
pal wearing sunglasses after dark
in the 1970s.
Photograph by Bob Gruen.

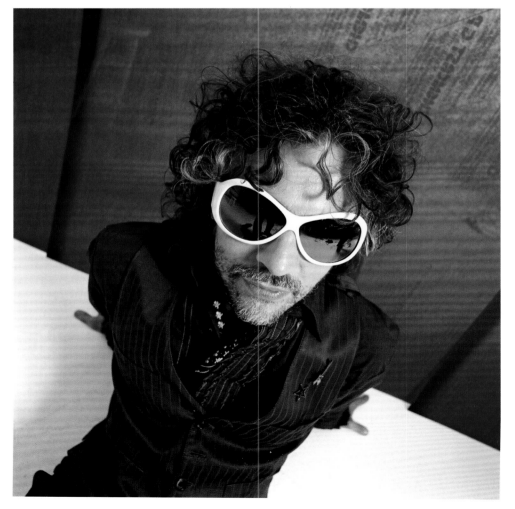

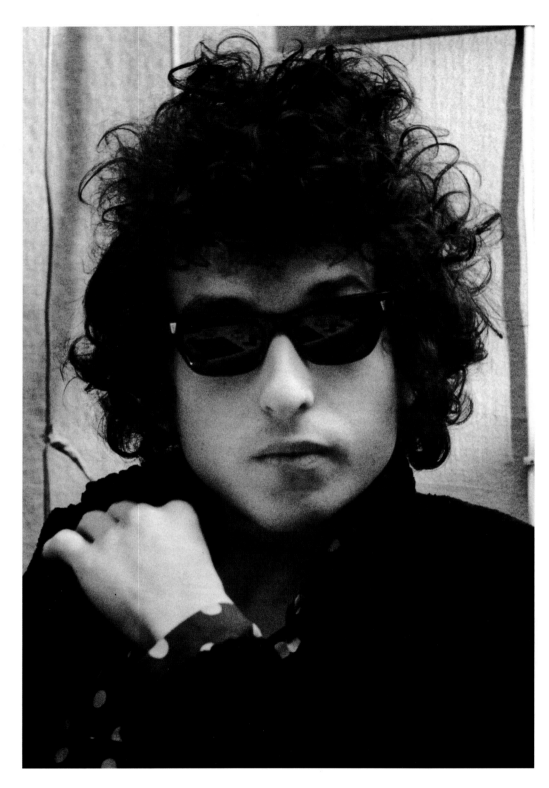

The mid-1960s period of **BOB DYLAN**'s
career is my favorite from a style
point of view. The classic black horn-
rimmed glasses never go out of style.
Photograph by Charles Gatewood.

OPPOSITE

IAN HUNTER's shades are his
trademark—that is, other than
his amazing hair and songwriting.
Photograph by Mick Rock.

EXTRA

POSTER BEATLES

CLOCKWISE FROM TOP LEFT

ELVIS COSTELLO is a man of many shades. His eyeglasses are such a significant part of his image that his Sundance TV show was called *Spectacle*. *Photograph by Roberta Bayley.*

DAVID JOHANSEN's always got it going on! *Photograph by Andy Willsher.*

DEBBIE HARRY sporting Ray-Ban Wayfarers in 1977. With her platinum hair and shades, she cultivated a Hollywood-meets-the-Bowery style. *Photograph by Bob Gruen.*

"My sunglasses are like my guitar."

—Patti Smith

OPPOSITE

Like Debbie Harry and Richard Hell, **PATTI SMITH** wore Ray-Bans; her look in 1976 was à big influence on New York's punk scene. *Photograph by Bob Gruen.*

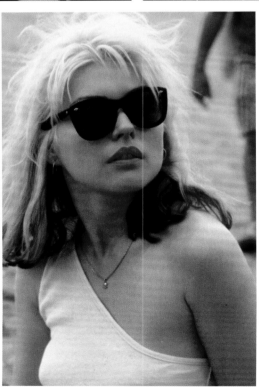

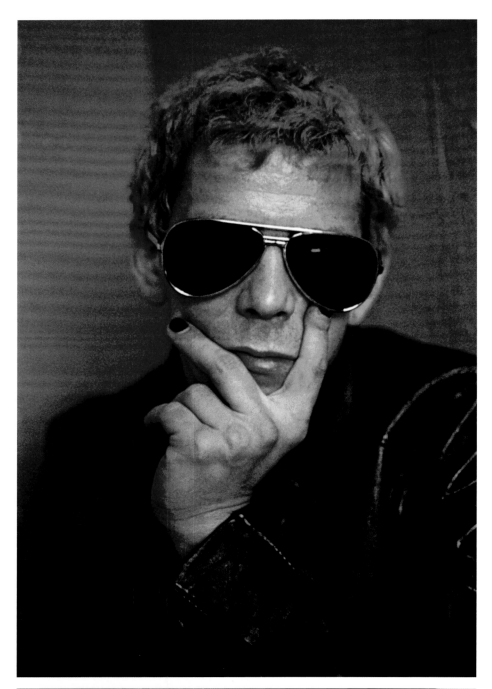

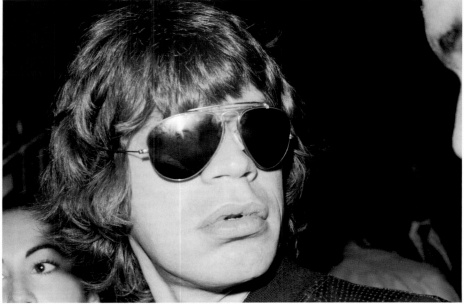

TOP, LEFT

LOU REED added a decadent
edge to the aviator shades style
popularized by Peter Fonda
in the 1967 film *Easy Rider*.
Photograph by Mick Rock.

LEFT

MICK JAGGER has worn all
styles of glasses. I love these
oversized aviators on him.
Photograph by Lynn Goldsmith.

OPPOSITE

JOHN LENNON, known for his
shades, couldn't decide which pair
to wear for this 1974 portrait.
Photograph by Bob Gruen.

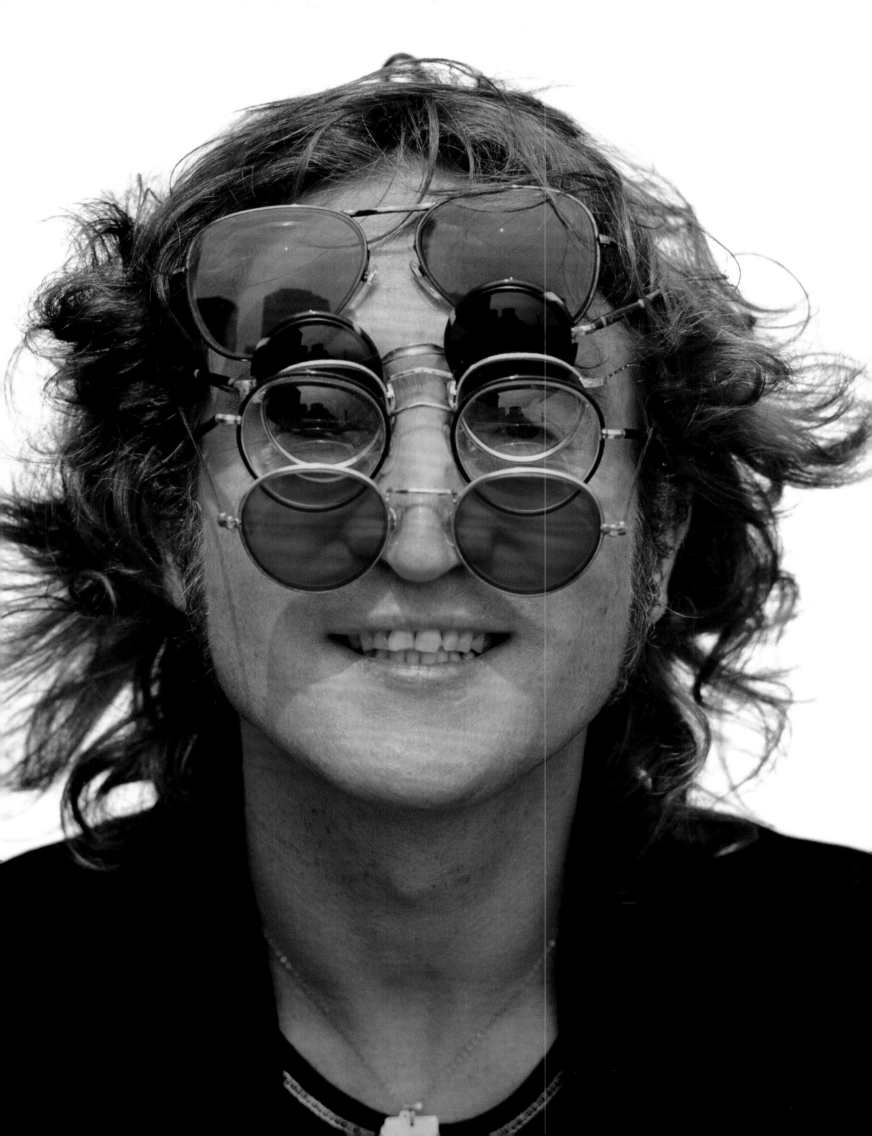

WHAM BAM THANK YOU MA'AM.

CHAPTER 4: GLITTER, GLAM, AND GIRLY

Transformer: That's the name of Lou Reed's second solo album, produced by David Bowie, and it references a change in rock fashion that started around 1969. Elvis Presley and Little Richard showed signs of rock androgyny back in the 1950s, but it wasn't until Mick Jagger appeared in a white, dress-like tunic in July 1969 at the Brian Jones memorial concert in Hyde Park that cross-dressing became acceptable in rock.

Three years earlier, the Stones had appeared in drag for a campy picture sleeve for "Have You Seen Your Mother, Baby, Standing in the Shadow?" but that was more of a joke than a style signpost. In 1970, Bowie's *The Man Who Sold the World* featured the self-proclaimed bisexual performer wearing a dress on its cover. Both Bowie's dress and Jagger's tunic were designed by British couturier Michael Fish. At London's Granny Takes a Trip boutique, designer Johnny Moke cut up girls' blouses and dresses and sold them to members of the Stones and Led Zeppelin, as well as to other musicians. Robert Plant most famously sported women's blouses, usually worn open, with his tight denim flares and masculine leather belt. He never looked femme in this getup, though he laughs about the look today.

Stateside, in the late 1960s, members of Alice Cooper dressed like depraved streetwalkers, a look that gradually evolved into their shock-rock style. In the early 1970s, the New York Dolls mixed thrift shop women's clothing with jeans and the occasional tutu. Photographer Bob Gruen, who shot the band consistently, told me that their look only increased their sex appeal. They had plenty of female groupies. The masculine meets feminine style has resurfaced throughout the years, with Kurt Cobain, Steven Tyler, Perry Farrell, Steve Harley, and Lenny Kravitz among the rockers who haven't been afraid to grab a boa or don a dress to show off their inner femme.

The outrageous look of glam was first sported in England by T. Rex's Marc Bolan, with his brightly colored satin jackets, platform shoes, and top hat perched on his black ringlets. Bowie took the look to another level with his Ziggy Stardust persona. Although his space-oddity getups—with oversized padded jumpsuits, lightning-striped makeup, and sky-high platform boots—and otherworldly orange-red hair color could be categorized as glam at the time, Bowie himself cannot. He's rock & roll's king chameleon, and he has taken on a range of looks and personas in the years since.

Also on the glam trip were UK bands like Queen, the Faces, and Mott the Hoople. In the United States, Lou Reed dyed his hair platinum and painted his fingernails black. Iggy Pop had always been outrageous, sometimes covering his torso in silver glitter (or with peanut butter), but during the glam era he wore a pair of silver leather pants so tight he must have had to peel them off.

TODD RUNDGREN took on many personas over the years. His answer to glam included feather eyelashes and eyebrows as well as a feather corset. A wizard, a true star! *Photograph by Lynn Goldsmith.*

STEVE HARLEY—a little fun, leather, and skin. The fur stole looks like it belonged to a 1930s gangster's moll. *Photograph by Mick Rock.*

"How we met [was] we were on the street and we'd see each other because we all had a similar aesthetic...we all noticed each other and started talking. It wasn't like we got together and took off our ties and decided to dress like that."

—David Johansen on the New York Dolls, from *Alibi*, 2011

OPPOSITE
The queens of Hollywood! The **NEW YORK DOLLS**—(from left) Jerry Nolan, Sylvain Sylvain, Johnny Thunders, David Johansen, and Arthur Kane—used a mix of thrift shop cast-offs, over-the-top hair and makeup, spandex, and platforms to make a glam-punk statement in Tinseltown. *Photograph by Bob Gruen.*

At the time, some glam bands had moved from playing clubs to performing in arenas, hence their transition to more outlandish attire. From the second balcony, glam getups and wild hair color and makeup are visually exciting to the audience. After all, it's more difficult to see—and remember—an artist wearing a black suit or leather jacket. Today, the most enduring element of the glam look is that artists are donning candy-colored stage gear to make their concerts more of a show.

Glam has influenced subsequent generations—especially artists like Prince and Michael Jackson in the 1980s, and bands like Brian Jonestown Massacre, D Generation, Scissor Sisters, and the Dandy Warhols more recently. Since artists take on various personas through their music and stage presentation, glam has proven to be an outrageous look that is continually revisited. Who can top the Alexander McQueen getups that became Lady Gaga's calling card? Trust me: somebody will try it again a few years from now—and a few years after that.

Just like glam, outrageous looks don't seep into everyday style, but they continue to keep us interested—in the visual pizzazz of performing, if not always the music itself.

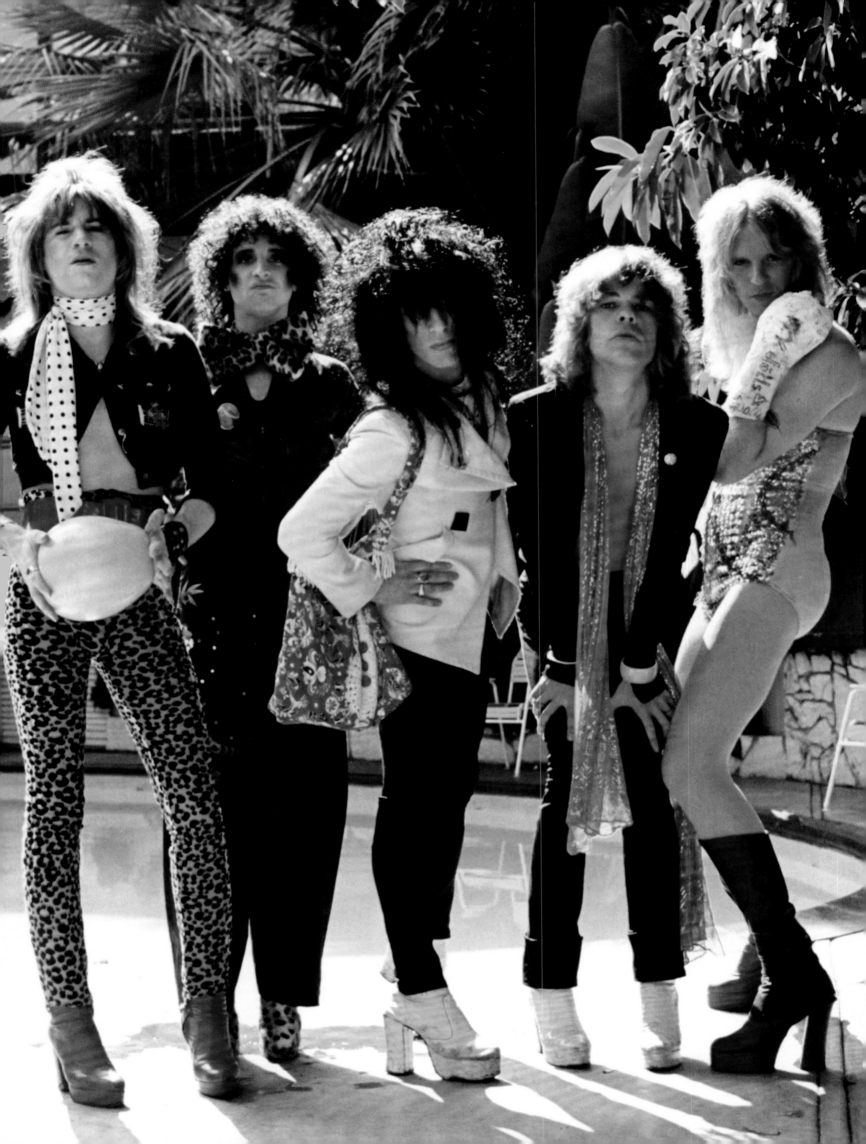

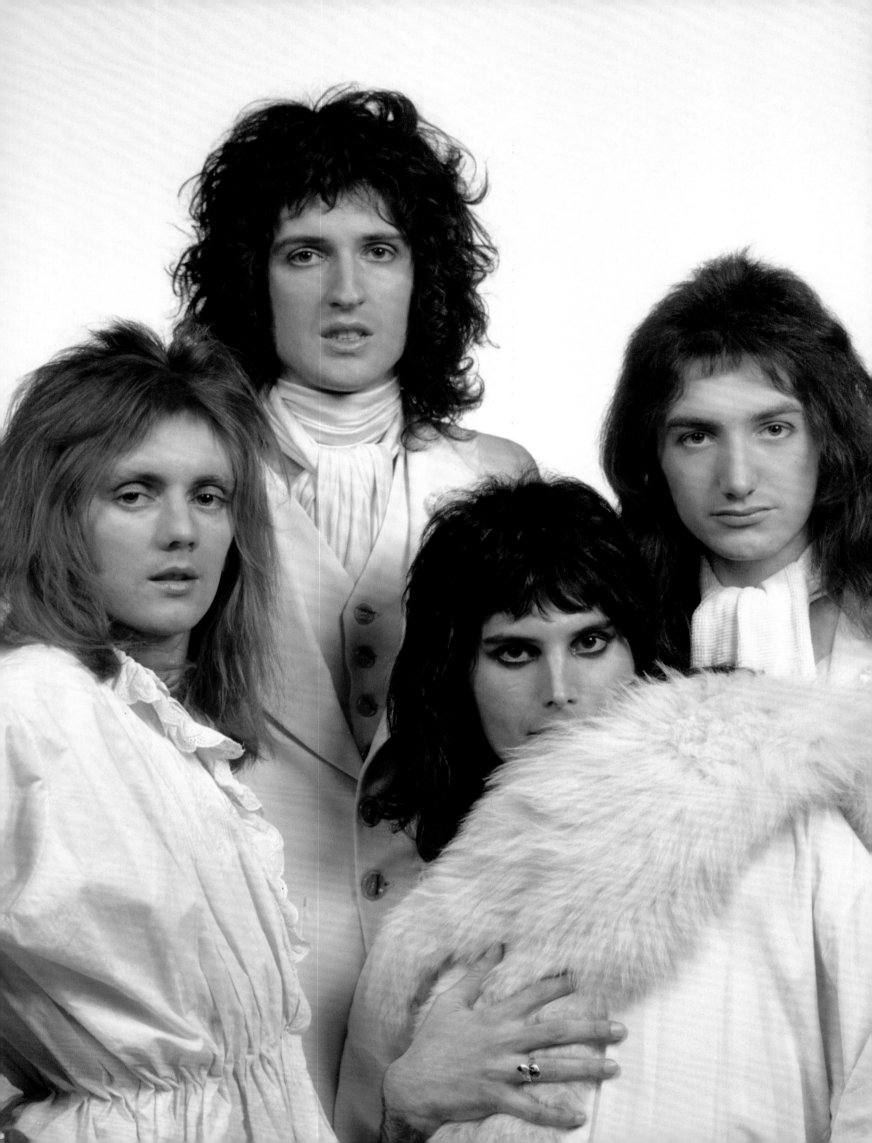

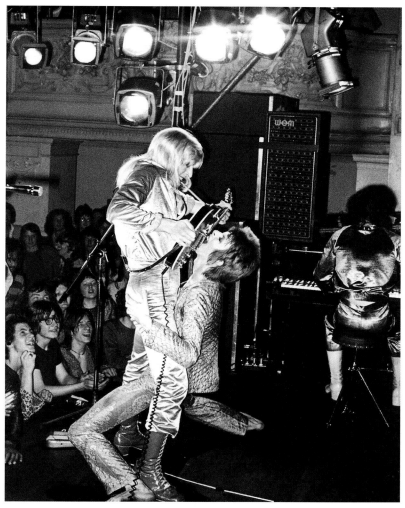

"What was quite hard was dragging the rest of the band into wanting to [dress glam]. That was the major problem—that we really didn't think alike at all. It was like, 'Jesus, come on, you lot—let's not just be another rock band, for chrissakes.' But they were a great little rock band, and they caught on to it as soon as they found that they could pull more girls. Then it was, 'Hey, they like these boots.' That's what it needed. Get a bit of sex into it and they were away, boy. Their hair suddenly got—oh, it was every color under the sun. All these guys that wouldn't get out of denims until two weeks ago."

—David Bowie on the Spiders from Mars,
 The "Rolling Stone" Interviews, 1989

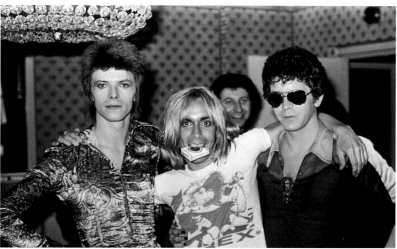

I saw **BOWIE**'s Ziggy Stardust and the Spiders from Mars tour. It was outrageous, mind-blowing, exciting, bombastic, sexual, and just the most amazing show on earth. While the costumes were eye candy, they were also durable enough for campy onstage theatrics.
Photograph by Mick Rock.

Three of my icons—**BOWIE**, **IGGY**, and **LOU REED**—embracing glam as much as each other. Note T-Rex's Marc Bolan on Iggy's T.
Photograph by Mick Rock.

"I dress to kill, but tastefully."

—Freddie Mercury

QUEEN in all their pomp splendor. This portrait shows their penchant for glam makeup and hair as well as fur and white silk.
Photograph by Mick Rock.

PAGES 70-71

DAVID BOWIE and **MICK RONSON**.
Just the most amazing picture.
It says it all!
Photograph by Mick Rock.

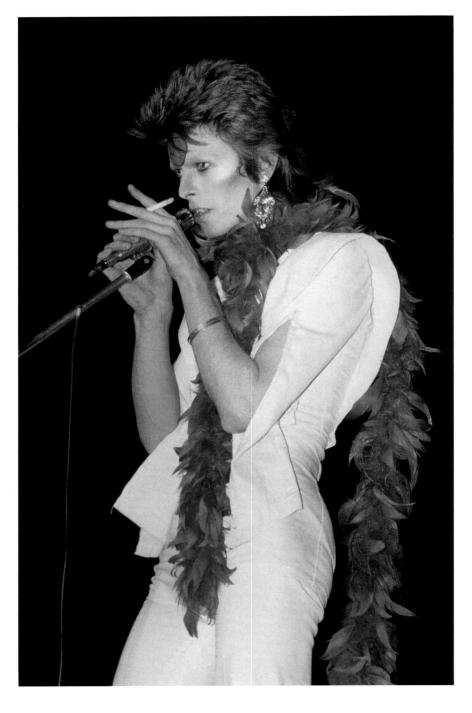

DAVID BOWIE and **MICK RONSON**.

"I believe rock & roll is dangerous. We...boys with our makeup and funny clothes...I feel that we're only heralding something even darker than ourselves."

—David Bowie, from *Rock and Roll Revealed*, 1993

Earrings and a boa push **BOWIE**'s
feminine side over the edge.
Photograph by Lynn Goldsmith.

OPPOSITE
Pumps and poses. In 1973, the
NEW YORK DOLLS made a pilgrimage
to Frederick's of Hollywood, where
fantasy lingerie was available in all
sizes. Johnny Thunders is at left,
David Johansen at right.
Photograph by Bob Gruen.

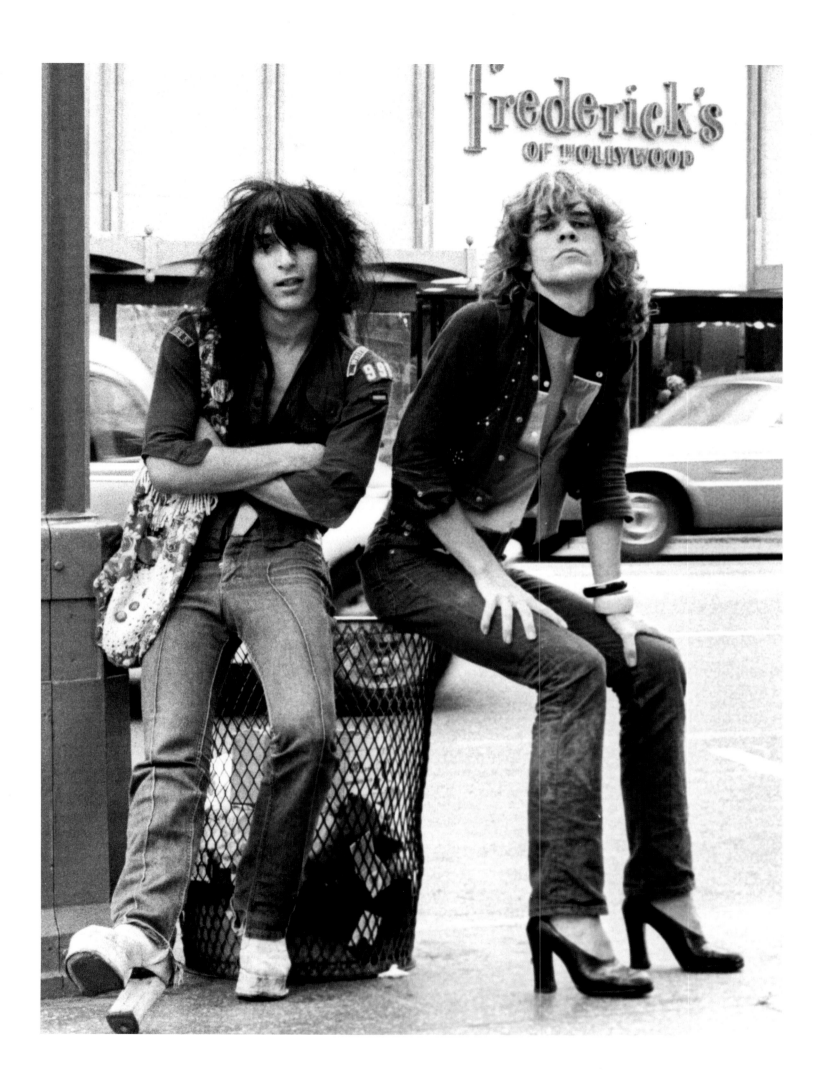

"Ninety-five percent of my success is the way I look. That's what people pick up on. The music is secondary."

—Marc Bolan, circa 1972

RIGHT
With his velvet and metallic ensembles and high-heeled shoes, **MARC BOLAN** helped originate the glam look in England. *Photograph by Keith Morris/Robert Matheu Collection.*

OPPOSITE
DAVID JOHANSEN doing his best Liza Minnelli. *Photograph by Bob Gruen.*

MAD HATTERS.

CHAPTER 5: ROCK & ROLL LIDS

Men's hats were a sign of conformity in the 1940s and 1950s. But they took a 360-degree turn when doffed by rock & rollers in the 1960s and 1970s, swinging from the conventional "I'm just like you" to the individual "I'm nothing like you! Look at me!" For some artists, wearing a particular hat became a trademark of their overall look.

The black top hat has been a signature style for distinctive rockers on both sides of the pond: Brit Marc Bolan made a statement wearing his atop his black curls; in the States, Leon Russell's top hat looked amazing perched above his long silver locks and beard and mustache. Alice Cooper's top hat gave off a sinister vibe; Elton John's extravagant lids competed with his outrageous eyeglasses; and later on, Steven Tyler's embellished, over-the-top hats definitely screamed Mad Hatter. Slash has said that whenever he has his top hat on, it's a sign he's about to charge onstage and play. I guess you could say the top hat has become a kind of musical wizard's hat.

Jimi Hendrix inspired rockers to don hats when he began sporting his wide-brimmed cordovan with its striking band of silver links. John Lennon wore a floppy brimmed chapeau after he quit the Beatles. Perhaps it was a sign of his independence.

Caps have been part of rock & roll since the 1957 emergence of rockabilly star Gene Vincent and his aptly named group, the Blue Caps. The young Jackson 5 wore caps, with Michael later popularizing the fedora and the trick of rolling it down his arm. Leather caps and slouchy oversized caps could be used to hide under, and fantastical hats could be entertaining show garb. A true hat man, Dr. John is rarely seen without one—and he has worn all kinds, from shaman-voodoo headdresses to berets, from fedoras to Panama hats.

The most American of hats—the Stetson—has occasionally been taken up by rock & rollers, as have other elements of western style. Nodding to Americana music traditions, trailblazers Bob Dylan and Neil Young have worn their share.

Whatever type of hat, it conveys individuality. And that's what rock style is all about.

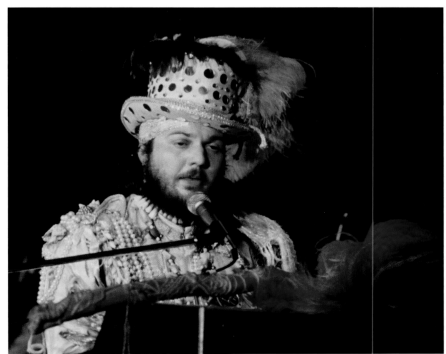

They called him the Night Tripper.
DR. JOHN's flamboyant hats and
curls added to the feeling of his
being out there.
Photograph by Bob Gruen.

I love this image of **BOB DYLAN** from
the Rolling Thunder tour in 1975. The
feather in his hat is a nice touch.
Photograph by Bob Gruen.

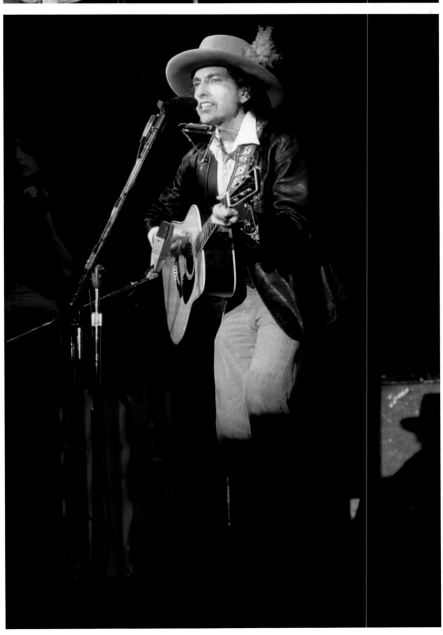

"I have three good top
hats, one of which I've
had ever since I can
remember. I bought—
stole—it from Retail
Slut in Hollywood,
California."

—Slash, 2012

SLASH's top hat has become part
of his personality and brand. There are
only a few people who are immediately
recognizable in silhouette—Jimi
Hendrix, Alfred Hitchcock, and Slash.
Photograph by Robert Knight.

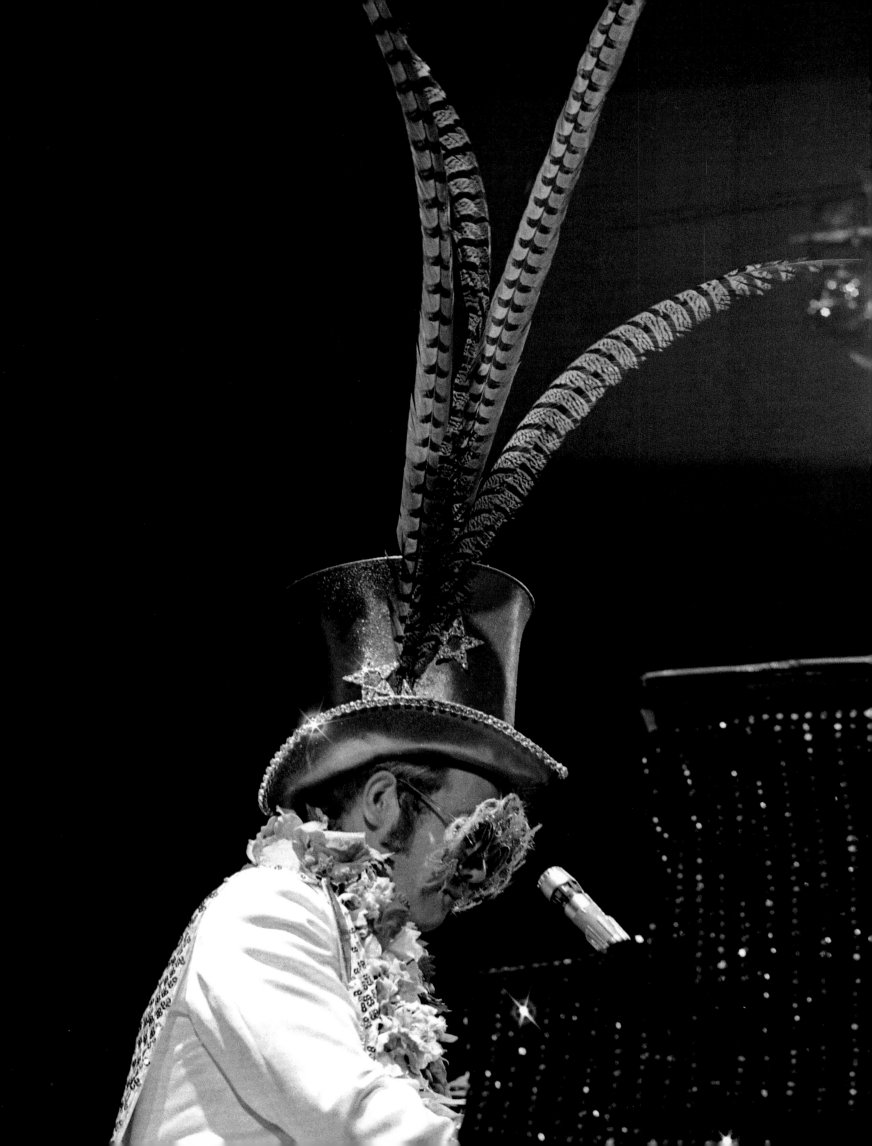

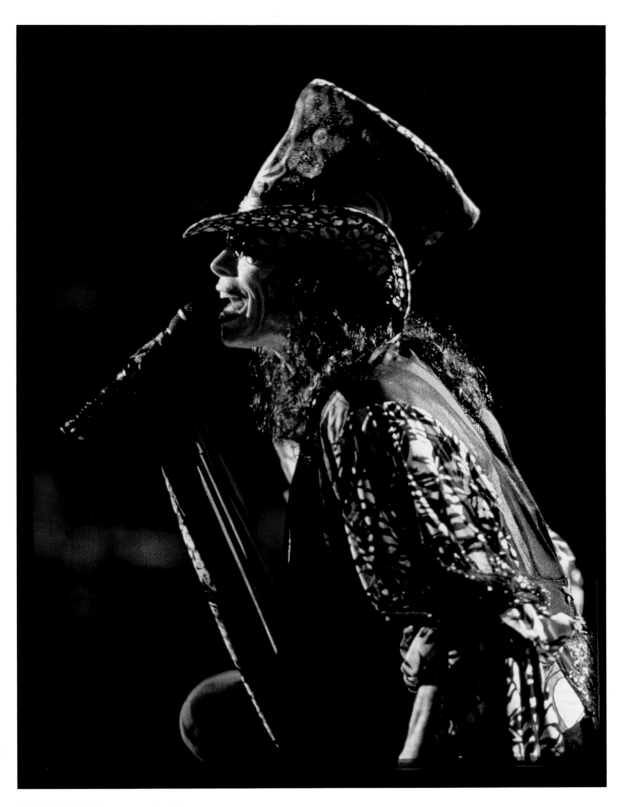

STEVEN TYLER's hat gives him
a Mad Hatter look.
Photograph by Ken Regan.

OPPOSITE

ELTON JOHN—more over the
top than ever!
Photograph by Robert Knight.

With that body and his tattoos, all
ANTHONY KIEDIS needs is a hat.
Photograph by Danny Clinch.

OPPOSITE

London scenester and DJ
VAUGHN TOULOUSE taught
UK punk rockers about the
beauty of the bowler. A very
special shot from 1982.
Photograph by Janette Beckman.

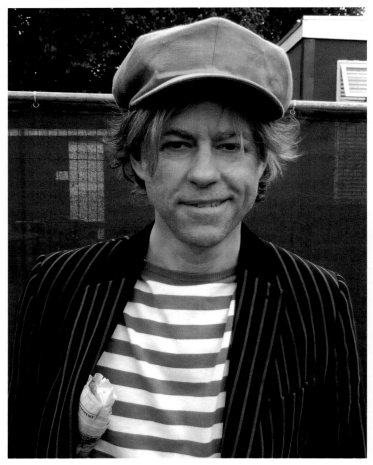

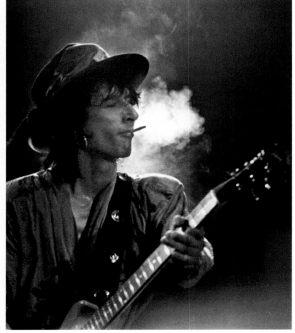

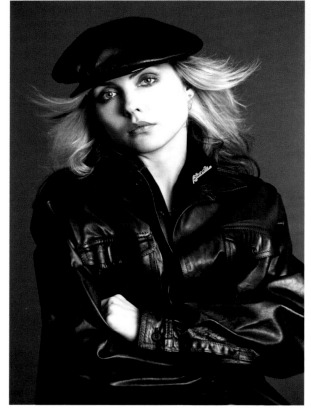

CLOCKWISE FROM TOP LEFT
BOB GELDOF in a fisherman's
cap—a great look with a striped
jacket and T-shirt.
Photograph by Mick Rock.

JOHNNY THUNDERS, seen here
in 1985, wore his hat with a scarf
as a hatband.
Photograph by Bob Gruen.

DEBBIE HARRY in her
motorcycle jacket and leather
cap. Looking gorgeous!
Photograph by Lynn Goldsmith.

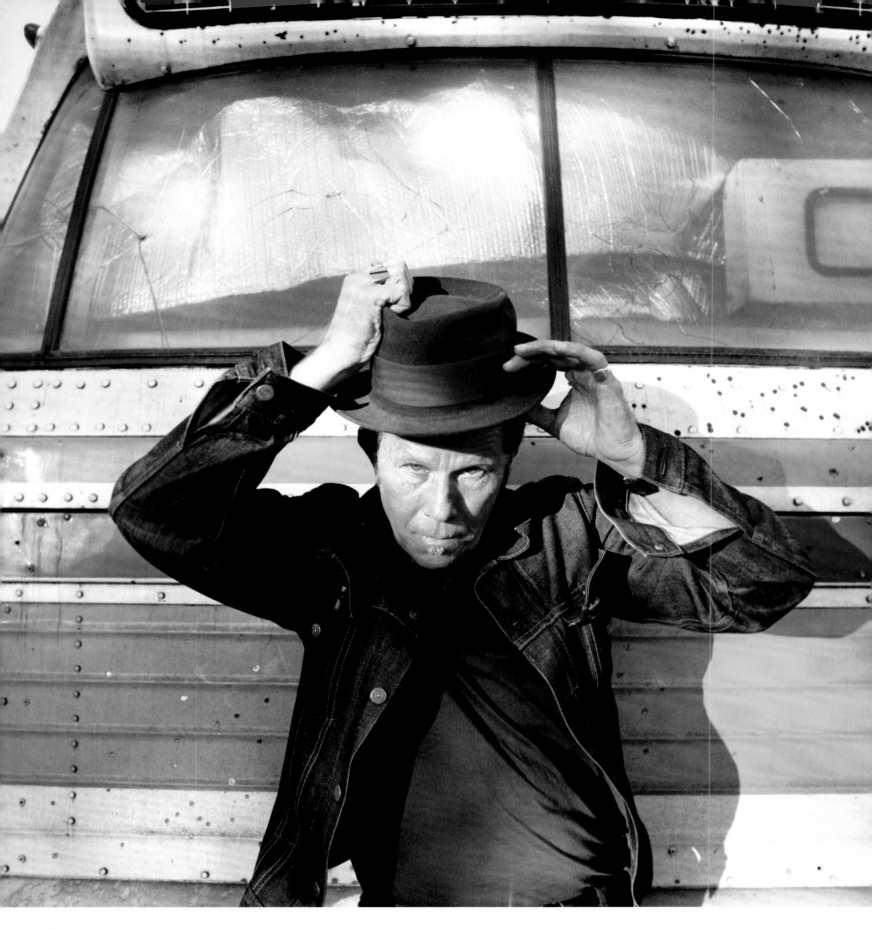

Though he started out wearing berets, **TOM WAITS** has made the porkpie hat his signature. *Photograph by Danny Clinch.*

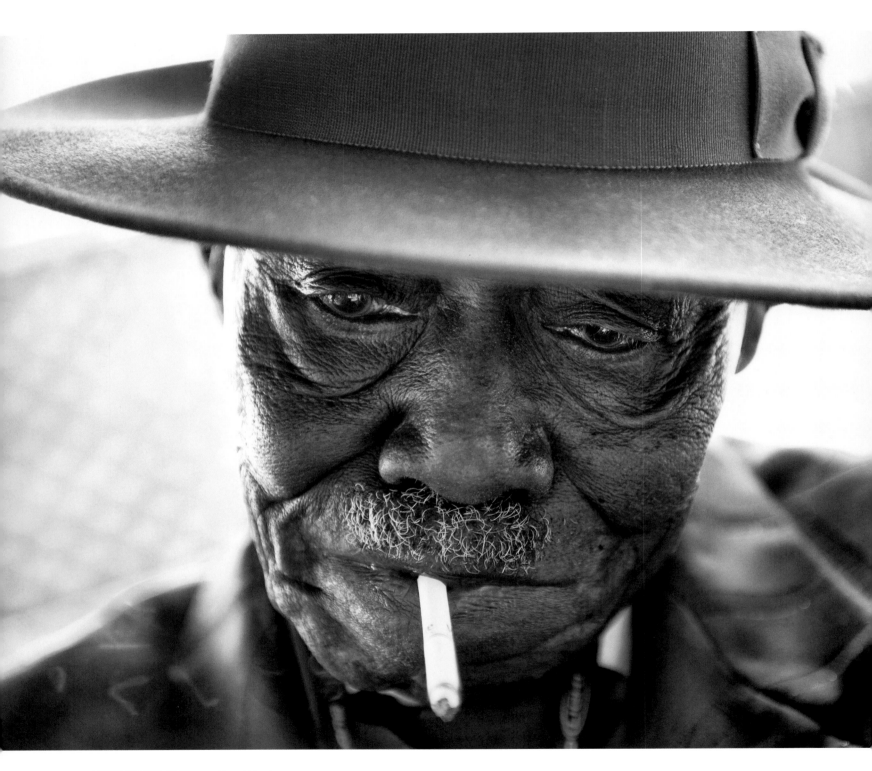

PINETOP PERKINS was the ultimate
blues piano player. He carried himself
with elegance, from his hat to his shoes.
Photograph by Jérôme Brunet.

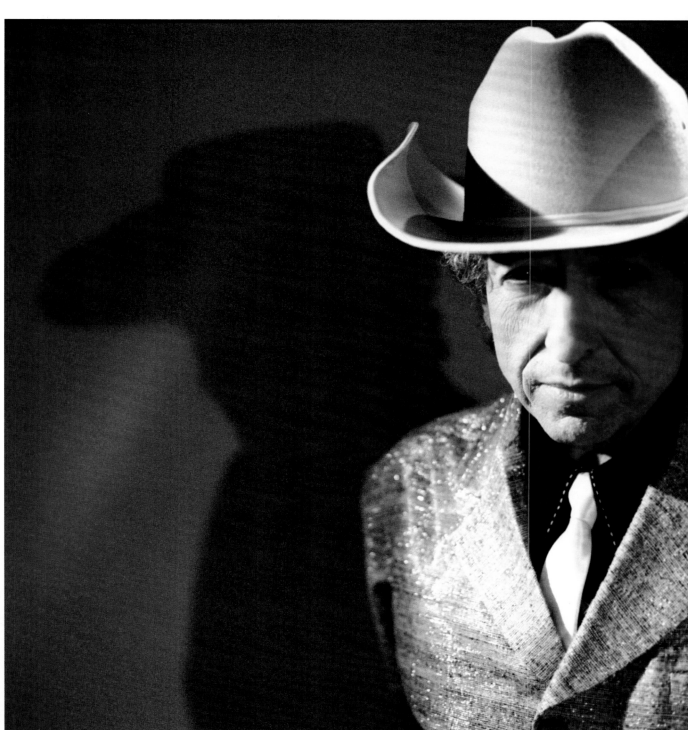

BOB DYLAN doing the western
glam thing.
Photograph by Danny Clinch.

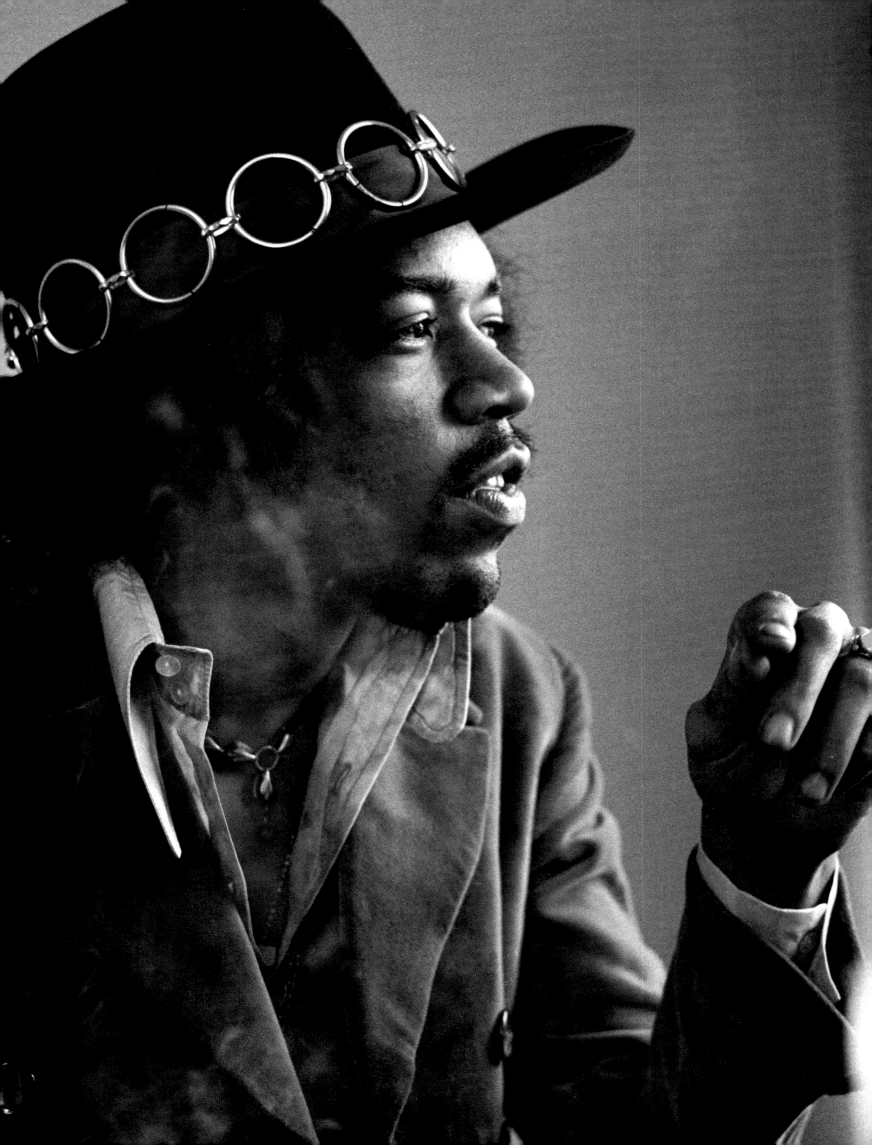

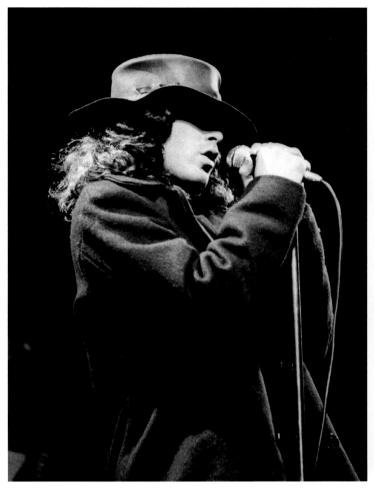

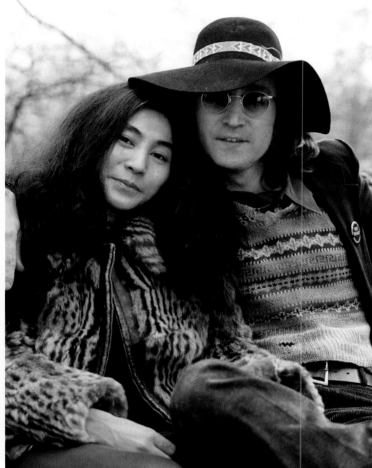

CLOCKWISE FROM TOP LEFT

JIM MORRISON loved leather. This leather brimmed hat added a bit of danger to his look.
Photograph by Ken Regan.

Not everyone can pull off a floppy hat. I think **JOHN** and **YOKO** shared this one in 1973.
Photograph by Bob Gruen.

The Cult's **IAN ASTBURY** makes his wide-brim hat sinister with a metal skull ornament.
Photograph by Lynn Goldsmith.

OPPOSITE
JIMI could carry off every style of hat. I love the chain band on this felt one.
Photograph by Baron Wolman.

<u>MICK JAGGER</u> in a patriotic top hat.
Photograph by Baron Wolman.

<u>BO DIDDLEY</u> loved a big felt hat.
He never took the stage without one.
Photograph by Robert Altman.

<u>LEMMY</u> of Motörhead—Go West,
Young Man!
Photograph by Robert Knight.

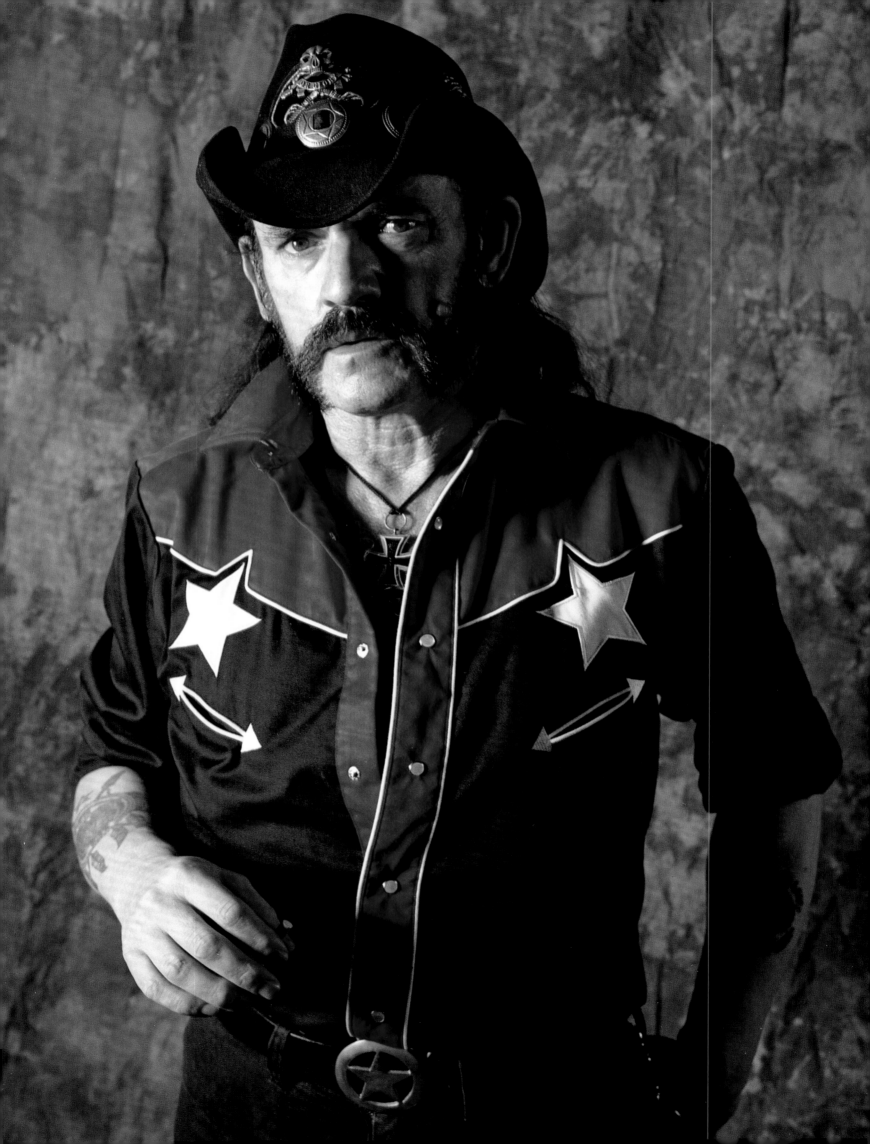

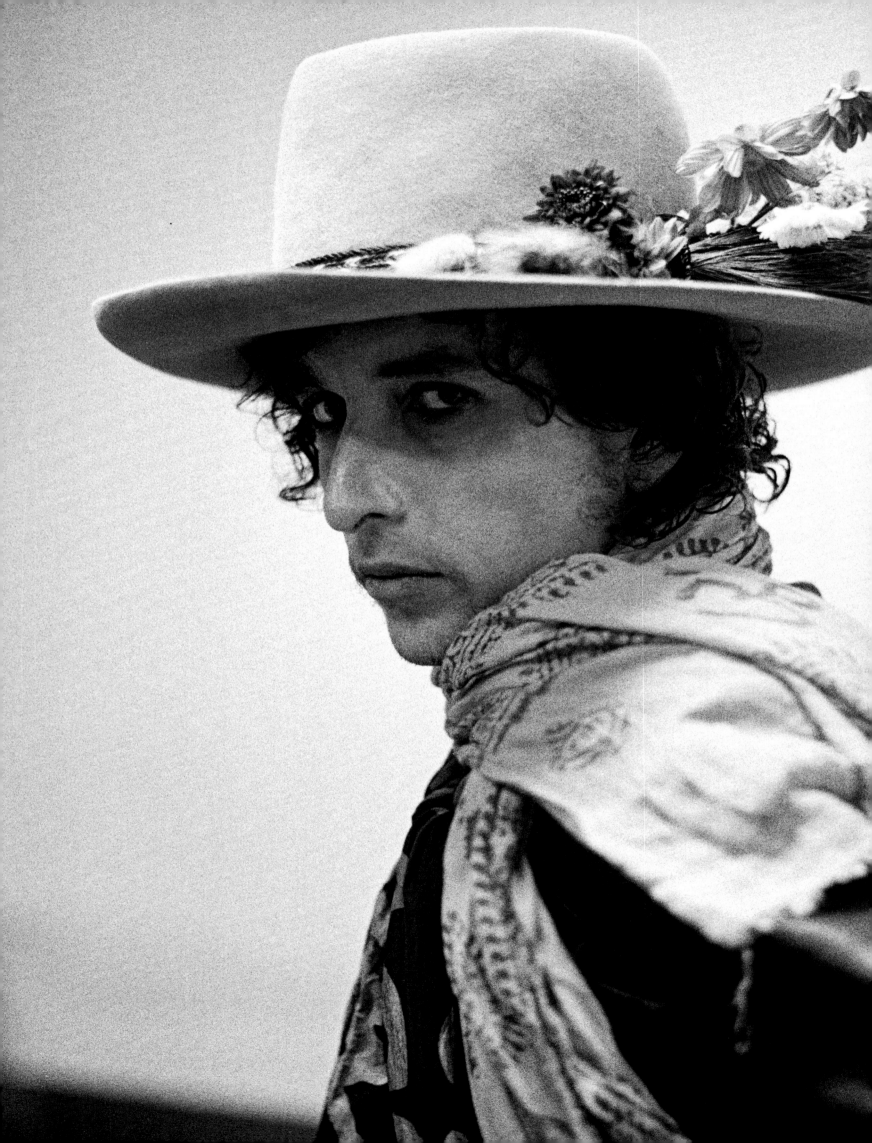

SCARF IT UP.

CHAPTER 6: THE ULTIMATE ROCK & ROLL ACCESSORY

For me, scarves and rock & roll are synonymous. In the early 1960s, there were bands that wore matching suits and ties, like the Dave Clark Five, but the rebellious groups at the time started donning scarves, whether a bandanna around the neck or a kerchief style tie. Gradually, scarves became more dramatic: Jeff Beck wore a long, flowing scarf around his neck. Good-looking guys like Mick Jagger, Keith Richards, Jimi Hendrix, Robert Plant, Jimmy Page, and Syd Barrett all dressed up by wearing scarves. Jimi Hendrix sported paisley silk scarves that he'd picked up in India. Keith Richards started wearing bilious woven scarves, draped as if he were in the Moroccan desert trying to keep out the heat and sand. The Stones wore them as sashes, wrapped around their waist, hips, or even a leg. Other rockers encircled their head with a scarf, a look Axl Rose adopted in the 1980s. Scarves went from being a formal accessory to a rock & roll adornment that represented an anti-establishment attitude.

In the 1970s, Steven Tyler took scarves to another extreme. He not only wore a scarf, but he also wrapped a dozen or so around his microphone stand, making it part of his performance. Steven carried that mic stand wrapped in billowing scarves like he was doing some kind of war dance. He's told me he'd like to do a collection of scarves someday. Maybe we will.

When I was in college in the early 1970s, I started wearing scarves, because I discovered that they're a very simple accessory that can reinvent your look. You can be wearing the same jacket and jeans, but when you put on a bandanna, or an oversized scarf, or a long silk one, you've changed the style completely. With a scarf, you can make a statement. The scarf finishes off the outfit, whether you're in a tailored jacket without a shirt and tie, or you're wearing a leather jacket and a T-shirt.

Since my first collection launched in 2000, my company's become known for its scarves. We feature lightweight ones in the summer and warm chunky ones in the winter. In our stores, the mannequins are always dressed with scarves. We've created our own way of loosely wrapping the scarf, and that has become our signature. All our scarves have a rock & roll feel: a certain swagger, a particular drape, a masculinity. I know some guys who previously would never wear scarves except in cold weather, but who now wear them as part of their year-round wardrobe.

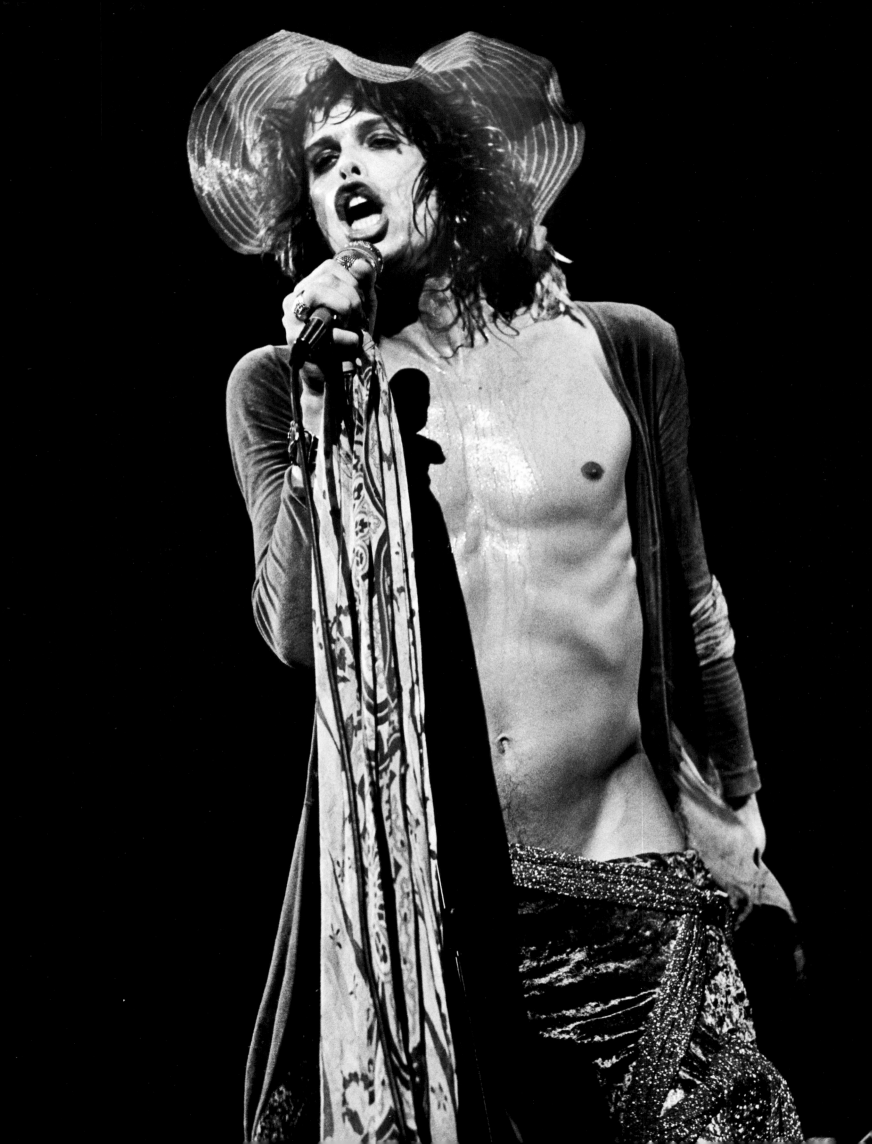

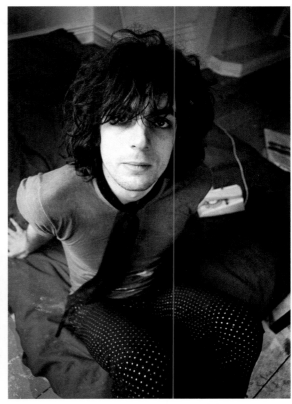

CLOCKWISE FROM NEAR RIGHT
A toned-down psychedelic print scarf adds rock & roll style to **STEVE WINWOOD**'s simple black sweater.
Photograph by Baron Wolman.

SYD BARRETT was it for me, stylewise—simply dressed with a T-shirt and skinny knitted scarf.
Photograph by Mick Rock.

JIMMY PAGE didn't think about wearing scarves for warmth. They were all about swagger.
Photograph by Janet Macoska.

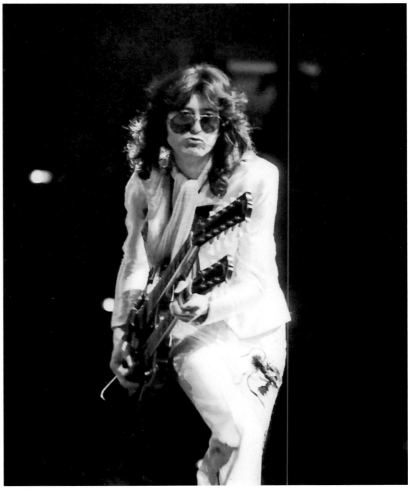

"Very early on, I had a favorite macramé shirt that I wore onstage all the time and an Indian scarf in my hair. The shirt and scarf got worn out and torn off me eventually, but rather than throw them out, I hung them on my mic stand for good luck. Must be the gypsy in me. It started there and grew into a trademark. Some of the scarves eventually had little pockets sewn in, and I'd weight them with Quaaludes and Tuninals—that way I wouldn't run out."

—Steven Tyler, 2012

OPPOSITE

STEVEN TYLER uses his often-scarf-wrapped mic stand as an extension of his body. The stand truly becomes part of the show.
Photograph by Charlie Auringer.

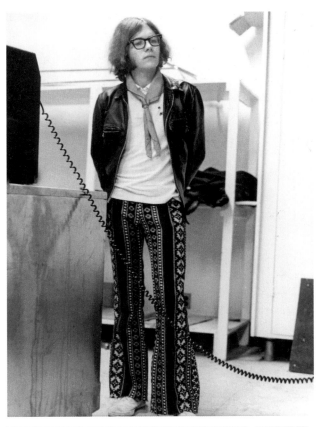

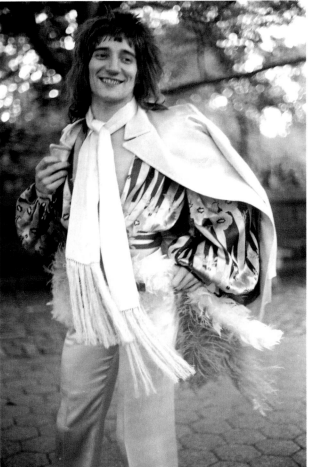

TOP

Here's **RON ASHETON** backstage in 1969 with the Stooges at the Birmingham Palladium. One of my Detroit heroes, he's wearing a scarf with a bit of a boy scout influence.
Photograph by Leni Sinclair.

BOTTOM

There's something about **ROD STEWART**'s feathers, print blouse, and fringed silk scarf that just works.
Photograph by Raeanne Rubenstein.

OPPOSITE

This is signature **ROBERT PLANT**, circa 1974—the golden locks, open shirt, western belt buckle, and, of course, a neck scarf.
Photograph by Bob Gruen.

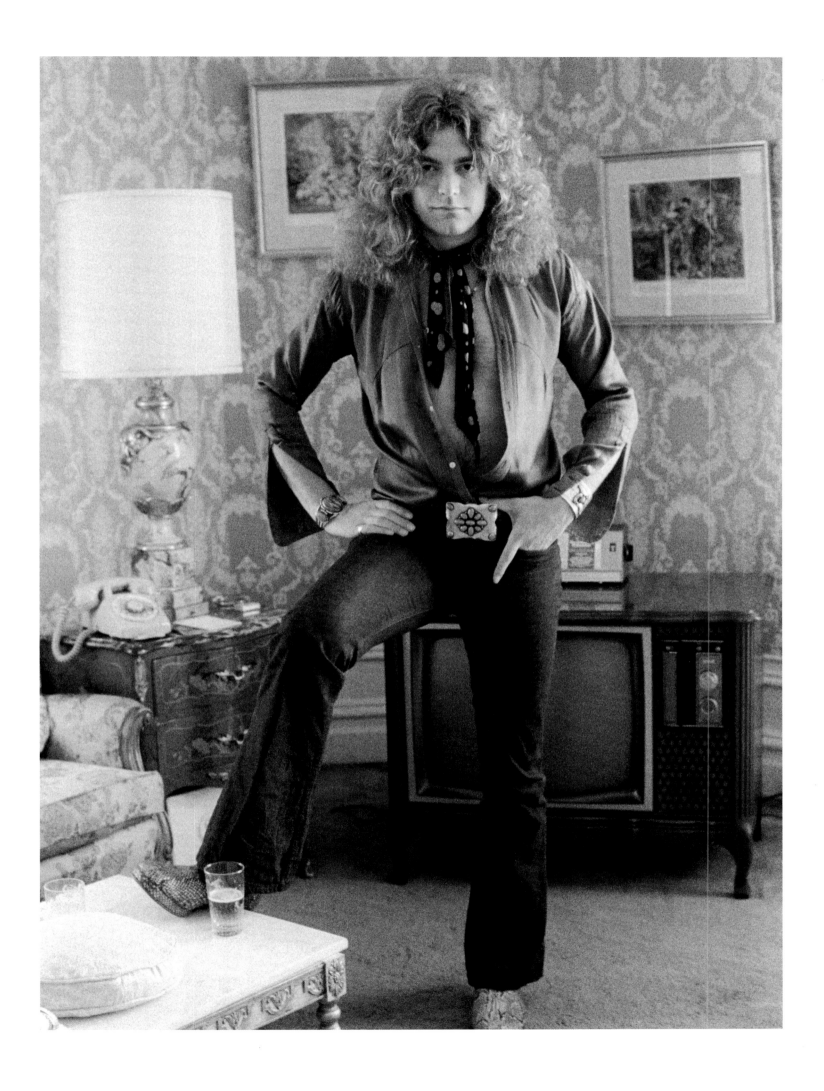

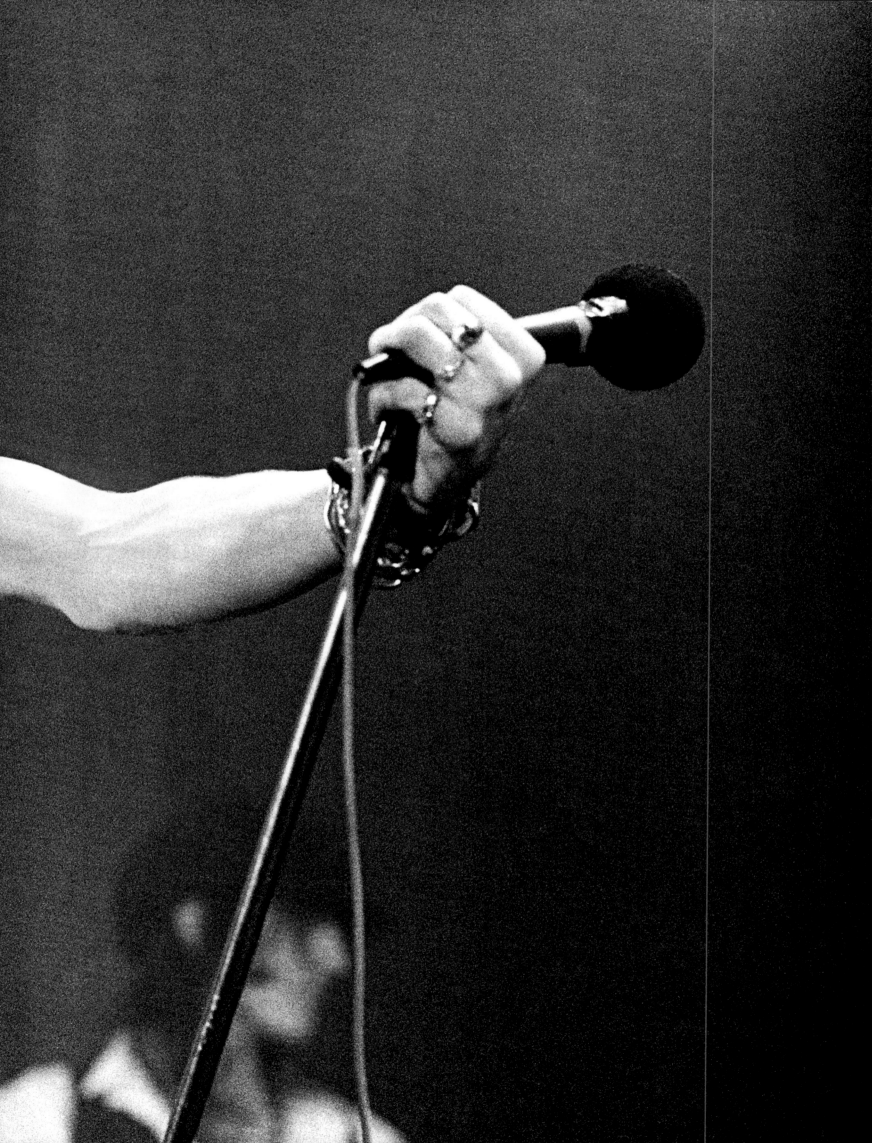

PAGES 98-99
The headscarf became
AXL ROSE's signature.
Photograph by Larry Busacca.

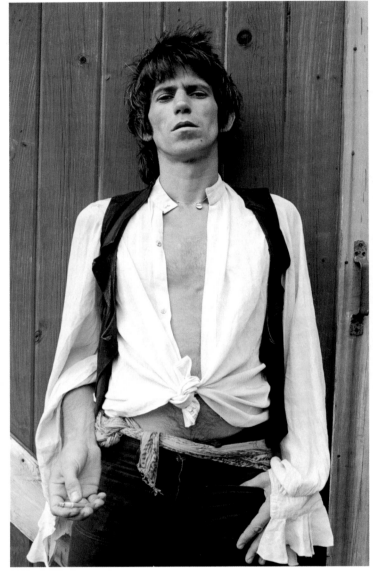

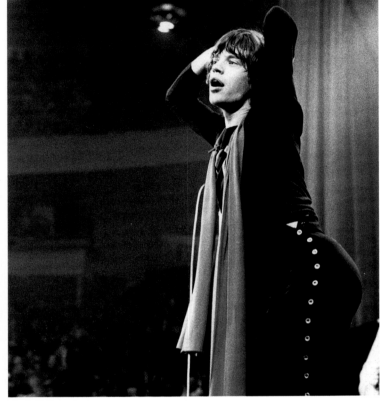

ABOVE

When it came to **MICK**'s choice of scarf
in the 1970s, the longer the better.
Photograph by Charlie Auringer.

LEFT

KEITH RICHARDS always loves
a good scarf. In this case, he's
putting it to use as a belt.
Photograph by Michael Putland.

OPPOSITE

RONNIE WOOD in Hawaii in 1975.
He's got it all going on: beaded vest,
laced leather bell-bottoms, and
a rockin' sash.
Photograph by Robert Knight.

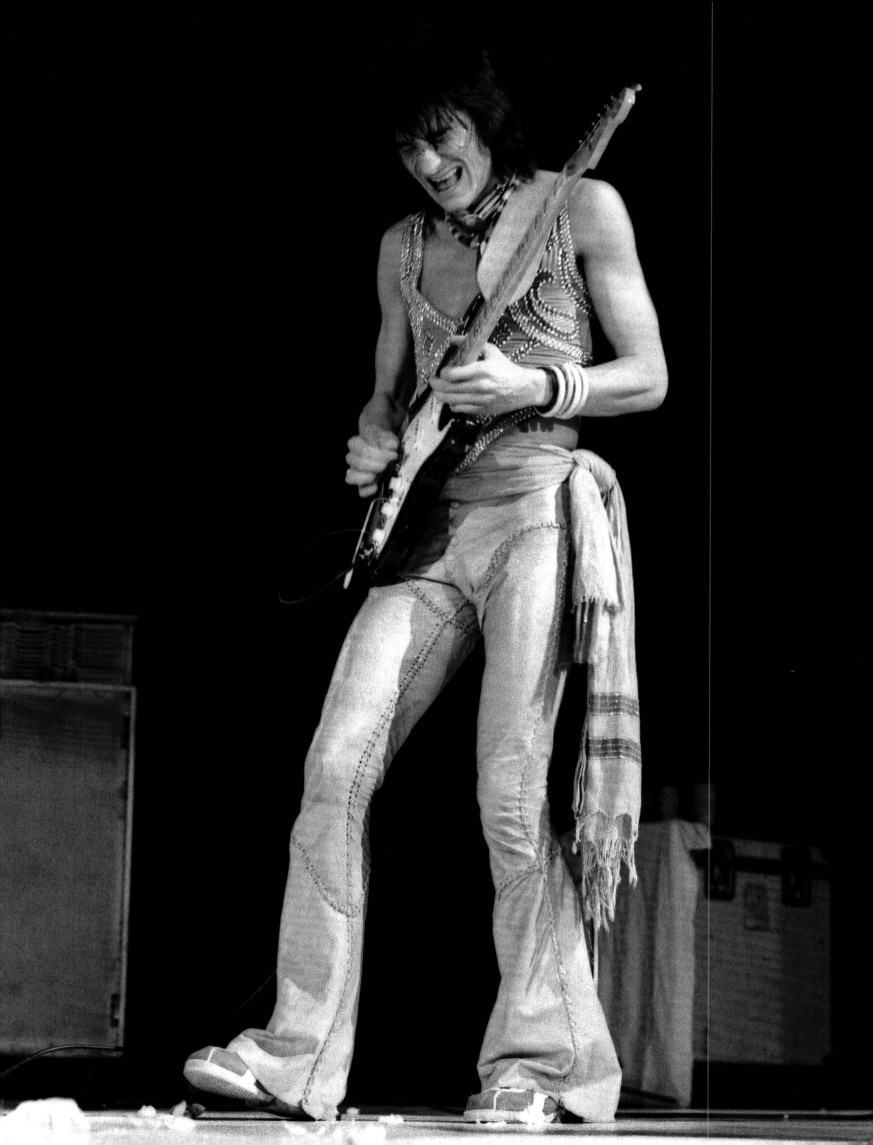

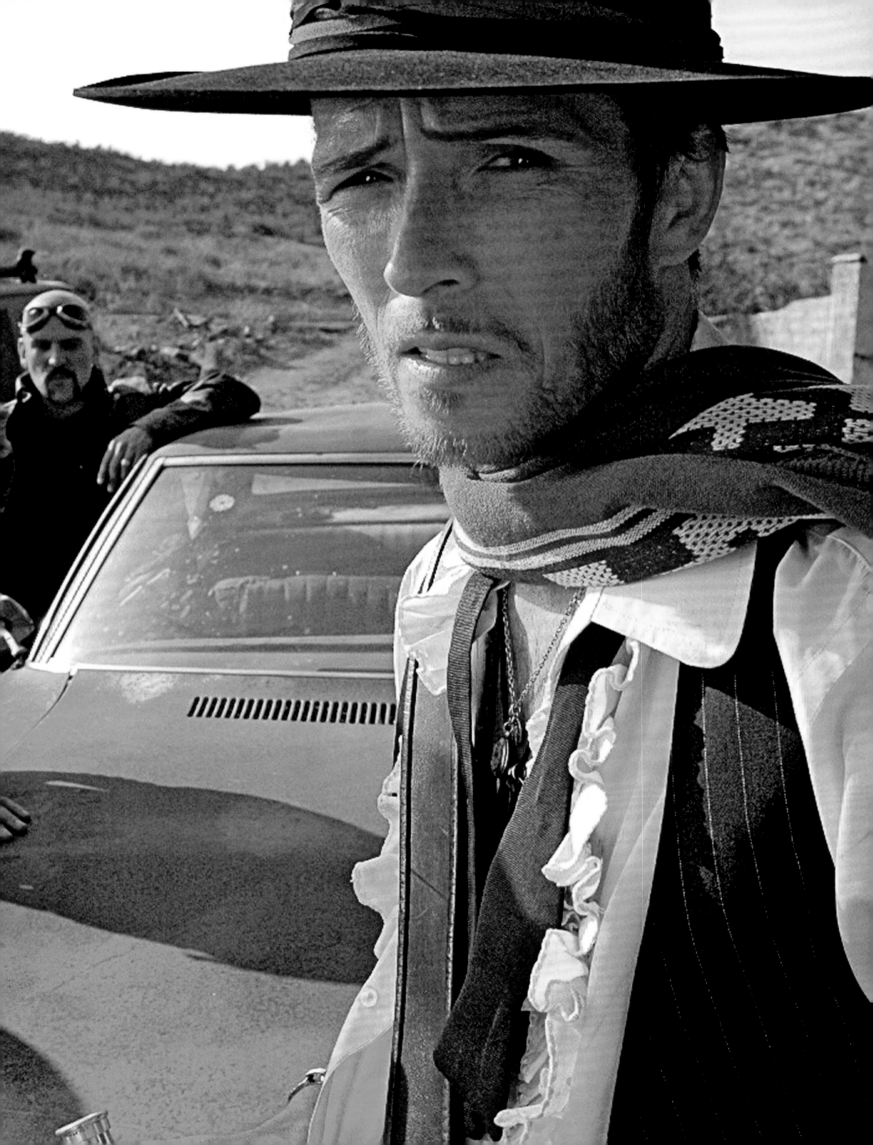

SCOTT WEILAND, one of the most stylish rockers of his generation, gives us a bit of Clint Eastwood with a southwestern serape-style scarf. *Photograph by Dean Karr.*

DON'T HANG UP MY ROCK & ROLL SHOES.

CHAPTER 7: BOOTS, SHOES, AND SNEAKERS

I spotted Beatle boots, the first rock & roll accessory to grab my attention, in the mid-1960s. The photos of John, Paul, George, and Ringo wearing cool black ankle boots are a vivid memory still. Those boots represented a new point of view, something kind of dangerous that really appealed to me. Looking back now, I can see that influence on my path as a designer. My favorite version of the boot had a zipper, a little bit of a heel, and a pointy toe. That boot marked the beginning of my obsession with boots in general, including such variations as the pull-on Chelsea boot with elastic side gores. Today, when you look at my collection and when people think about my brand, the boots are probably what stand out the most.

Rock stars—from the Rolling Stones to Kings of Leon—have always worn boots. In the late 1960s, some artists like Neil Young started wearing fringed moccasin boots. The western boot has gone in and out of style, but it remains a constant in rock & roll. Today, Americana bands like Drive-By Truckers are the primary musicians wearing cowboy boots.

The most outrageous boots surfaced during the glam craze in the early 1970s: mile-high platforms became synonymous with bands like T. Rex and Mott the Hoople—and made their way onto the feet of all sorts of bands. Even macho hard-rock groups could be seen tottering around onstage in their platforms. The platform has come back a bit but in a pretty subdued form compared to the early 1970s.

Then there's the sneaker, the opposite of a fad. The sneaker is probably the most timeless American shoe; it's been around since the early 1900s. Most kids in the 1950s were wearing Red Ball Jets, Converse, or Keds PF Flyers. I loved my Converse Chuck Taylors, and I discovered that some of my early heroes wore Converse: James Dean sported white Jack Purcells, and Elvis Presley favored black Chuck Taylors. When I was a teenager, I noticed rockers like the Who wearing Converse, too.

I never dreamed that one day I would have my own collection of Converse sneakers. It's been an amazing collaboration with Converse, and I'm proud to have been given the opportunity to take such an iconic product and put my design twist on it. In 2004, we cooked up the laceless Converse Chuck Taylors, which has gone on to be a worldwide hit and copied by numerous brands. What a kick!

OPPOSITE
It's pretty amazing **JERRY NOLAN** could play drums in a rock band with those shoes. But style was that important to the New York Dolls' persona. *Photograph by Bob Gruen.*

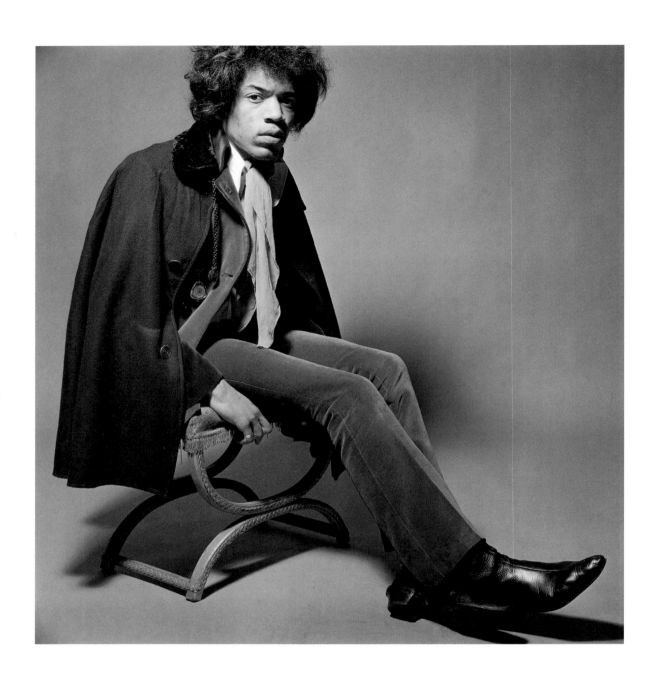

ABOVE

JIMI in his Beatle boots. I absolutely love his style.
Photograph by Gered Mankowitz.

LEFT

These black Beatle boots, imported from England, caught my attention when I was just a kid. I've been a fan ever since.
Photograph by Lynn Goldsmith.

OPPOSITE

PAUL McCARTNEY showing off those famous Beatle boots.
Photograph by Ken Regan.

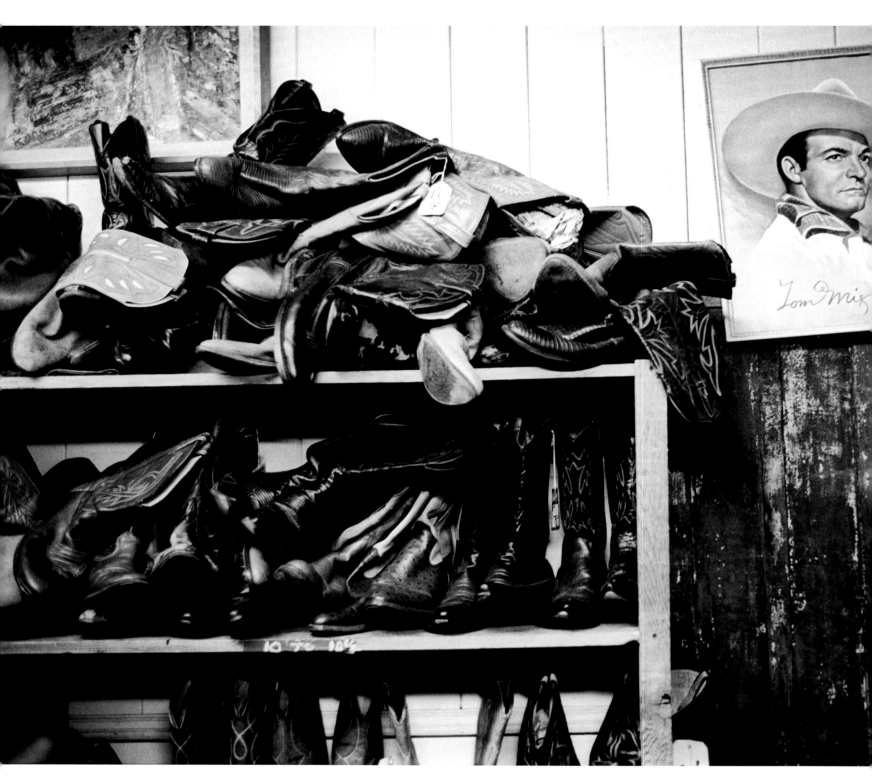

If you're going to wear cowboy boots, go for a vintage pair. This pile was shot at a used boot store in Texas. Note the portrait of Tom Mix, one of the first silver screen cowboys to wear fancy western boots.
Photograph by Danny Clinch.

A Texan is never without his
boots, and **JOE ELY**'s even have
his name on the spurs.
Photograph by Janette Beckman.

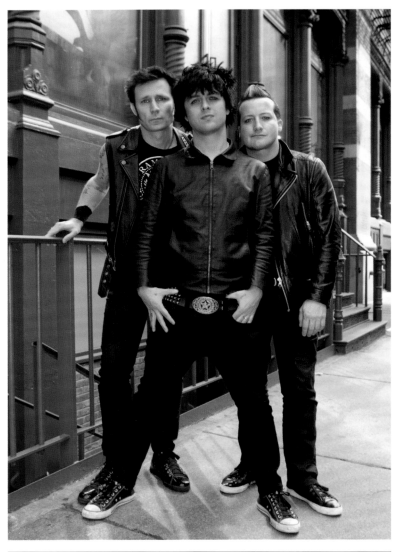

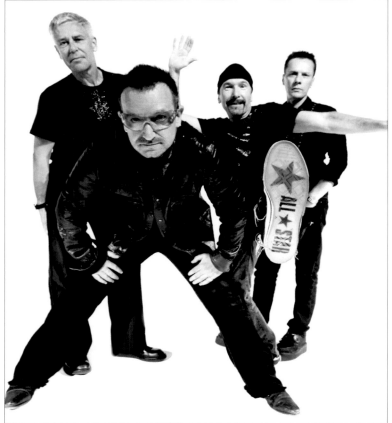

GREEN DAY pairs their punk rock
look with Converse sneakers.
Photograph by Bob Gruen.

THE EDGE (third from left),
with his U2 bandmates, wearing a
pair of John Varvatos Converse.
Photograph by Andy Willsher.

The Rockats' guitarist **TIM SCOTT**
was influenced by Elvis and the
rockabilly rebels before him.
Photograph by Janette Beckman.

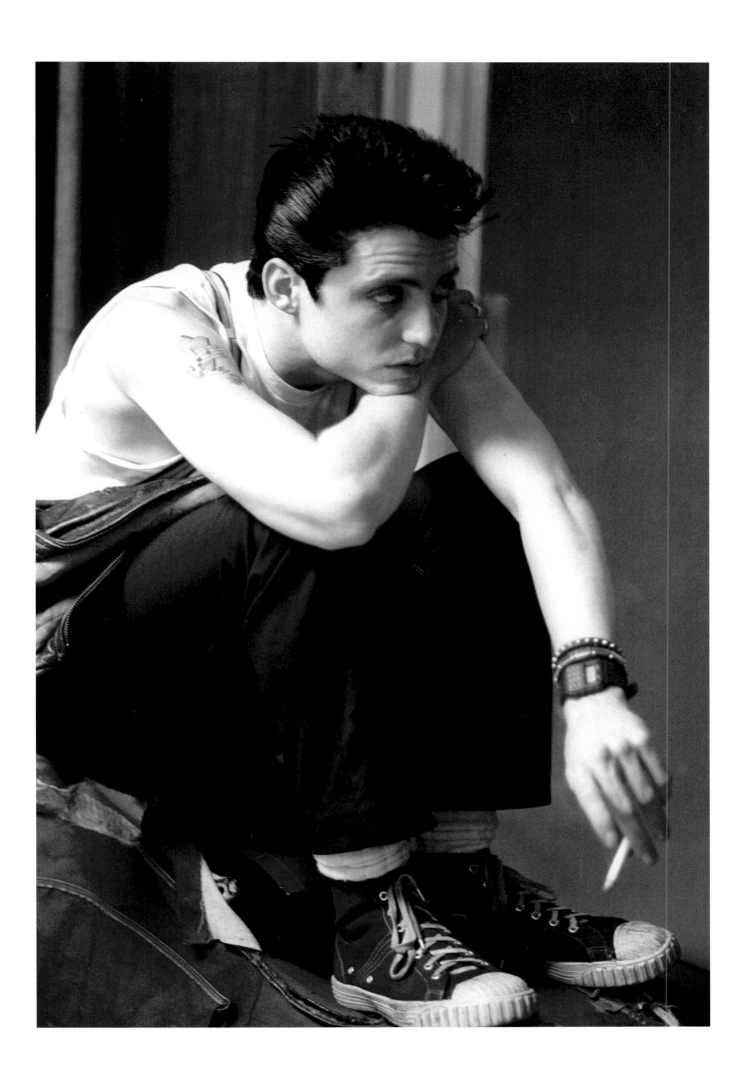

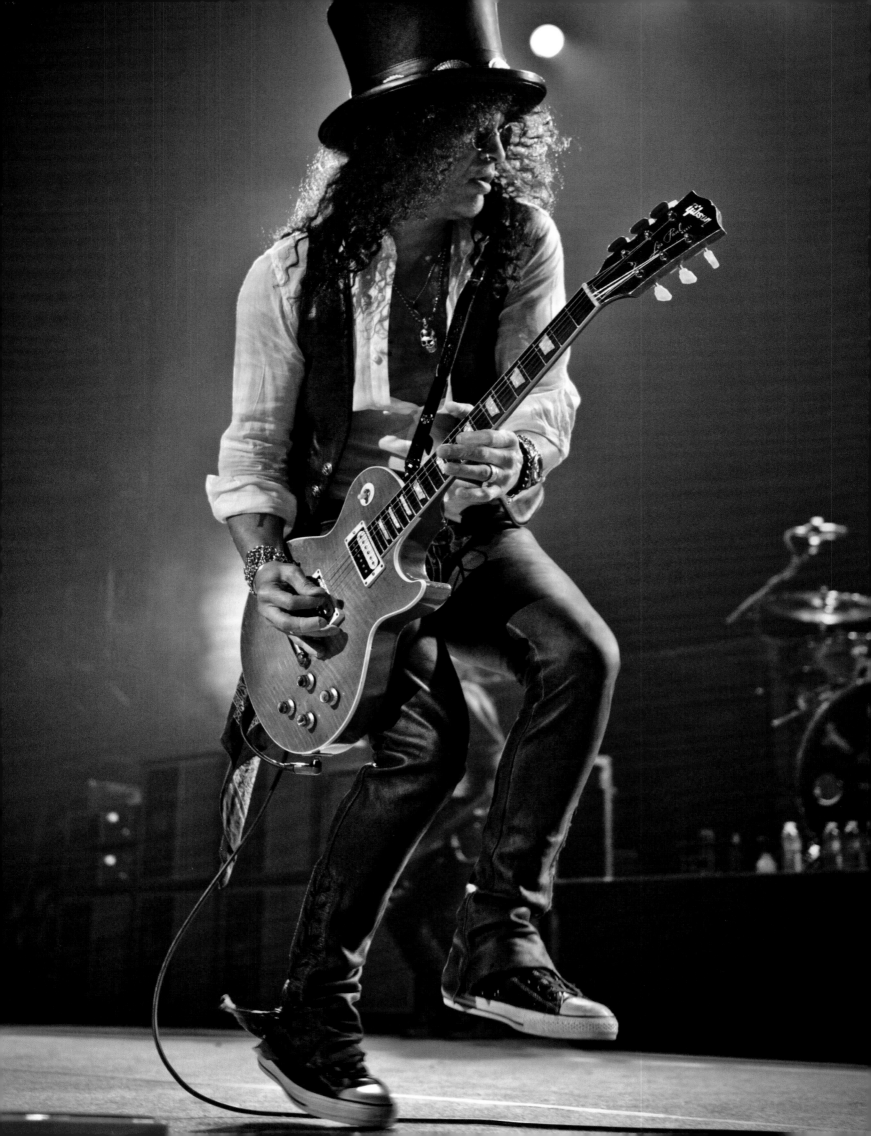

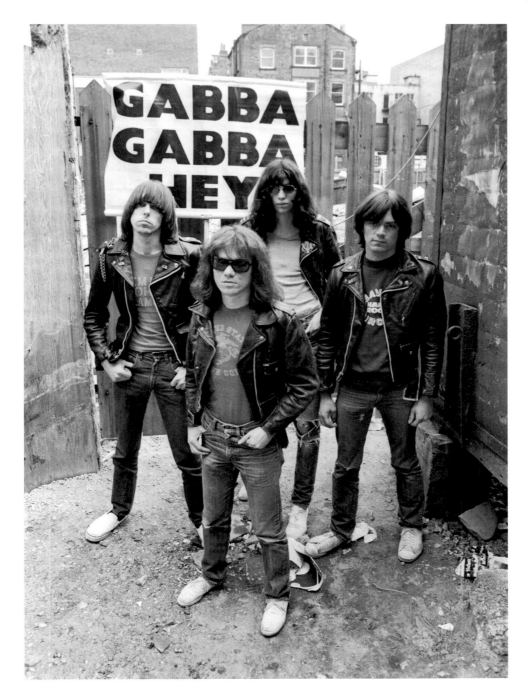

THE RAMONES and sneakers go hand in hand. Here, you've got Converse, Vans, and Jack Purcells.
Photograph by Ian Dickson.

"These are the coolest Converse ever."

—Slash, 2011

OPPOSITE
SLASH in John Varvatos Converse Chuck Taylors.
Photograph by Jérôme Brunet.

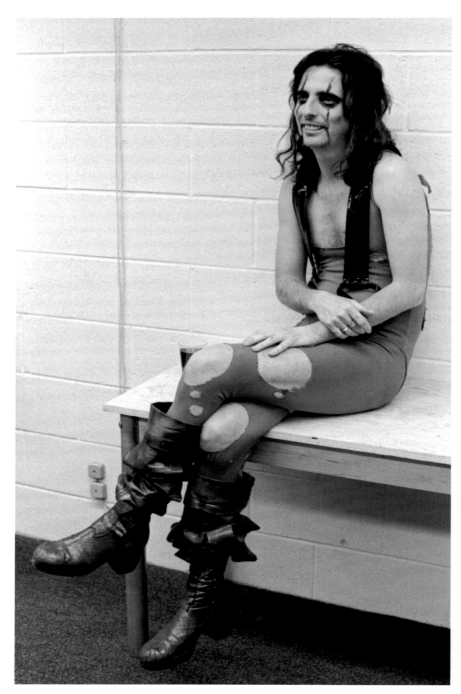

> "Our stage persona was as important as the music. The hippies wanted peace and love. We wanted Ferraris, blondes, and switchblades."
>
> —Alice Cooper, 2012

LEFT

ALICE COOPER, who created shock rock, also embraced glam. The added touch of femininity, as shown in this 1973 image, helped create his whole over-the-top stage persona. *Photograph by Bob Gruen.*

BELOW

ALICE COOPER's boots were not much of an influence on my work, but so memorable nonetheless. In 1975, both Alice and the New York Dolls were going for animal print in a big way. *Photograph by Leni Sinclair.*

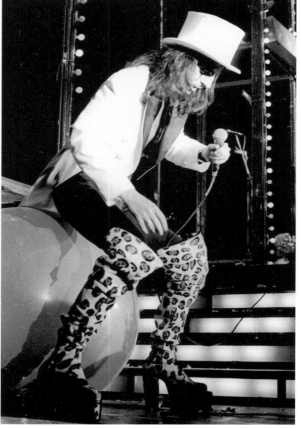

ABOVE

ELTON JOHN takes flight with his
winged ankle boots.
Photograph by Robert Altman.

RIGHT

BOWIE doing his wrestling shoes look.
Photograph by Michael Putland.

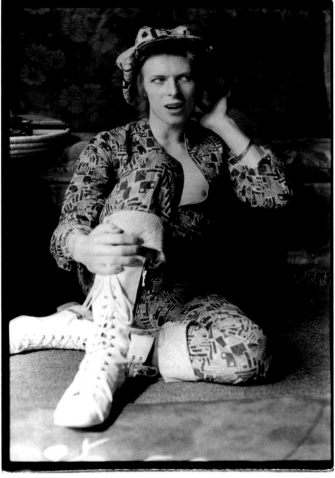

I love **TAJ MAHAL**'s whole vibe, but especially the shoes! Usually associated with glam style, platforms take on a different look when worn with down-to-earth denim.
Photograph by Baron Wolman.

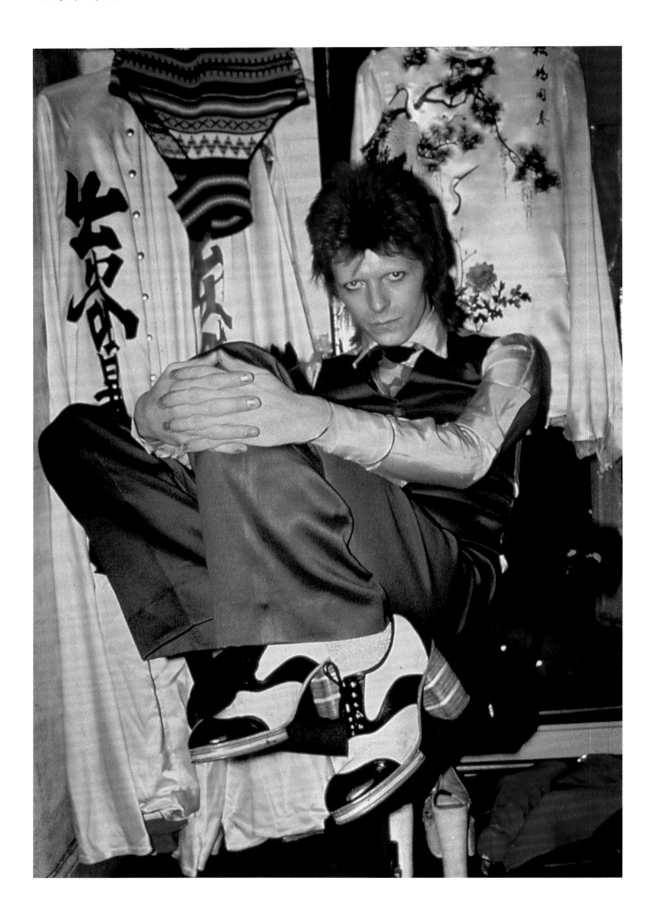

CLOCKWISE FROM TOP, LEFT

RYAN ADAMS under the influence
of the 1970s in his glam-style,
two-tone platforms.
Photograph by Neal Casal.

JOSEPH ARTHUR in his white
wingtips in New York City.
Photograph by Danny Clinch.

DYLAN's closet—fantastic shoes!
Photograph by Danny Clinch.

OPPOSITE

DAVID BOWIE took the classic
black-and-white wingtip and grooved
it up with a platform and high heel.
Photograph by Mick Rock.

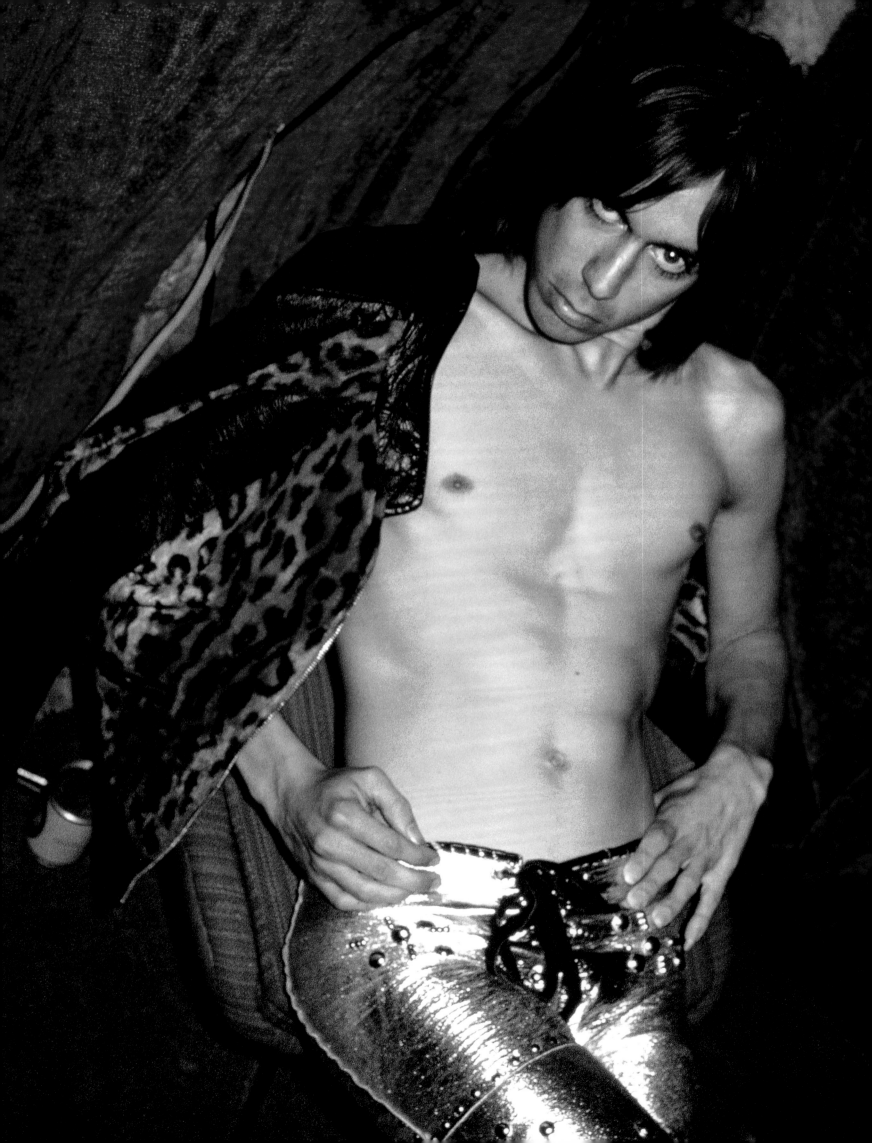

STREET-WALKING CHEETAHS.

CHAPTER 8: ANIMAL PRINTS, EMBROIDERY, AND FLORALS

What could be more eye-catching than a suit covered in embroidered flowers or fabricated from faux leopard fabric? In the 1960s, rockers looked to some style ideas from the past, turned them on their head, and the result was a new kind of rock & roll outrageousness.

Many of the brightly colored fabrics originated in London shops like Granny Takes a Trip on King's Road. Founded by former Savile Row tailor John Pease, vintage clothing collector Sheila Cohen, and artist Nigel Waymouth, the boutique opened in January 1966. The shop originally sold vintage clothing, but soon added Pease's bright floral-pattern shirts, with a slim fit and long collars, to the mix. Lennon and McCartney discovered the place, and then all the bands flocked to the store to pick up the increasingly psychedelic-inspired designs. You can see some of the Granny gear on the Beatles' *Revolver* and the Stones' *Between the Buttons* album covers. The Small Faces, the Who, and Pink Floyd were regulars there, and when the Byrds came to London in 1966, new member Gram Parsons fell in love with the shop. Branches later opened in New York City's East Village and in Los Angeles.

Back in the States, Gram Parsons started frequenting Nudie's Rodeo Tailors on Lankershim in North Hollywood. Nudie's had been ground zero for singing cowboys' and country and western stars' duded-up outfits with glitzy rhinestones and lavish embroidered imagery since the late 1940s. Parsons commissioned embroidered and rhinestoned suits for himself and his new band, the Flying Burrito Brothers, with motifs of marijuana leaves, naked ladies, pills, dinosaurs, and peacocks. Parsons wasn't trying to be a cowboy by wearing these outfits. He was creating his own identity and expressing his personality. He commissioned hip-hugger pants with flames climbing up the flared legs in place of the traditional high-waisted, wide-leg, western-style trousers.

No one with long hair had worn these suits before—or with Parsons's attitude. Soon, British artists such as Elton John and the Stones were heading to North Hollywood for their rock & roll embroidered suits. Though the vintage Hank Williams and Gene Autry outfits may have been the original inspiration, the rock & roll versions had an edgy, modern look. Both retro and edgy styles have continued to cycle through fashion,

"I'm a street-walking cheetah with a heart full of napalm."
—Iggy Pop, "Search and Destroy," 1973

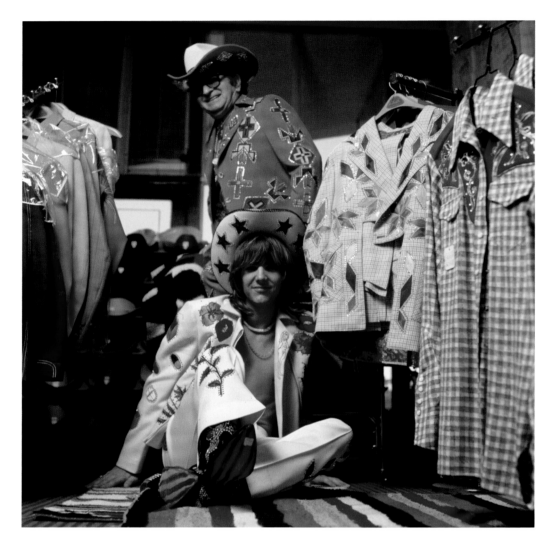

LEFT

GRAM PARSONS and **NUDIE COHN**—the guys who brought the embroidered western suit to rock & roll—at Nudie's North Hollywood shop. *Photograph by Raeanne Rubenstein.*

OPPOSITE

WAYNE COCHRAN, one of the godfathers of rock, wearing an amazing embroidered cape suit. *Photograph by Baron Wolman.*

and in recent years have appeared on Mike Mills of R.E.M., Beck, Jeff Tweedy of Wilco, and Jack White. I remember seeing young bands in the 1990s wearing embroidered jackets or embroidered western shirts. Today, the look still adds life to the stage.

My all-time favorite embroidered outfit, though, came from Jimmy Page. He designed and had custom made two versions of his legendary dragon suit—a black one and a white one—both with intricate imagery stitched in contrasting colors. He was a major influence on me, and his exciting visual appeal hammered home the impact of show clothes. Taking showmanship to another level, Jimmy awed audiences with his unique outfits, along with his double-necked guitar and his virtuosity, violin bow and all.

A vintage look of the 1950s originally associated with rockabilly (as well as pinup girls and Tarzan), the wild animal print came back into vogue in the 1970s. Again, when worn by musicians, there's a certain irony and edginess to the look: from glam to punk to metal and hair bands. In rock & roll fashion, what goes around, comes around.

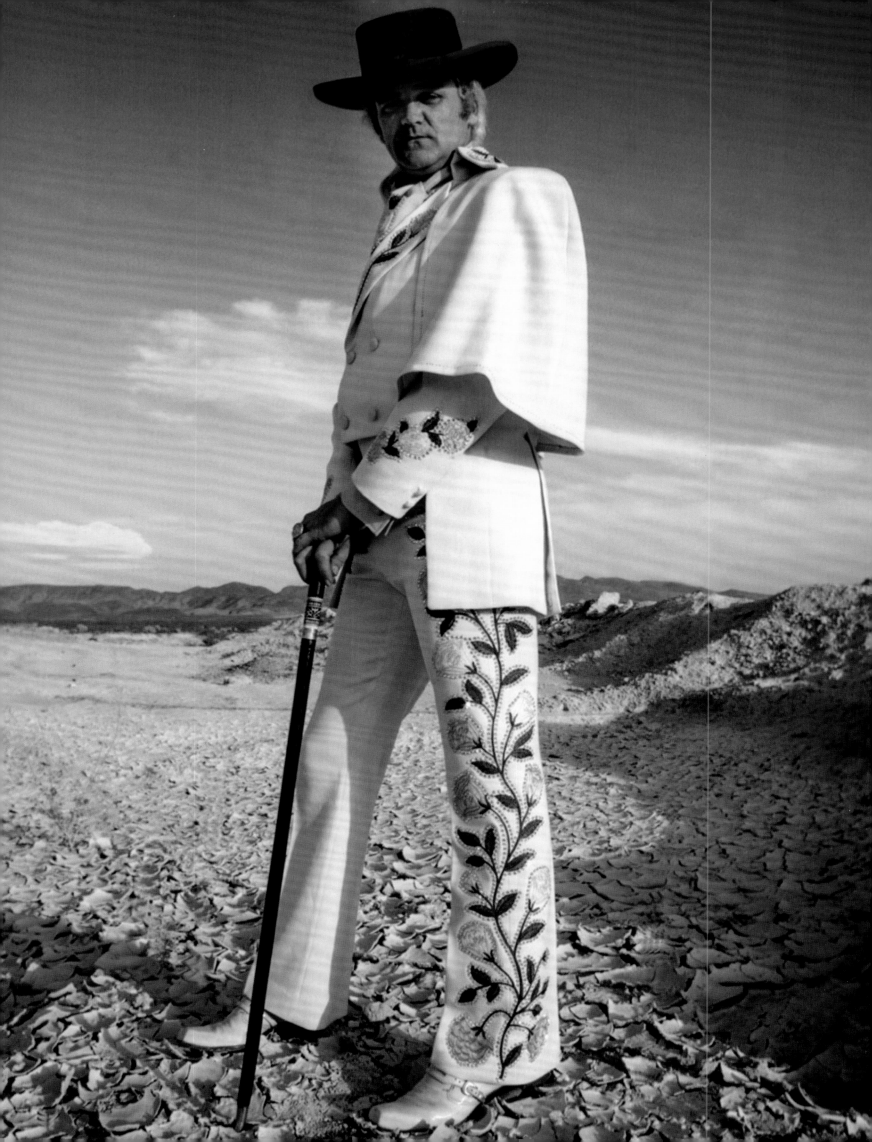

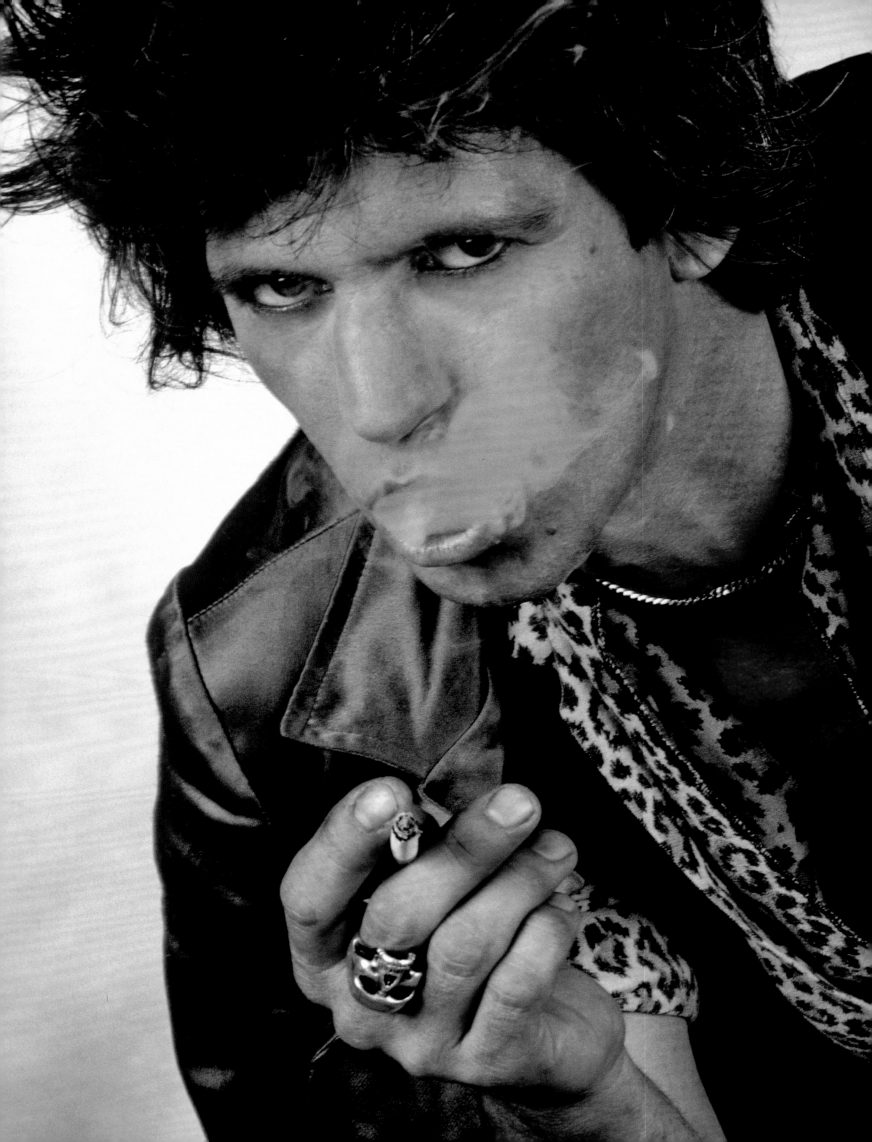

PAGES 124-125
KEITH RICHARDS, looking like a chain-smoking leopard ready to pounce. *Photograph by Lynn Goldsmith.*

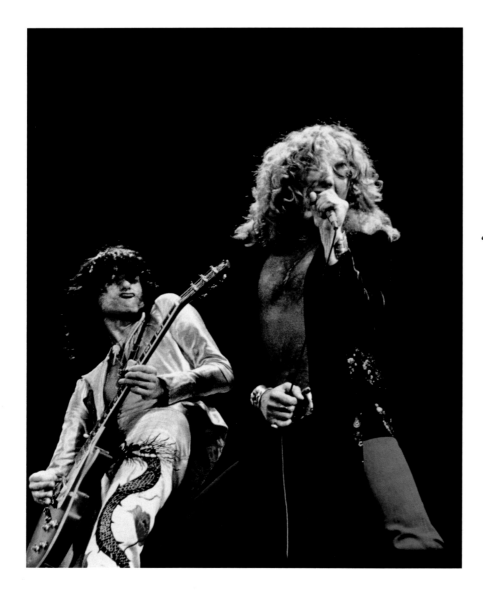

"The dragon suit became the most famous of my stage clothes. I designed a black one and a white one that were actually quite different. Years later I lent one to the Rock and Roll Hall of Fame. When I was there as a presenter, I visited it at the museum, and I was appalled to see it on a form making me look five feet tall."

—Jimmy Page, 2012

LED ZEPPELIN live in 1977. Check out Jimmy's amazing white dragon suit and Robert's embroidered velvet smoking jacket. *Photograph by Bob Gruen.*

OPPOSITE
ROBERT PLANT and **JIMMY PAGE** onstage with Led Zeppelin during their 1973 world tour. Jimmy wears his incredible black dragon suit. *Photograph by Baron Wolman.*

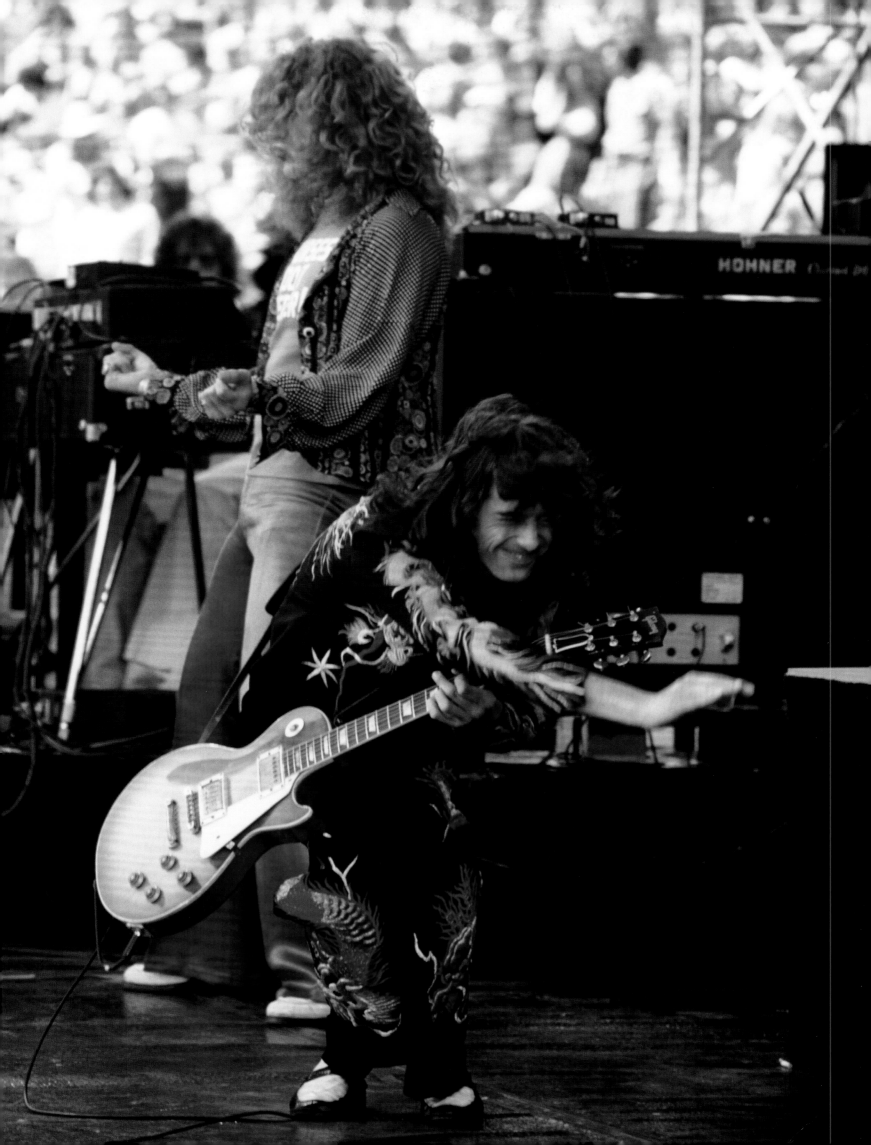

ABOVE
This is **<u>JOHN LENNON</u>**'s nod to
West Coast country-rock style.
Photograph by Michael Putland.

RIGHT
<u>LOU REED</u> in a velvet-embroidered
suit, one so flashy that it even made
him crack a smile.
Photograph by Mick Rock.

OPPOSITE
What an amazing shot! Check
out **<u>MICK RONSON</u>**'s toreador
pants through which you can see
<u>DAVID BOWIE</u> in embroidered
trousers and leather bomber jacket.
Photograph by Mick Rock.

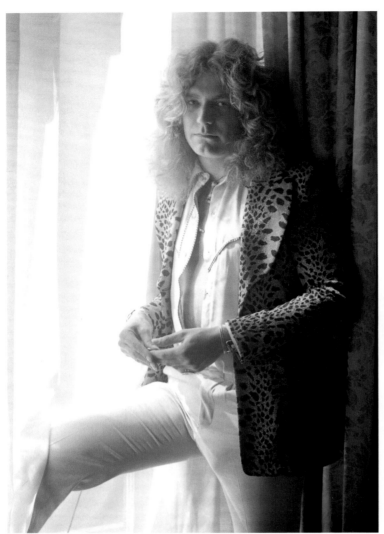

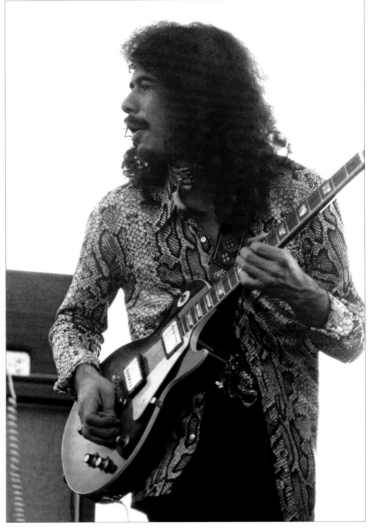

LEFT

A different look for **MR. PLANT**,
in 1974.
Photograph by Bob Gruen.

RIGHT

<u>CARLOS SANTANA</u> looks super
cool in this cobra-skin shirt
jacket, especially with the Native
American choker.
Photograph by Robert Knight.

OPPOSITE

<u>STEVEN TYLER</u> (shown here
in 1976 with Bebe Buell) loves
leopard-print duds.
Photograph by Bob Gruen.

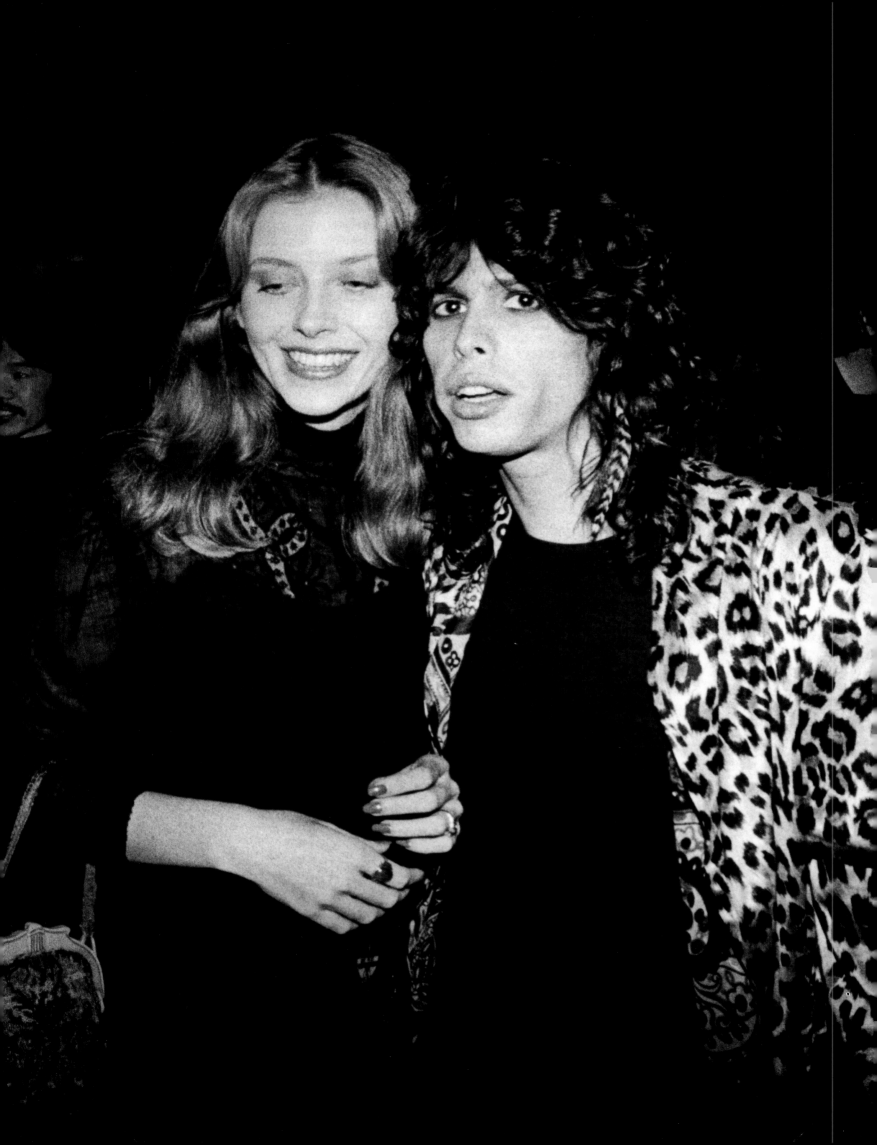

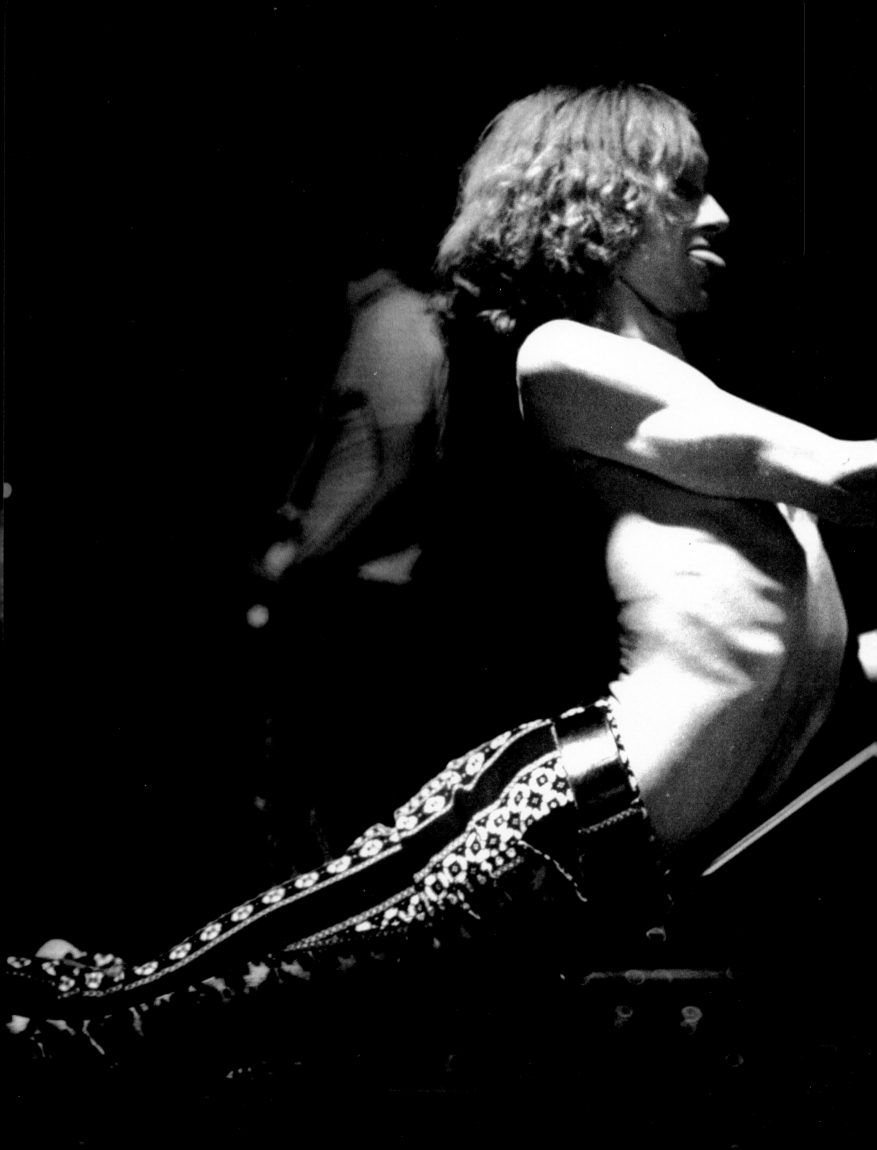

IGGY POP with the Stooges at Detroit's Grande Ballroom in 1968. How does he pull off the embroidered print pants? *Photograph by Leni Sinclair.*

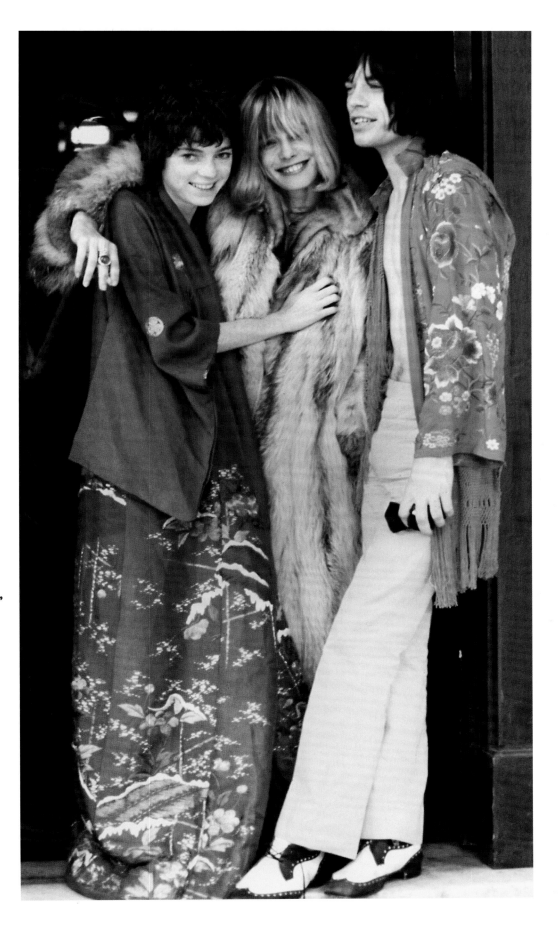

"[In 1967] everyone
started dressing like
Gram Parsons or Mick
Jagger. It actually
became quite difficult
to suss out who was a
pop star and who wasn't."
—Christopher Gibbs, UK scenester
 and art dealer, from *The Look*, 2001

RIGHT

MICK JAGGER with Anita Pallenberg
(center) and Michele Breton—all three
are simply gorgeous. Spending time with
Gram Parsons led the Stones to Nudie's
Rodeo Tailors and to wearing custom-
embroidered clothing.
Photograph by Andrew Maclear.

OPPOSITE

NOEL REDDING's floral print jacket
doesn't overshadow his wire-rims
and his Afro.
Photograph by Baron Wolman.

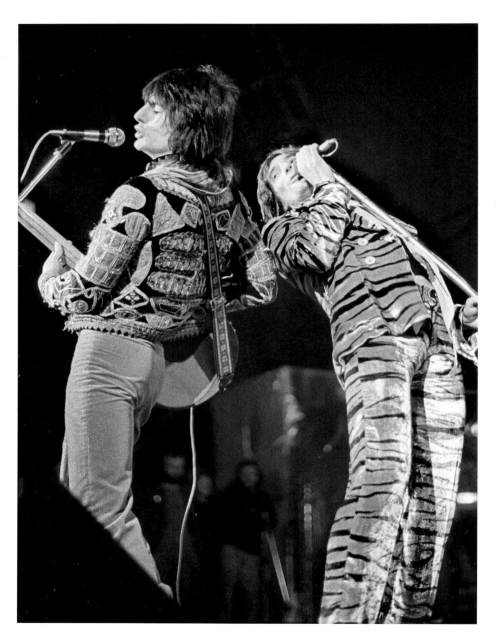

"On King's Road, [to boutiques] like Hung on You or Granny Takes a Trip...we'd all go shopping together and see who could get the most stupid clothes made. We tried to out-do each other with the most outrageous outfit. I used to go shopping with Marc Bolan and he'd go, 'Ooh, what jacket are you going to have?' and I'd go, 'Ooh, what feather boa are you having, dear?' 'It's gig day, I want to look spiffy.' Our look set us apart."

—Ron Wood on the Faces, from *Faces*, 2012

ROD STEWART (at right with **RON WOOD**) taking animal prints to a new high.
Photograph by Barrie Wentzell.

OPPOSITE

From left: Faces **RONNIE LANE**, **RON WOOD**, and **ROD STEWART**. Ron and Rod are a contrast in graphic glory; I especially love Ron's exotically embroidered pants. *Photograph by Barrie Wentzell.*

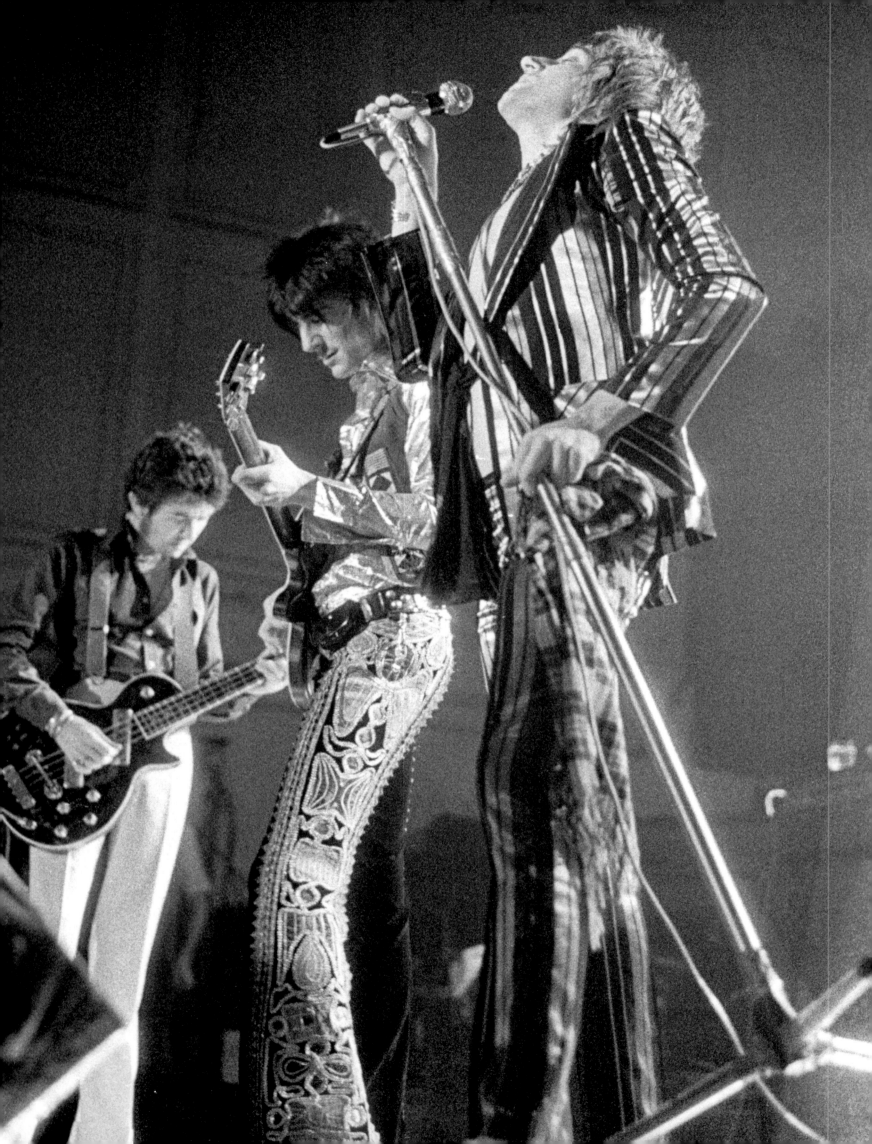

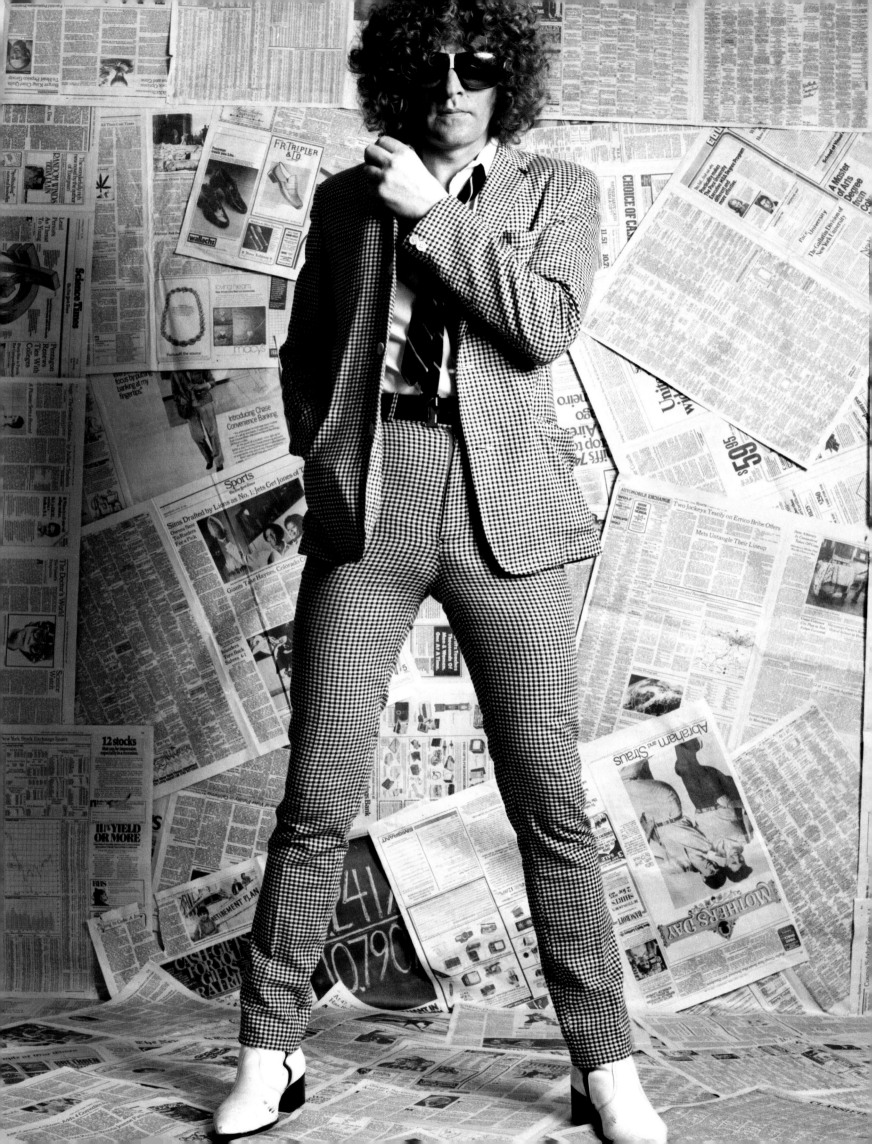

PATTERN MAKERS.

CHAPTER 9: BLACK-AND-WHITE GRAPHIC DESIGNS

Op art–inspired graphics popped up in rock & roll clothes in the mid- to late 1960s, along with other fun prints that came out of London's Carnaby Street and King's Road boutiques. Some mod and postmod bands, like the Faces, found the occasional graphic black-and-white print shirts and jackets, while the Stones and others picked up striped trousers. At the same time in New York, Andy Warhol and his coterie of Factory hipsters such as Edie Sedgwick and Viva were wearing black-and-white minidresses with white go-go boots. Blondie's Debbie Harry, who waitressed at Max's Kansas City when the Factory elite congregated there, definitely was inspired by this look, creating some cool black-and-white wardrobe choices in the 1970s. Ric Ocasek and the Cars also chose black and white for their band style. Eddie Van Halen frequently donned striped pants and shirts when onstage with Van Halen.

The black-and-white checkerboard graphic is a novelty print that comes in and out of style over the years. Cheap Trick guitarist Rick Nielsen took on the black-and-white checkerboard as his signature style, wearing it from head to toe. Even his guitar was laminated in a checkerboard pattern. The bold graphic impact of black and white, done appropriately, is very rock & roll: it was an especially big influence on the Two-Tone ska revival bands that formed in London in the late 1970s and early 1980s. Black-and-white graphics have inspired my clothing line on occasion, particularly the fabric tone and fluidity of the look. You really can't go wrong with black and white.

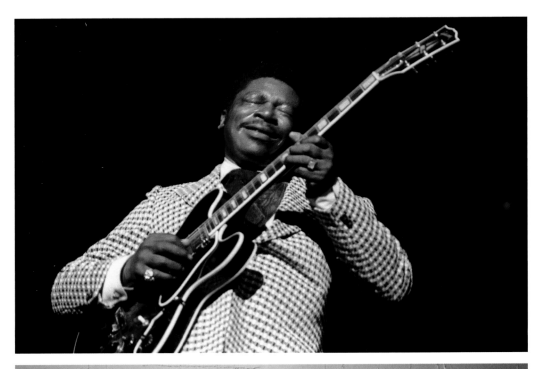

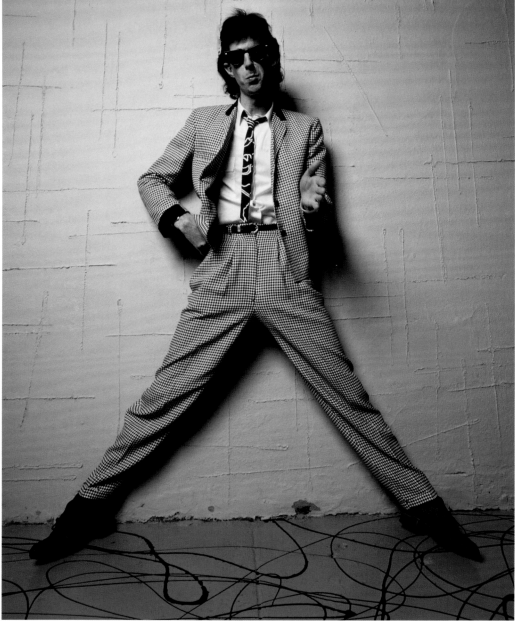

TOP

B.B. KING pulls off this checked
jacket with class.
Photograph by Robert Knight.

BOTTOM

RIC OCASEK suits it up! Ric's
interpretation of the black-and-white
houndstooth suit is definitive 1980s
style—and looks dated now.
Photograph by Lynn Goldsmith.

OPPOSITE

ROD has always dug graphic outfits,
like this giant checked topcoat worn
with cuffed trousers.
Photograph by Kate Simon.

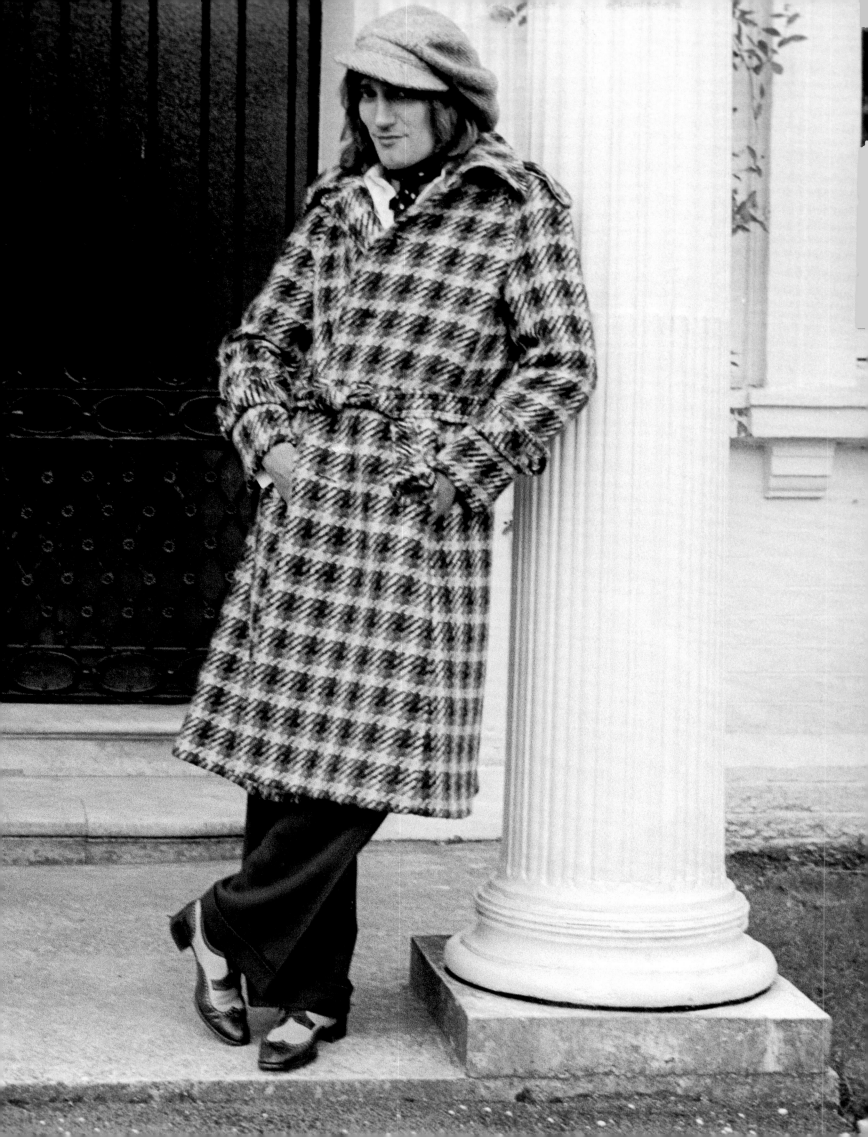

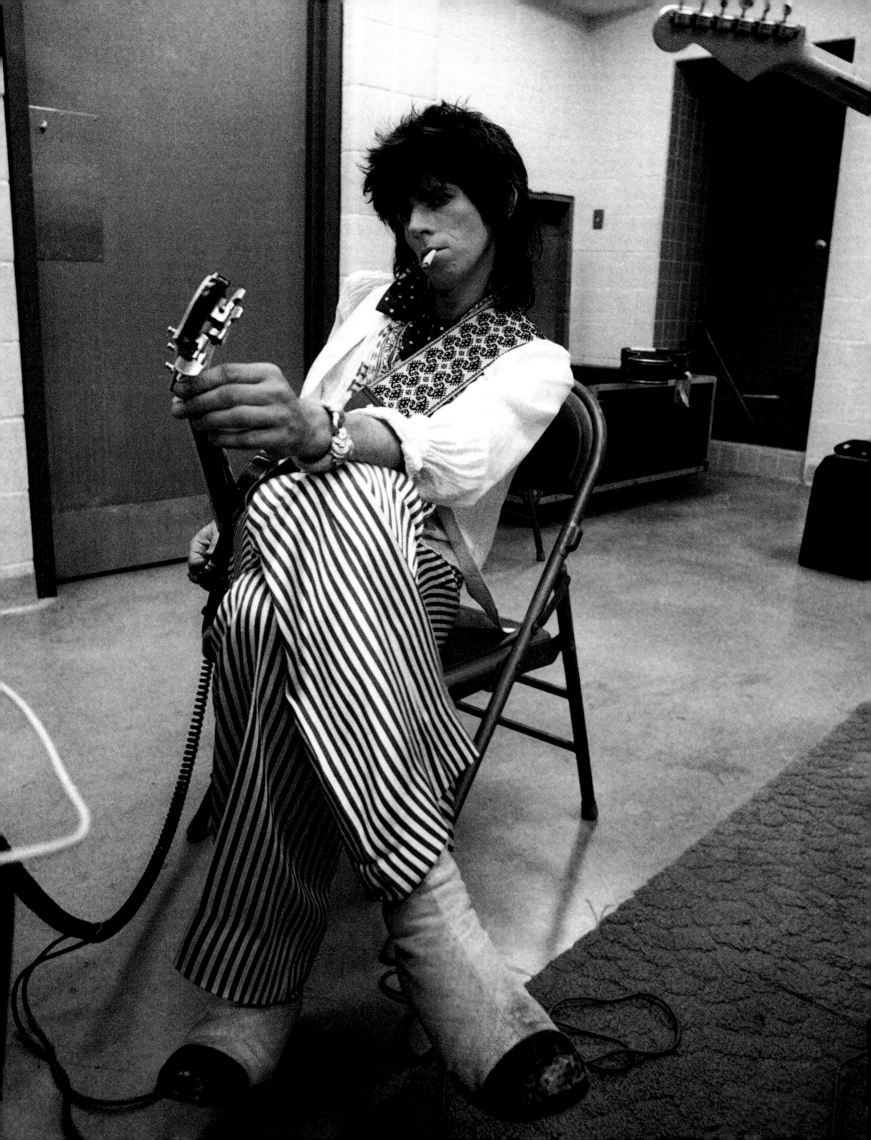

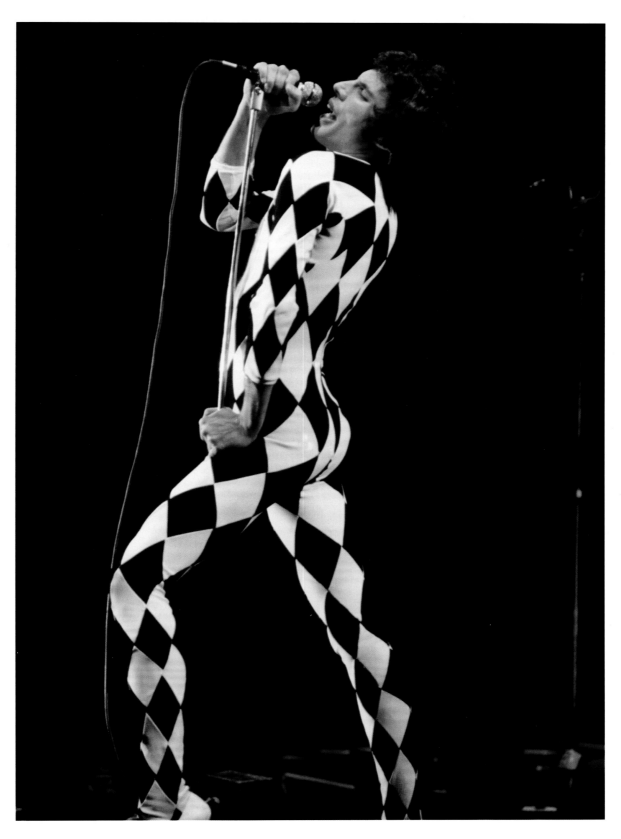

FREDDIE MERCURY's harlequin
unitard adds a hint of the jester
to Queen's stage show.
Photograph by Neal Preston/Corbis.

OPPOSITE

KEITH RICHARDS looks effortlessly
chic in his striped wide-leg trousers.
Photograph by Ken Regan.

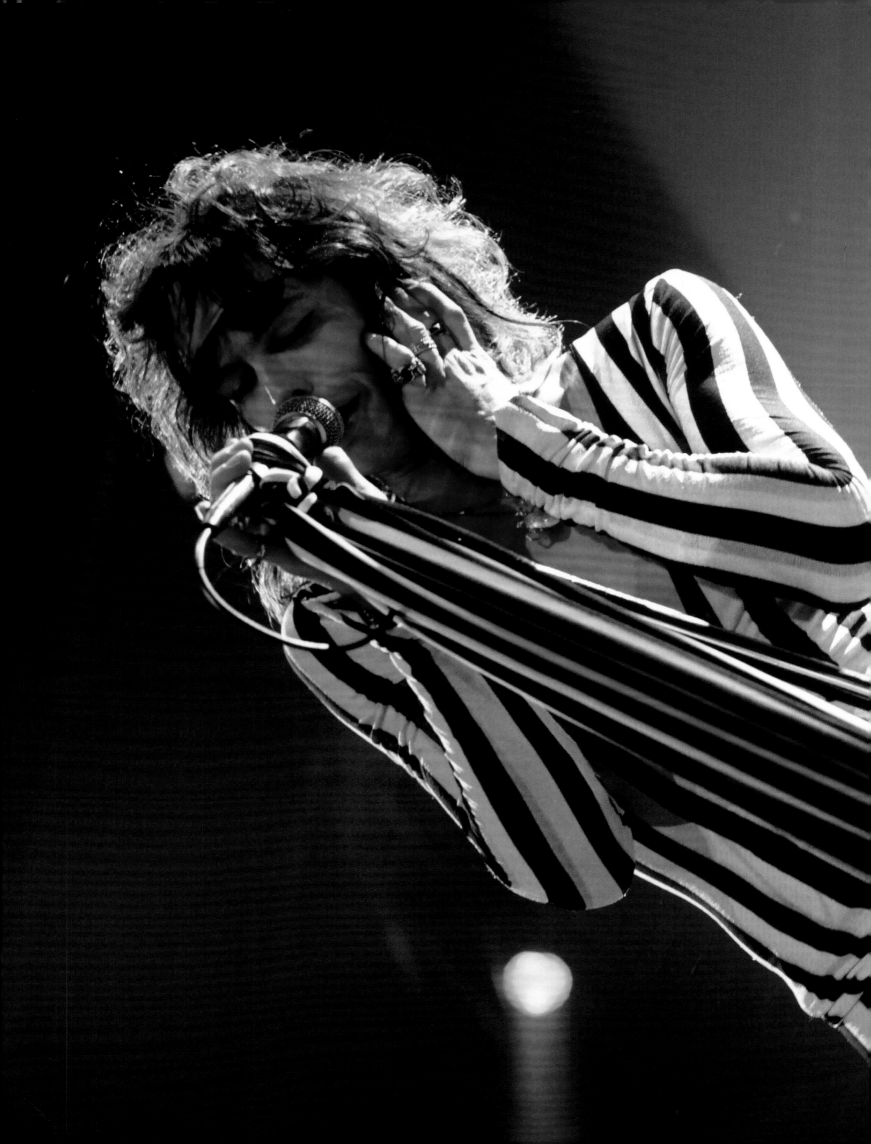

PAGES 146-147
Somehow **STEVEN TYLER** can pull off
all those stripes!
Photograph by Robert Alford.

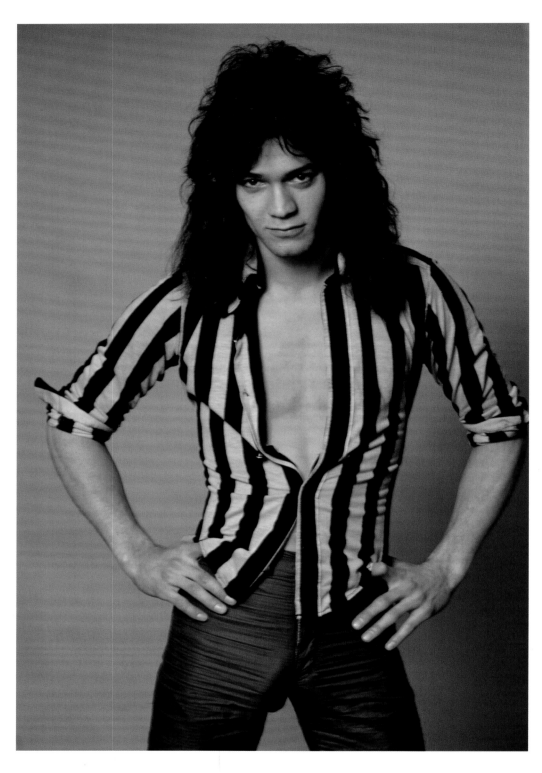

EDDIE VAN HALEN has always had
a thing for stripes on his clothes
and on his guitars.
Photograph by Lynn Goldsmith.

OPPOSITE

BILLY IDOL in a turn-of-the-century
vest with skintight leather pants.
Photograph by Kate Simon.

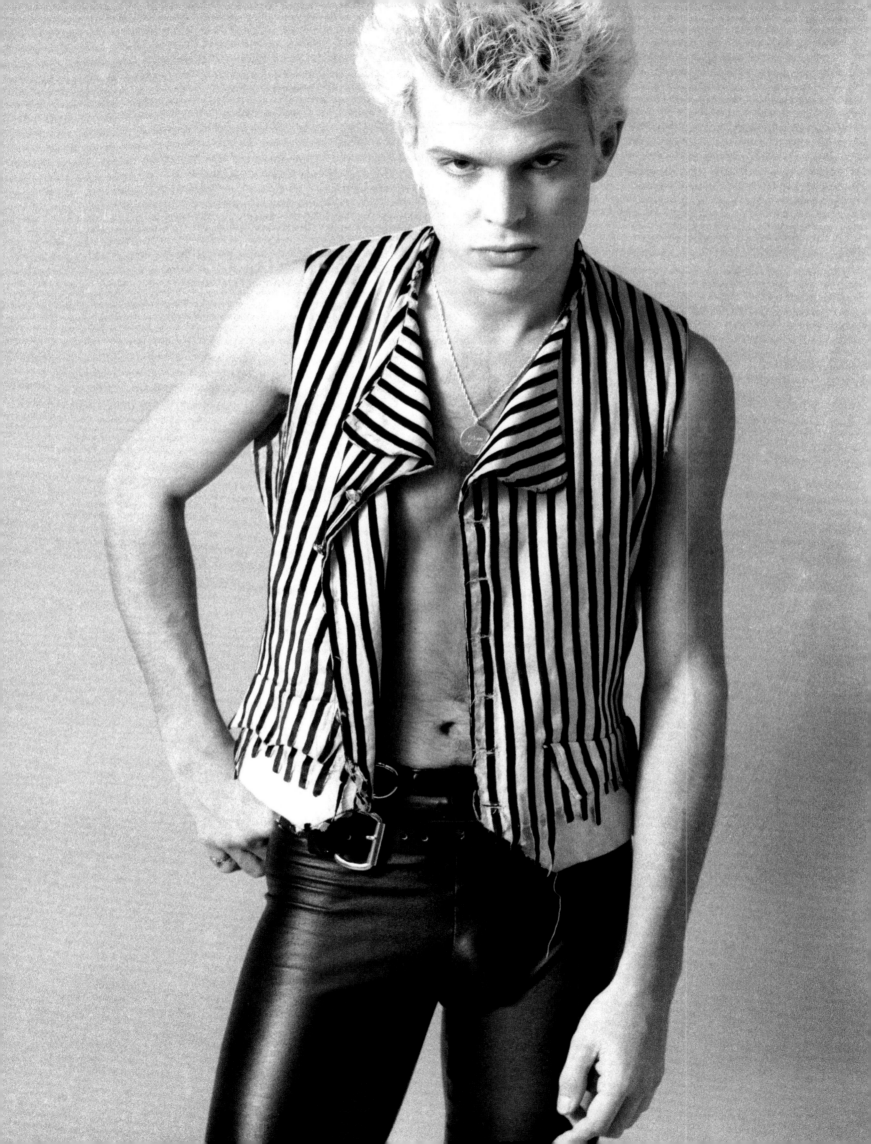

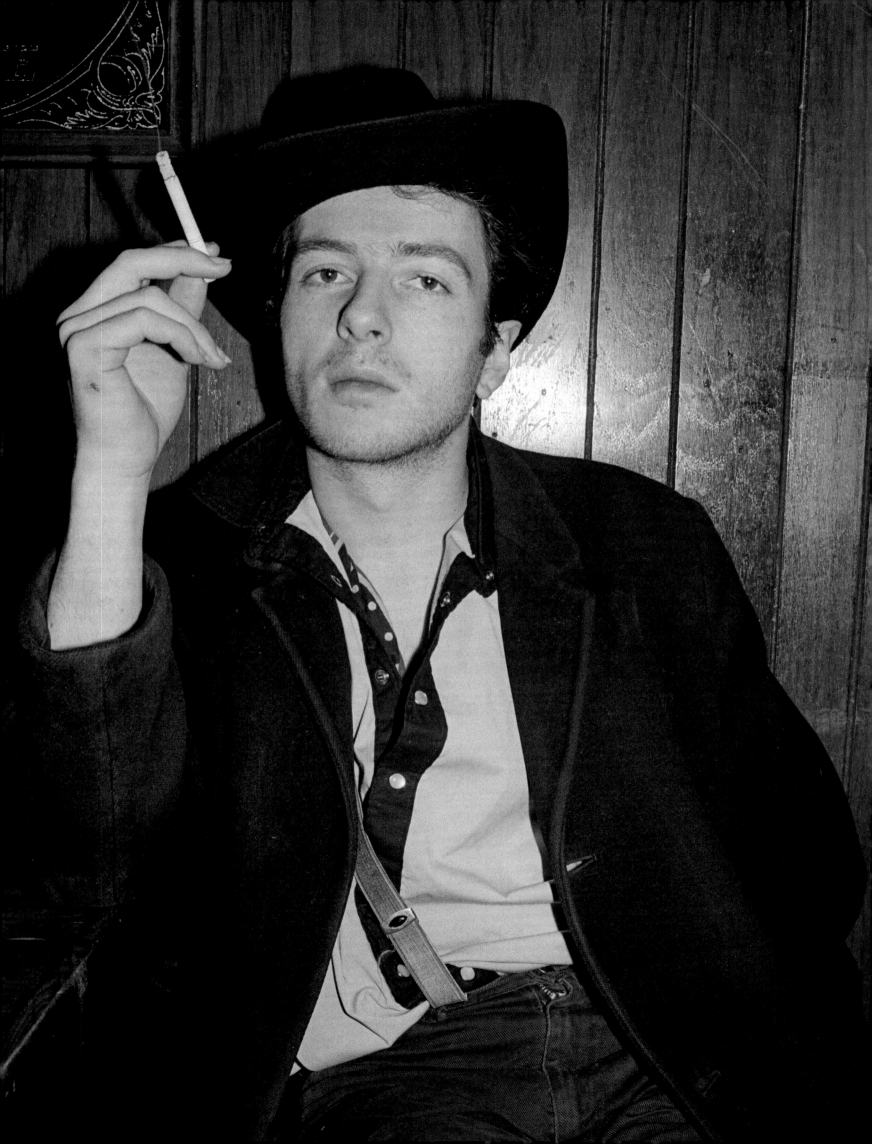

SUIT YOURSELF.

CHAPTER 10: IT'S ALL ABOUT TAILORING

Tailoring, for me, is the heart and soul of rock & roll fashion: the tailored topcoat, jacket, pant, and vest. When you consider music history, every important artist's look was based on tailoring, be it Frank Sinatra, Elvis Presley, Ray Charles, Duke Ellington, or John Lee Hooker. The Chicago blues players wore a tailored suit: a jacket, a shirt, a tie, a vest, and trousers. Over time, wearing just the individual pieces has become more popular among musicians, rather than putting on the entire three-piece suit—except for traditionalists like Leonard Cohen and some young bands who've acquired a taste for tailoring, such as Franz Ferdinand, Interpol, and the Strokes.

I became interested in tailoring when I was young. As a kid, I never wanted to wear a suit, but then I saw cool-looking bands wearing them, and that totally changed my thinking. I loved the mods' custom-made, three-button, Italian-styled suits with skinny lapels, short jackets, and narrow pants—perfect for riding a scooter or Vespa.

Dylan transformed his look in 1965, when he toured England and picked up his pegged pants, polka-dot shirts, and tailored jackets on Carnaby Street. Some British groups started going for longer jackets inspired by England's Edwardian period, with a silhouette more like an hourglass, and King's Road shops were a prime source for these. Granny Takes a Trip made crushed-velvet jackets and suits, giving us the rock & roll dandy. They

also took a classic shape such as the two-button suit and created the garments in exotic fabrics. In the 1970s, Roxy Music's front man and fashion plate, Bryan Ferry, wore eye-catching custom-made suits. Some of the design ideas from these halcyon days are still with us. Paul Smith said in the book *Rock Fashion*, "It was really the [London] shops of the times that led the bands and then the bands who make a particular look [like] the neat, mod-inspired look....They all made the looks that the bands took on, and that led to acceptance by the mainstream. These shop owners and designers were the unsung heroes of fashion."

Over the decades, the changes in tailoring styles, such as the width of the trouser leg, have affected other garments. For example, the bell-bottom jean came from the bell-bottom tailored garment, and both wide-leg and skinny jeans started as a suit style. Every season for my new collection, I begin with the tailoring. Whether it's casual, funky, or chic and elegant, tailoring is at the root of every collection I design. In menswear, the tailoring is what differentiates one designer from another; along with cut, shape, and fit, it's important how you make a statement with fabric. Changes in men's tailoring tend to come as a gradual evolution: the lapel gets slightly wider or narrower; the pant gets a bit trimmer; the rise on a pant gets shorter or longer. In the last ten years, narrow pants and skinny jeans have become popular; a heavier guy feels slimmer in these, and a slimmer guy

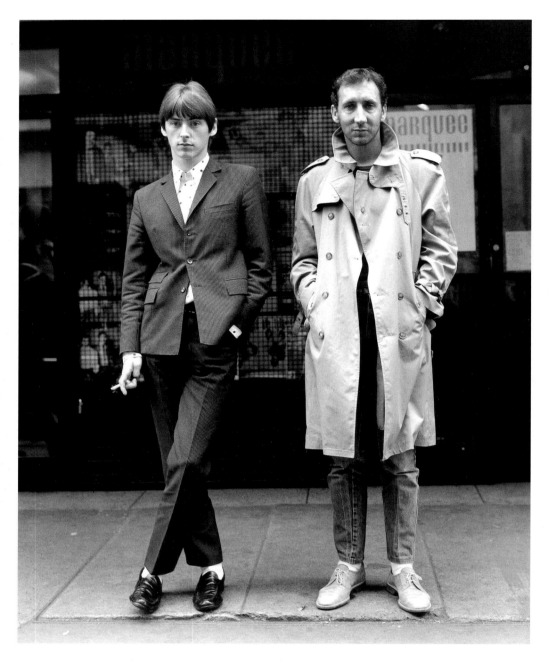

"Mod had had a vast effect on the bands... rather than vice versa... Townshend has always gone to great lengths to explain the influence mod had on him. Small Faces, Rod Stewart, David Bowie, and Marc Bolan—all of them came out of the mod scene."

—Paul Weller, from *Cool Cats*, 1982

just feels kind of cool wearing them. With a tailored jacket, the shoulders can make you look stronger, tougher, or very sexy, depending on the cut.

Onstage, artists want fabrics that reflect light so they stay cool while they're performing: they want lighter-weight clothes, textiles with sheen, fabrics they can move in and that aren't going to cause them to sweat under hot lights.

But rock & roll fashion isn't just about the stage. Fashion starts on the street, then artists grab it, make it their own, and take it to the stage. Of course, rock & roll fashion can go the other way: it often starts on the stage and the audience emulates it.

Thanks to Bob Dylan, I've worn vests ever since I was a kid. In my closet, there's one rack filled with at least fifty vests. Dylan had such style: he wore skinny black jeans with a pointy boot and a vest over an undershirt or a dress shirt with French cuffs.

Over time, a lot of rockers would throw on a vest. Whenever I talk with musicians about what their stage wardrobe will be, there's always a vest included in the conversation. Not one of them has said, "That's not my thing." A vest with a shirt that's styled a certain way, along with a scarf or jewelry, is a great look. You can't go wrong with a tailored vest, whether you wear it with a suit, jeans, or a leather jacket.

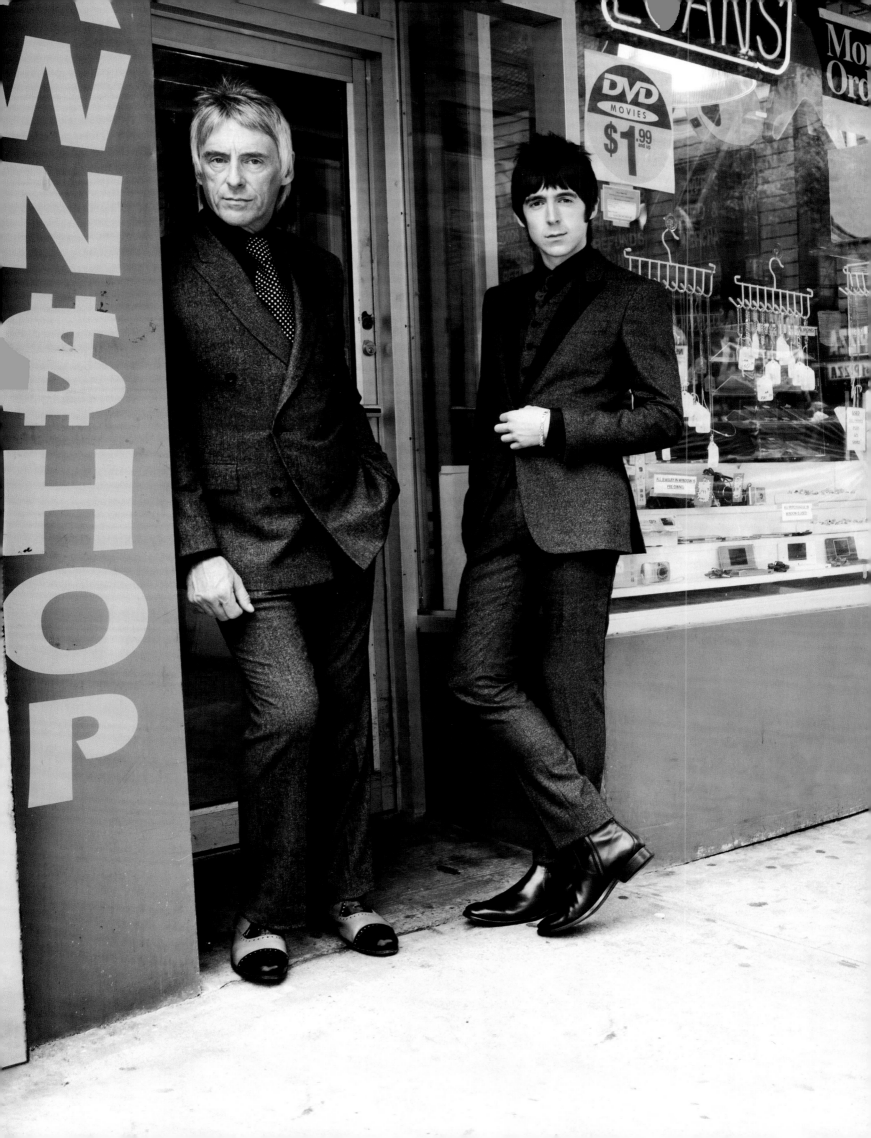

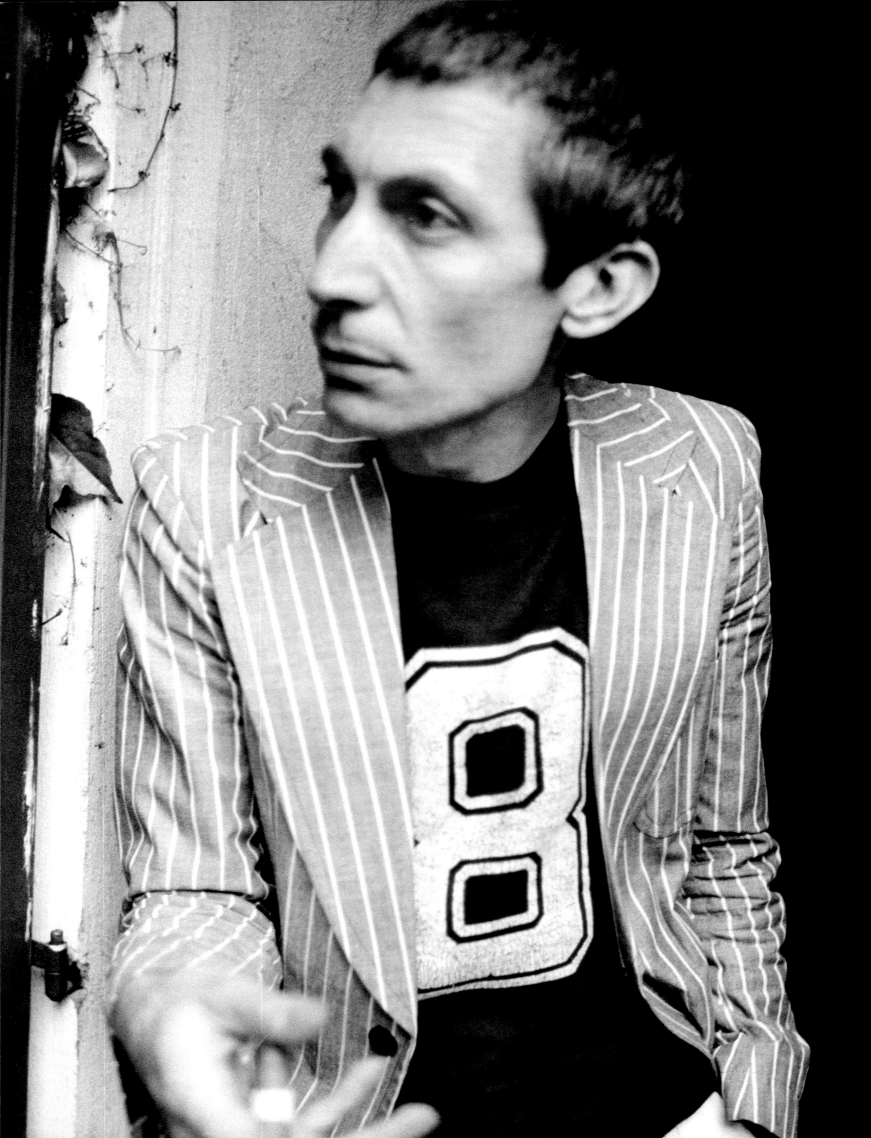

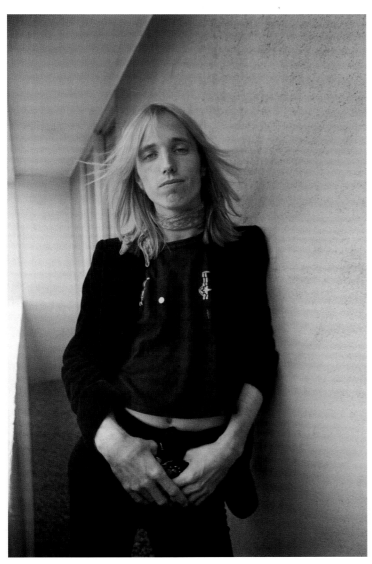 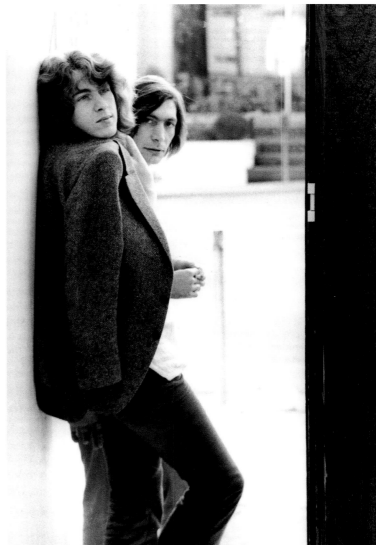

TOM PETTY in a velvet blazer and
scarf. Since the Beau Brummels of rock &
roll—the Stones, the Small Faces, and
others—picked up on velvet in London in
the mid-1960s, each new generation that
comes along goes for velvet at some
point. The look made sense for Tom Petty,
who first found an audience in England
before making it in America in the 1970s.
Photograph by Michael Zagaris.

Though Keith, Mick, and Brian Jones
were the most flamboyant dressers
in the Stones, Brian's replacement,
MICK TAYLOR, and drummer
CHARLIE WATTS sometimes went
for a more sophisticated look.
Photograph by Robert Altman.

CHARLIE WATTS combines a tailored
pinstripe jacket with a football jersey.
Photograph by Kate Simon.

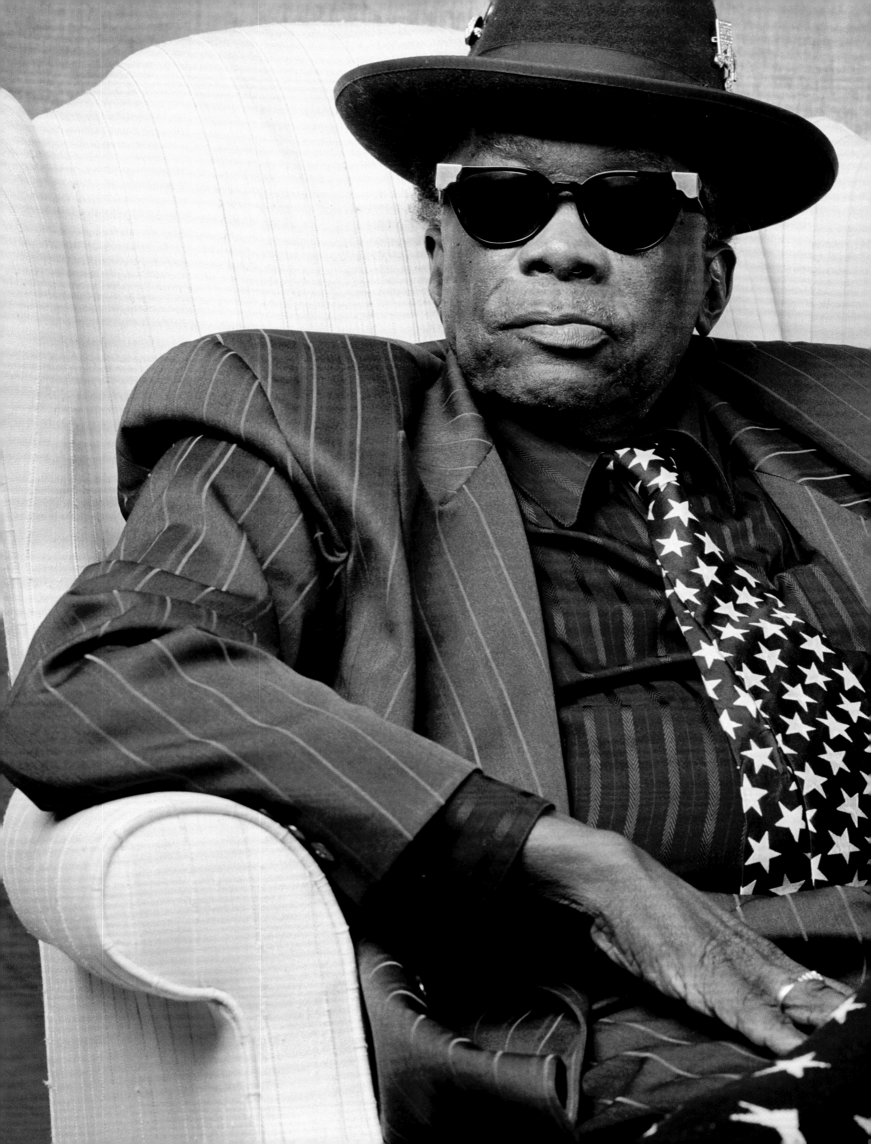

PAGES 156-157
Blues master **JOHN LEE HOOKER**
shows his stars.
Photograph by Robert Knight.

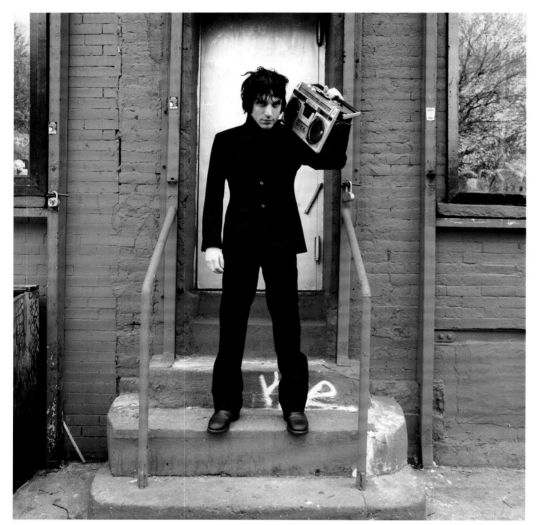

CLOCKWISE FROM TOP
I love everything about this picture
of **JESSE MALIN** wearing one of my
suits on New York's Lower East Side,
where he first started playing in punk
bands as a teenager.
Photograph by Danny Clinch.

Roxy Music was known for wearing
outrageous outfits, but front man
BRYAN FERRY always looked elegant
in a custom-tailored suit. He's
maintained the look since becoming
a solo artist.
Photograph by Mick Rock.

BILLY CORGAN looking imperfectly
perfect: his rumpled clothing has
a thriftshop mix 'n match feel that
really works for him.
Photograph by Wendy Lynch Redfern.

OPPOSITE
LEONARD COHEN: chic, chic, chic!
He gave up the cigarettes, but he'll
never stop wearing the tailored suit.
Photograph by Mark Hanauer.

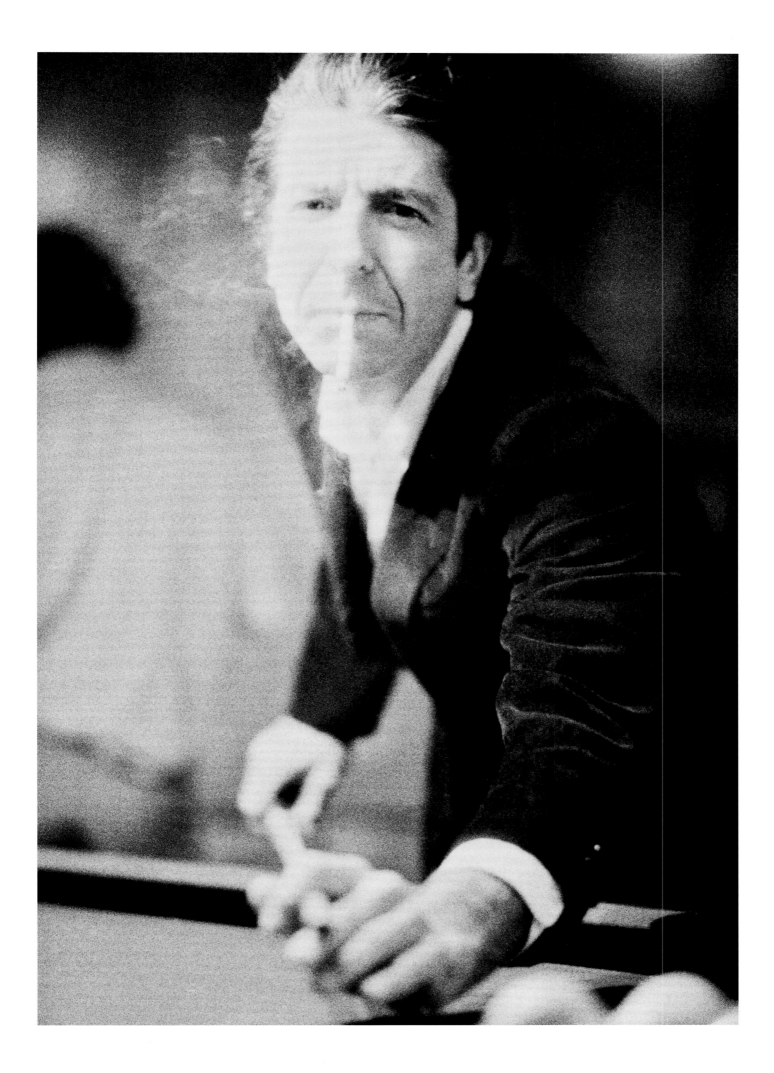

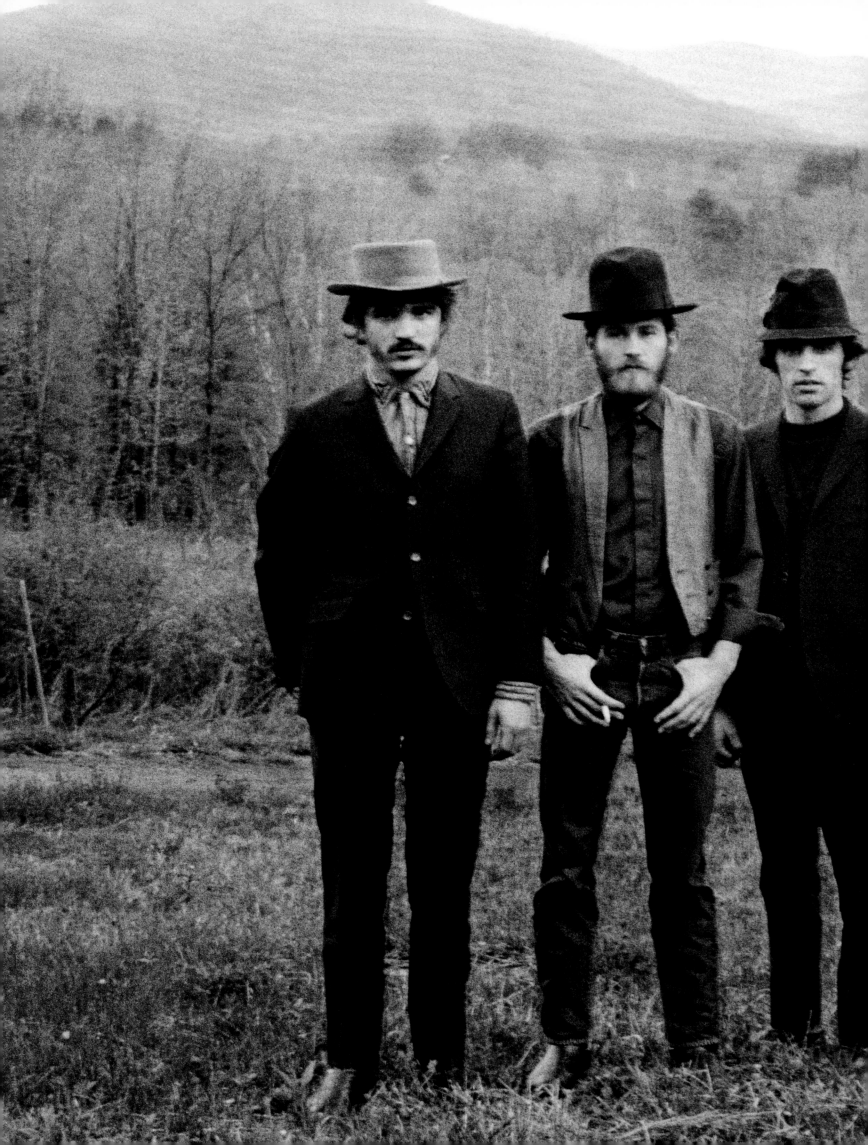

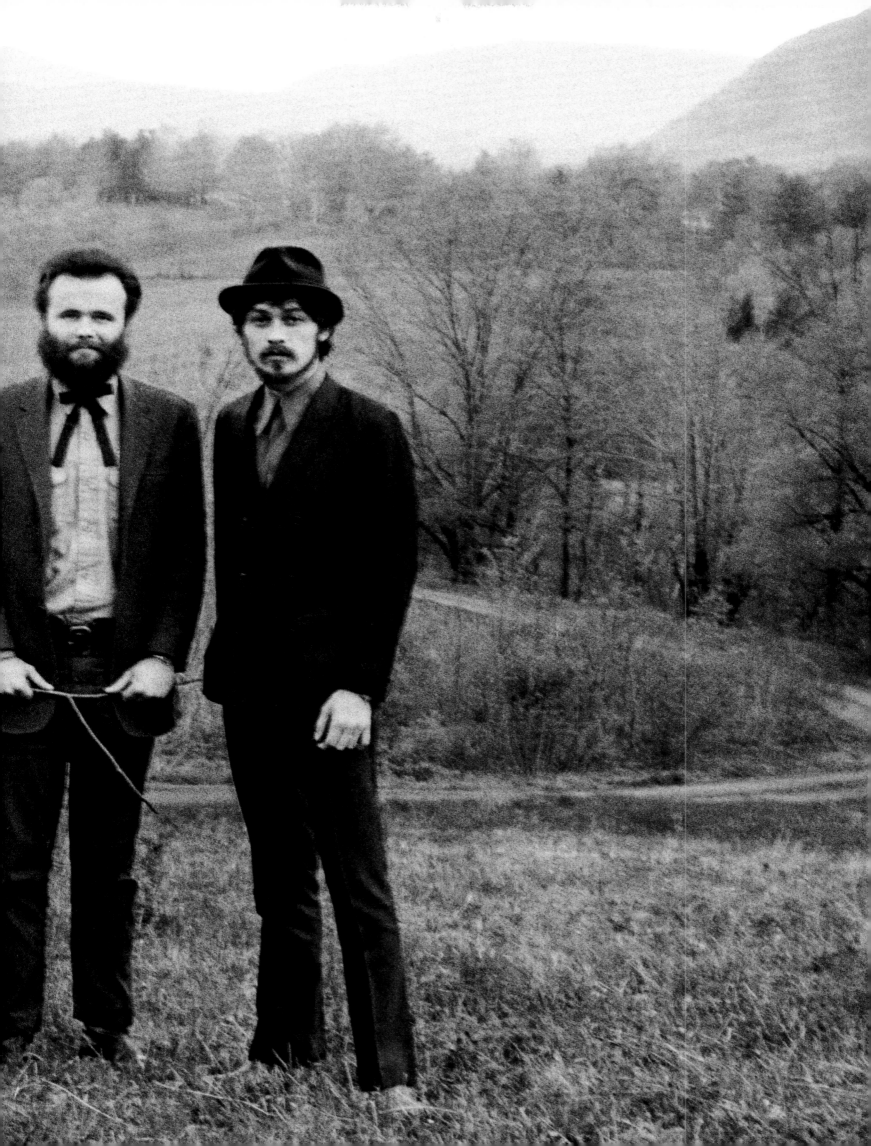

"We weren't dressing up for the shoot for the Band's first record, *Music From Big Pink*. This was not meant to be a fashion statement. In 1968, the look was flowery prints, polka dots, stripes, baggy sleeves, and lots of velvet. We were rebelling against the rebellion. Every day we wore plain dark clothes and hats. Maybe living in Woodstock, the Catskills, mountain country, had something to do with it. Elliott Landy understood his subjects' impatience and the time limitations of getting the shot, so he had a naked girl sit in front of us. The boys said, 'Elliott, take your time. This photo shoot is working out,' which gave him the opportunity to get set up and in focus. Then the girl stepped away, and he got this classic photograph of the band."

—Robbie Robertson, 2012

PAGES 160-161
This timeless shot of **THE BAND**, taken in Woodstock, New York, documents their simple yet sophisticated Americana style.
Photograph by Elliott Landy.

ALICE COOPER, from the John Varvatos Fall 2007 advertising campaign.
Photograph by Danny Clinch.

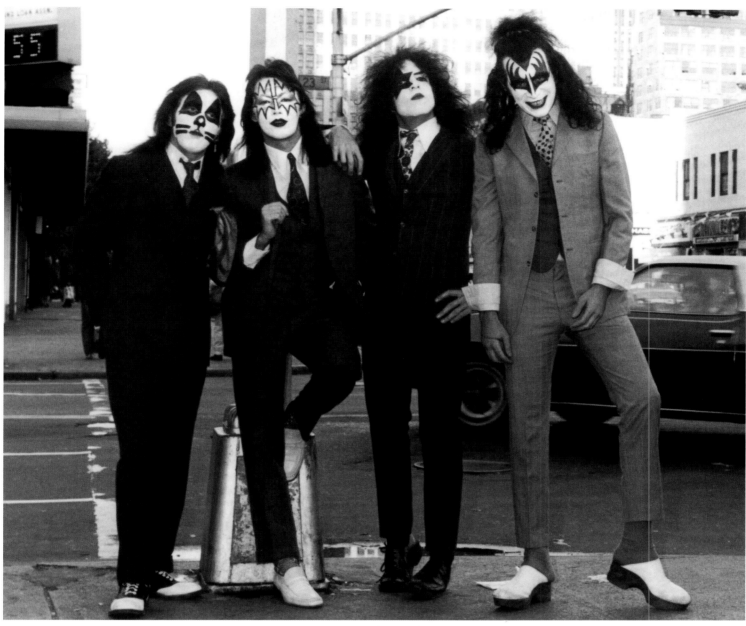

KISS dressed to kill. I'd love to
photograph them wearing John Varvatos.
What could be crazier than those
personalities in my clothes?
Photograph by Bob Gruen.

AC/DC'S **ANGUS YOUNG** took an
old schoolboy's suit, tailored it to
the extreme, and made it his signature,
which complemented his antic stage
persona. You would never expect to
see Angus onstage in anything but that
schoolboy look; in fact, you would be
sorely disappointed if he wasn't in
that tailored outfit with those shorts.
Photograph by Lynn Goldsmith.

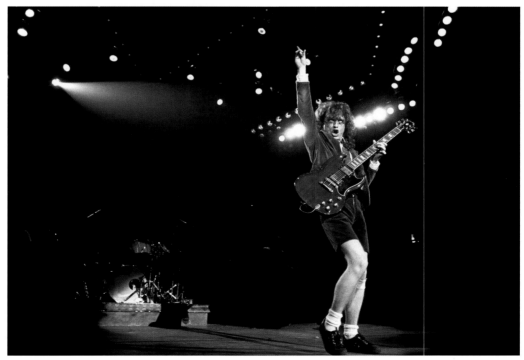

"Whether I'm standing still and wearing what I slept in last night, it's still a performance. Art is the biggest fabrication. It's about owning that fabrication and presenting it with your best abilities. If it takes acting or pushing yourself to do something you've never done before, then it's worth it. I mean, I don't want to see a regular guy walk out on stage. Fuck that! Imagine how disappointed you'd be if Michelangelo was just a normal guy. I don't want to know that. Do you? I want to see something interesting, special, and beautiful. Something I haven't seen before."

—Jack White, from *AnOther Man*, 2010

THE WHITE STRIPES' Meg White and Jack White, the latter looking like an old-time gangster in his black suit and bowler. Jack's probably the brightest light when it comes to today's stylish dressers.
Photograph by Andy Willsher.

OPPOSITE
Growing up in the Motor City, I wanted to make **MC5**'s exact look my own. Usually dressed more low-key, drummer Dennis Thompson looks smashing here in a red pinstripe suit, and Wayne Kramer's black clothing paired with a white jacket is striking.
Photograph by Raeanne Rubenstein.

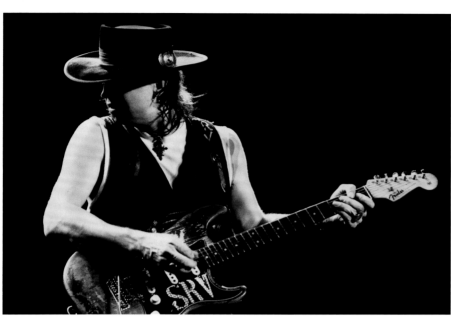

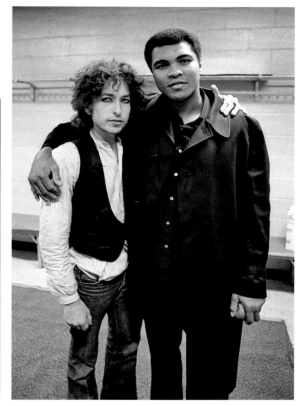

CLOCKWISE FROM TOP LEFT

STEVIE RAY VAUGHAN: Note the southwestern touches to his vest, which he usually wore over a white tank T. He was rarely seen without his hat.
Photograph by Robert Knight.

BOB DYLAN, seen here with **MUHAMMAD ALI** on a stop during the Rolling Thunder tour, wearing a tuxedo vest with a nineteenth-century-style grandfather shirt.
Photograph by Ken Regan.

Anyone wearing a vest looks elegant. Whether the vest is worn with a button-down shirt, with a shirt and tie, with a T-shirt, with no shirt, or with a scarf, it all says "rock & roll." This is not your father's vest: you give it your own twist. That's what **MICHAEL JACKSON** did.
Photograph by Bob Gruen.

OPPOSITE

DAVID BOWIE's sophisticated Thin White Duke is almost unrecognizable from his glammed-out Ziggy Stardust. Bowie's definitely the king chameleon of rock stars. Whatever look he goes for, he puts it together beautifully.
Photograph by Andrew Kent.

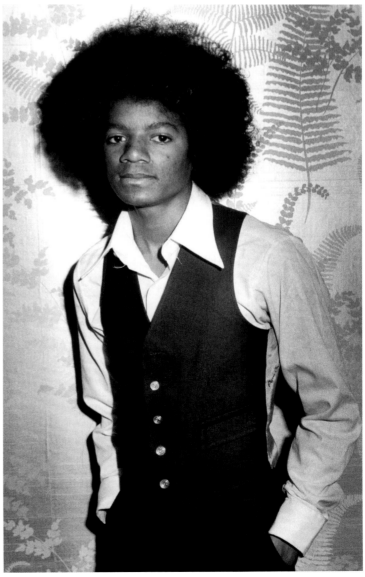

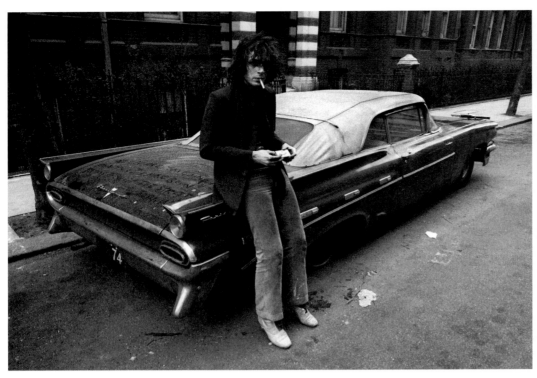

"He's wearing my overcoat, which is why it's too small for him. It's a brown 1940s postwar utility coat that I found at the Chelsea Antiques Market [in London]. Syd borrowed it, even though it didn't fit him. His trousers were from Granny Takes a Trip."

—Mick Rock, from *Mick Rock Exposed*, 2010

SYD BARRETT's style transcends every era. These late 1960s pictures look like they could have been taken yesterday. Every guy in a young band today would like to look like Syd Barrett in terms of his physicality (his hair, build, posture, body language) and his style (the cut of his tailored jacket and pants, the way he wore his scarf). He's got it all.
Photographs by Mick Rock.

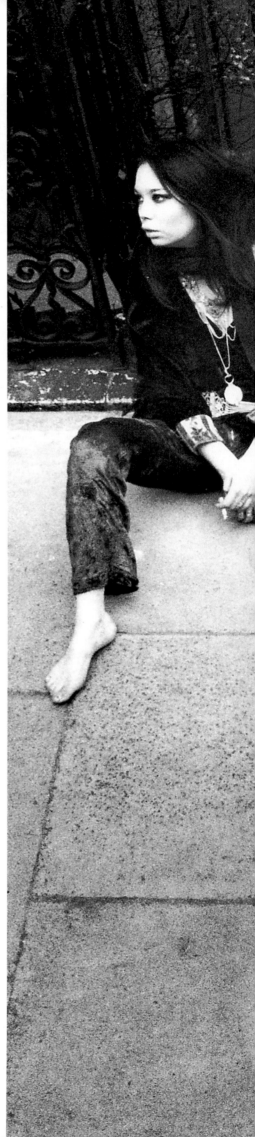

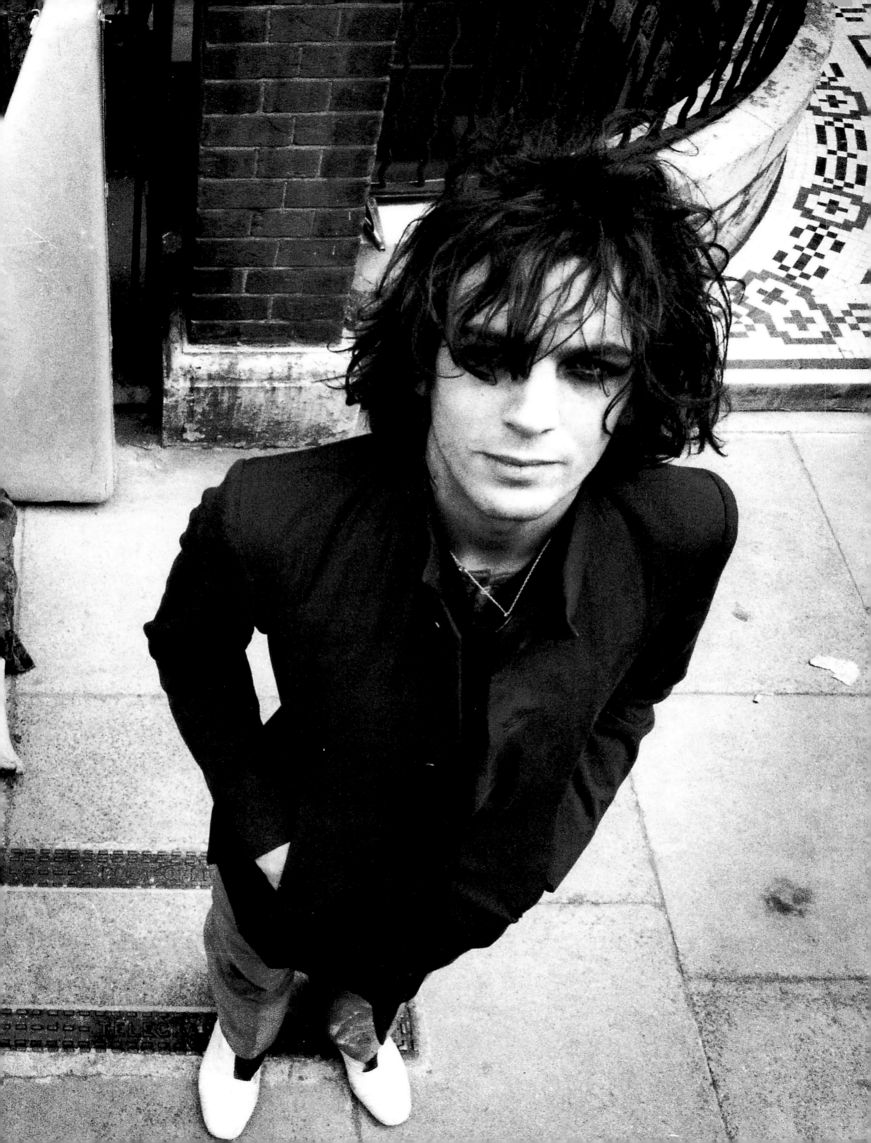

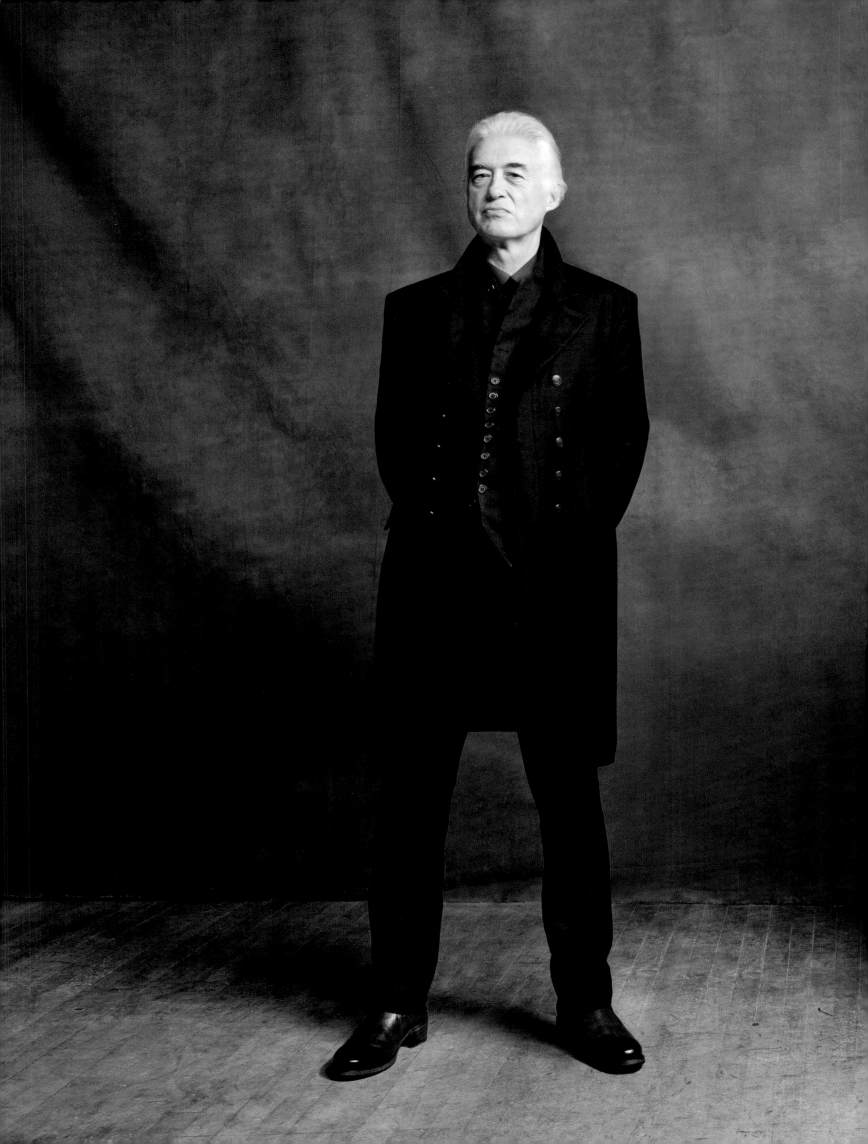

PAGES 170-171
An ad from the John Varvatos Spring 2013 advertising campaign. That pairing was a dream come true: one of my icons, **JIMMY PAGE** (left), with **GARY CLARK JR**. It doesn't get much better than that! *Photograph by Danny Clinch.*

LEFT

Since the early days of R.E.M. when he bought his clothes in thrift shops, **MICHAEL STIPE** has always been a man of style. I love this crisp white summer suit with shirt and tie. A white suit will always be part of my spring and summer collections.
Photograph by Mick Rock.

RIGHT

DAVID JOHANSEN does the tux look with a flared pant—fantastic.
Photograph by Bob Gruen.

"Music television had an influence on what we did with our stage clothes. Through the years, we've had a lot of fun with designing our gear. Women love a sharp-dressed man."

—Billy Gibbons, ZZ Top, 2012

From left: **DUSTY HILL**, **FRANK BEARD**, and **BILLY GIBBONS**.
ZZ Top: The sharp-dressed men in 1989.
Photograph by Bob Gruen.

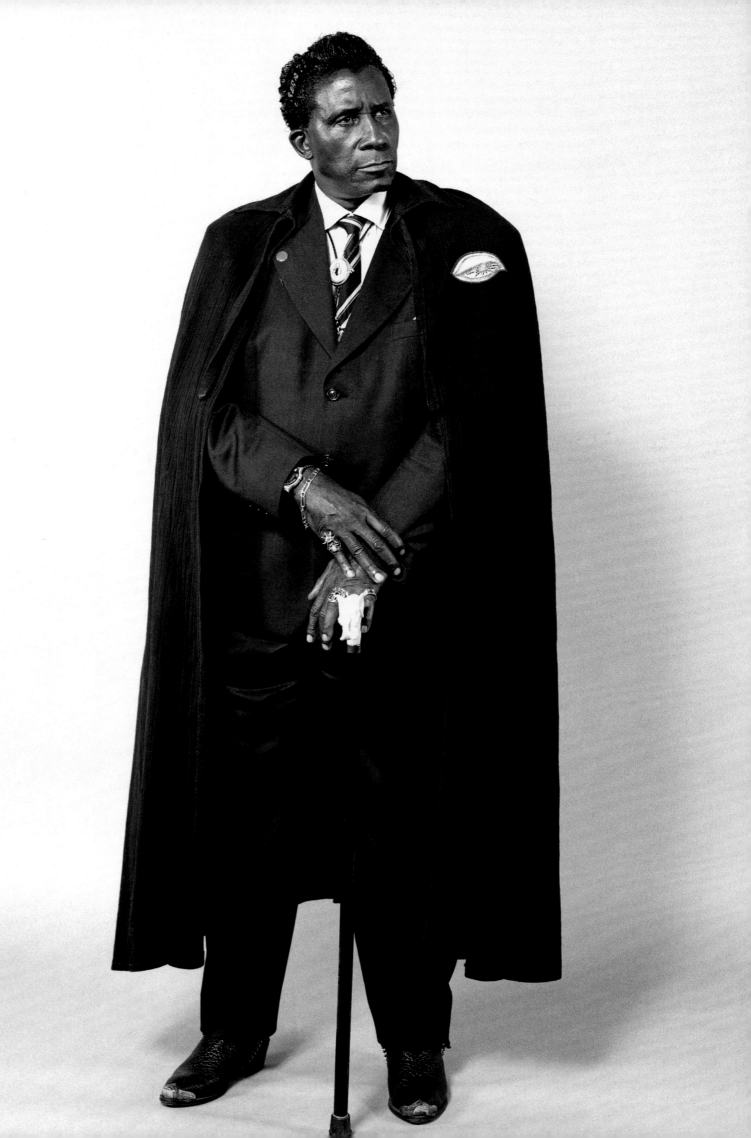

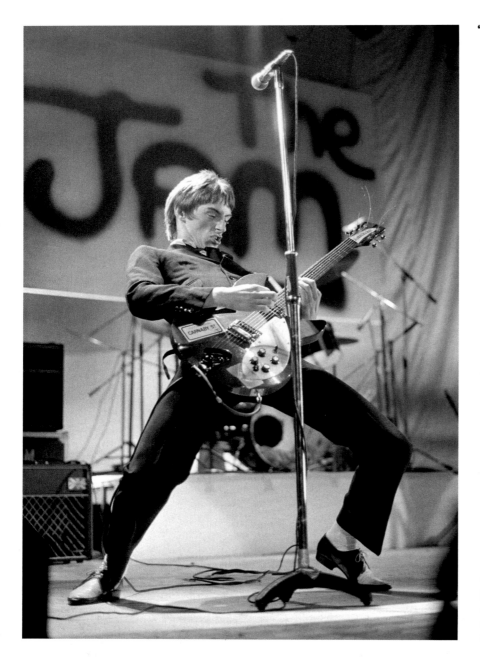

"My interest is with the style years...from 1963 to 1967...I saw that through becoming a mod, it would give me a base and an angle to write from, and thus the group would take on an individual identity. And this we eventually did. We went out and bought black suits and started playing Motown, Stax, and Atlantic covers....I tried to style my hair like Steve Marriott's, circa '66. I felt so individual and so arrogant because of it."

—Paul Weller, from *Cool Cats*, 1982

Cool and confident, **PAUL WELLER** looks as good today in a suit as he did in the 1970s.
Photograph by Ian Dickson.

OPPOSITE

RICKY WILSON of the Kaiser Chiefs often wears stylish suits onstage. His persona is that of chic modern rocker.
Photograph by Andy Willsher.

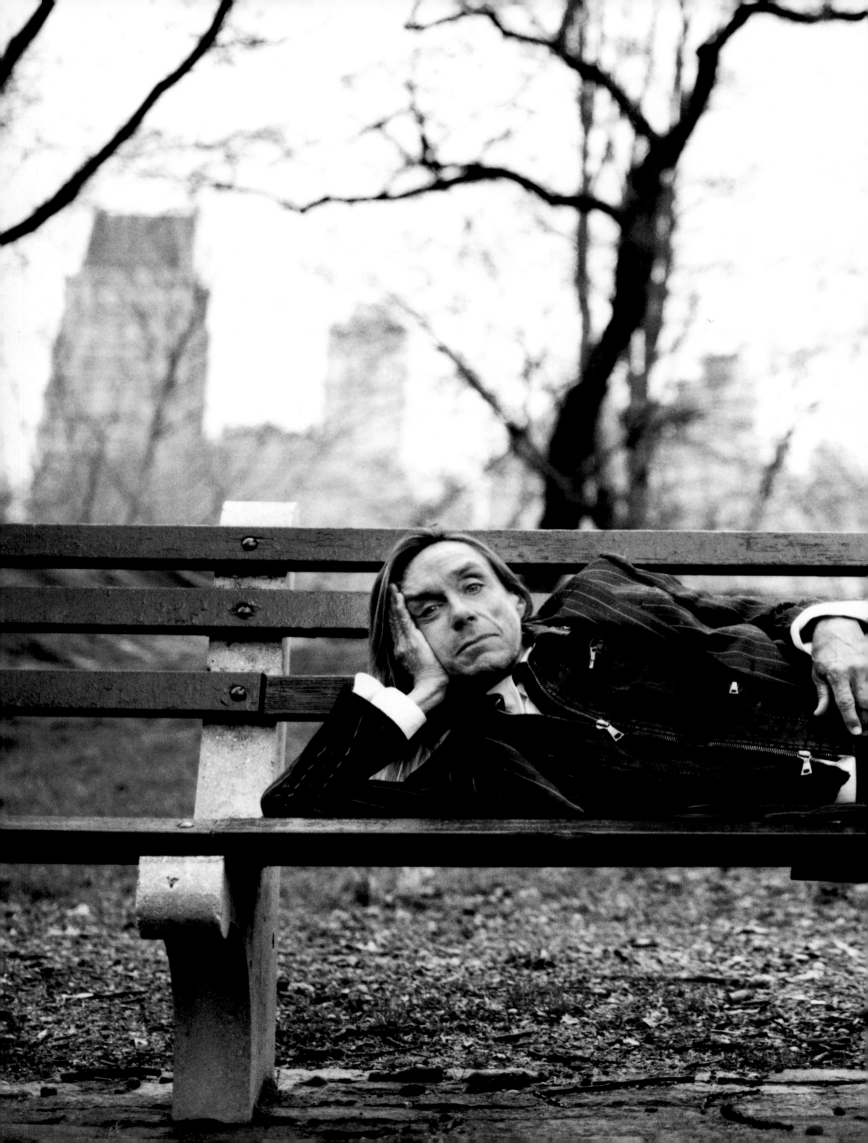

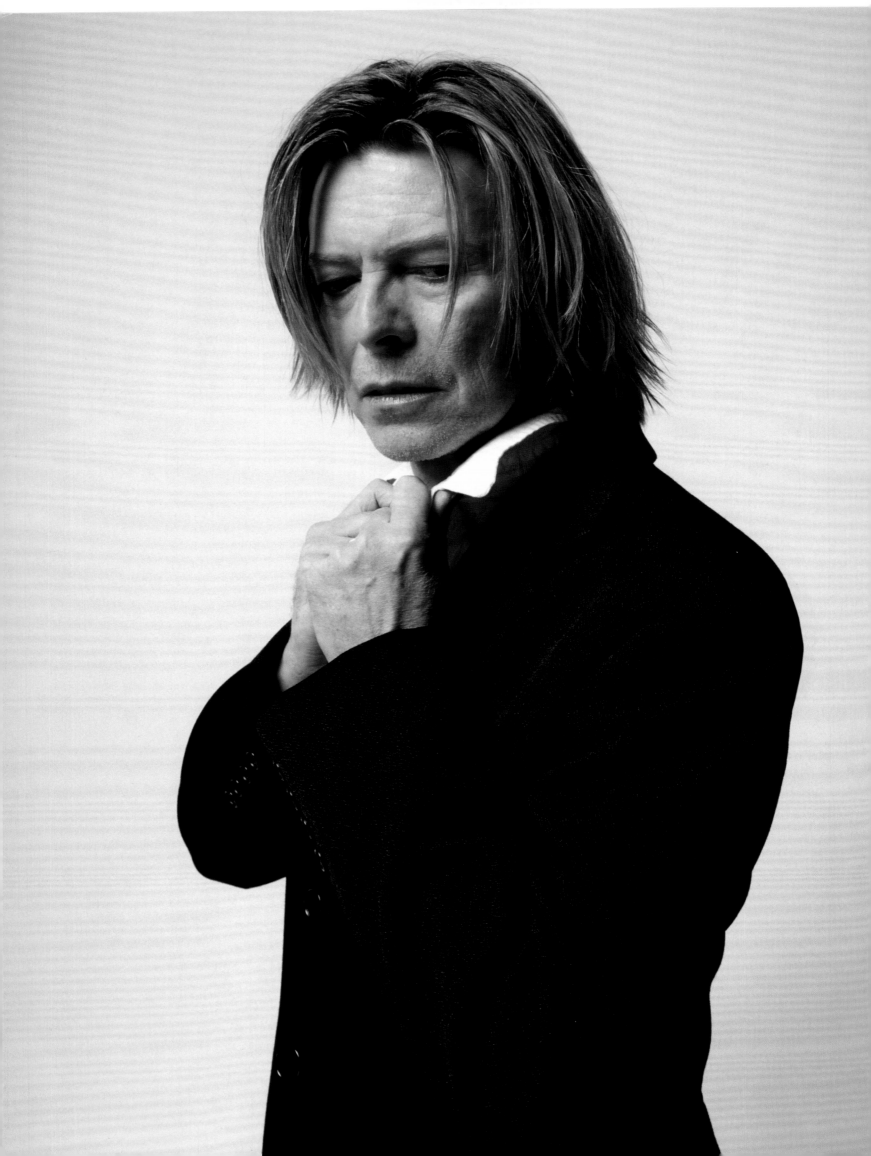

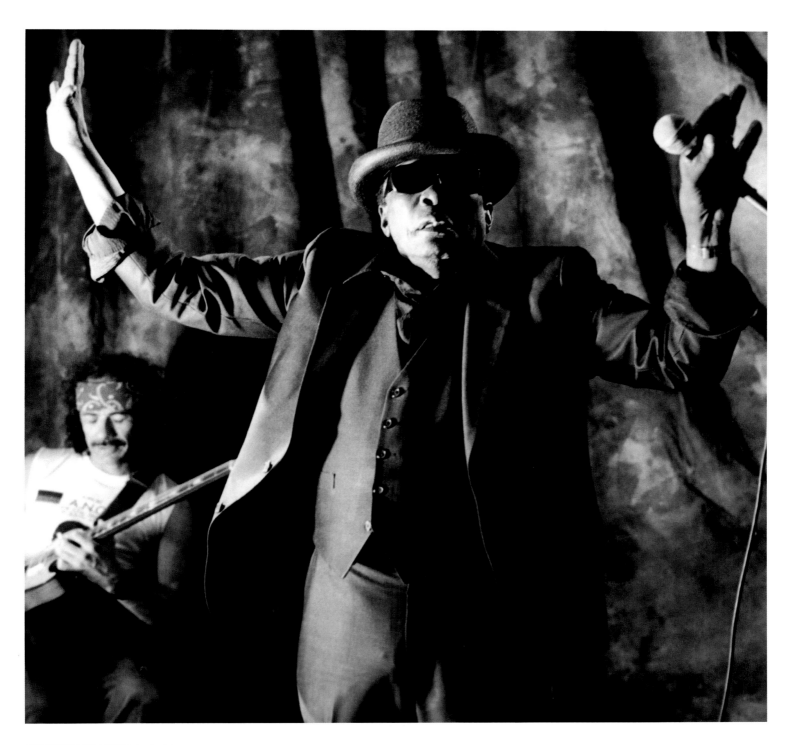

JOHN LEE HOOKER backed by
CARLOS SANTANA. Here, John Lee
"The Healer" shows off his sartorial
splendor. The man's sharp threads
usually involved a three-piece suit,
shades, and the perfect brimmed hat.
Photograph by Richard E. Aaron.

OPPOSITE

This shot of **BOWIE** is one of the
pictures I had on my wall while
creating my first collection in
2000. It conveyed a casual elegance
with a bit of rock & roll edge
that I wanted in my clothing line.
Photograph by Mick Rock.

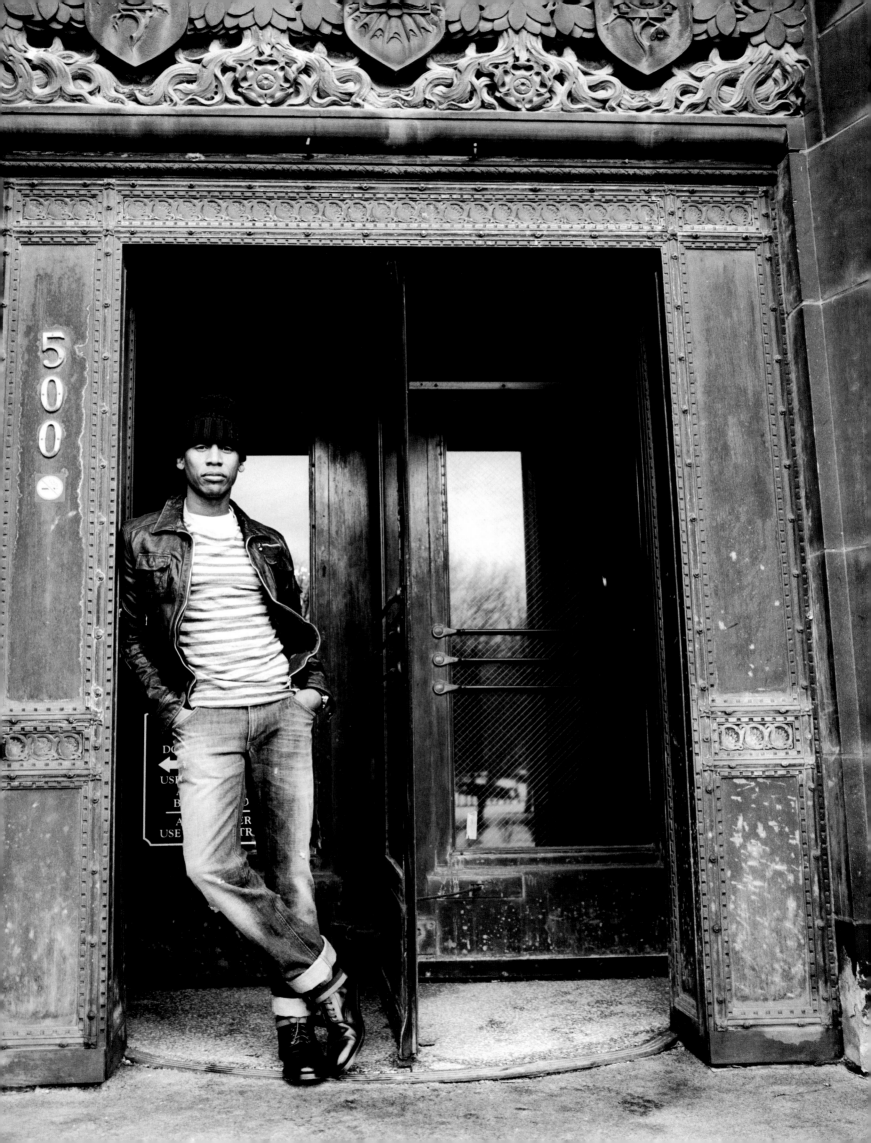

GOT THE BLUES.

CHAPTER 11: FROM SKINNY JEANS TO BELL-BOTTOMS

Denim is sexy. It can be tough, feminine, or masculine—and it can be all three rolled into one. It can be elegant. It can be punk. It lives in many worlds and speaks many languages, from bell-bottoms to straight legs, from a fitted jean jacket to the western-style shirt rockers have made their own. Denim is a true American classic.

Denim molds to the body. That's what makes it sexy—it can be worn tight or loose. There isn't a single rocker who doesn't have denim in his wardrobe, and there's probably not one who hasn't performed in denim. You can live in denim, you can sleep in it—and they've all done it. When someone asks me what the most important thing a guy has to have in his wardrobe, I always say, "a great-fitting pair of jeans."

Denim's tough side comes from its provenance—American work wear. The prototypical denim jeans, Levi's, were "invented" in 1849 when Levi Strauss, of a New York tailoring family, joined the California gold rush. He planned to finance his trip out West by selling bolts of canvas to make into tents. Instead, he found customers needing sturdy britches, so he fashioned the durable fabric into trousers, and by 1860 his indigo-dyed pants with copper rivets were coveted by miners. Later, cowboys, farmers, and other workingmen donned them;

then in the 1950s, rock & rollers started wearing straight-leg, cuffed versions.

In the late 1960s, bell-bottoms and flares, inspired by navy pants, came out of England, and the style caught on like crazy in America. I still love a flared pant whether it's on a guy or a girl. It's timeless. There's something sexy about the way it rides low on the hips. A jean with the shorter rise, a slim thigh to the knee, with a slight flare over the boot is my favorite. A flared or boot-cut jean transcends every decade, and I always have one in my collection. Elephant bells, on the other hand, say 1970s; they just don't have the same timeless appeal.

In the late 1970s and early 1980s, the straight-leg jean, like the classic Levi's 501 and the skinny-leg jean, came back in style, mainly among punk rockers. Over the last few years, skinny-leg jeans have returned with a vengeance.

Grunge, a label most musicians of the period hate, also included denim in a big way. Worn with flannel shirts, it hearkened back to Neil Young's style in the 1960s and early 1970s. In the 1990s, bands like Nirvana, Pearl Jam, and Soundgarden tried to put their own spin on Neil's look. These guys didn't have any interest in fashion; they made the look fashionable in spite of themselves. That's what rock & roll style is all about.

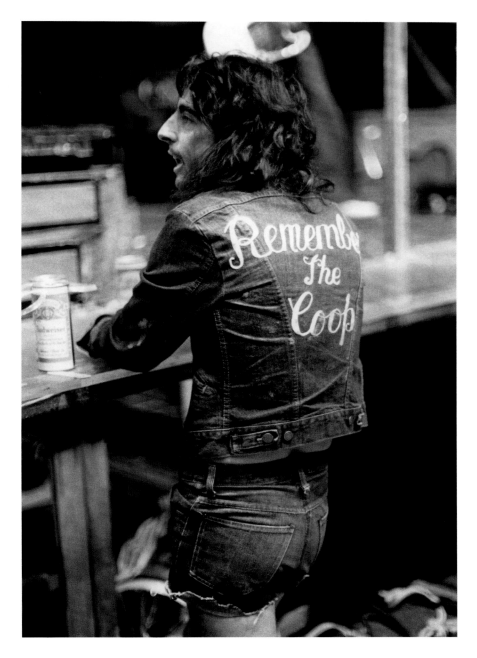

I bet **ALICE COOPER**'s denim jacket
(circa 1973) would fetch a pretty sum
in a vintage store. I can't say the
same for those short shorts.
Photograph by Bob Gruen.

OPPOSITE

BRET MICHAELS, taking denim and
leather to a new high—or is it low?
Let's try and forget this period—tight,
shredded jeans under chaps is a look
that thankfully never caught on!
Photograph by Lynn Goldsmith.

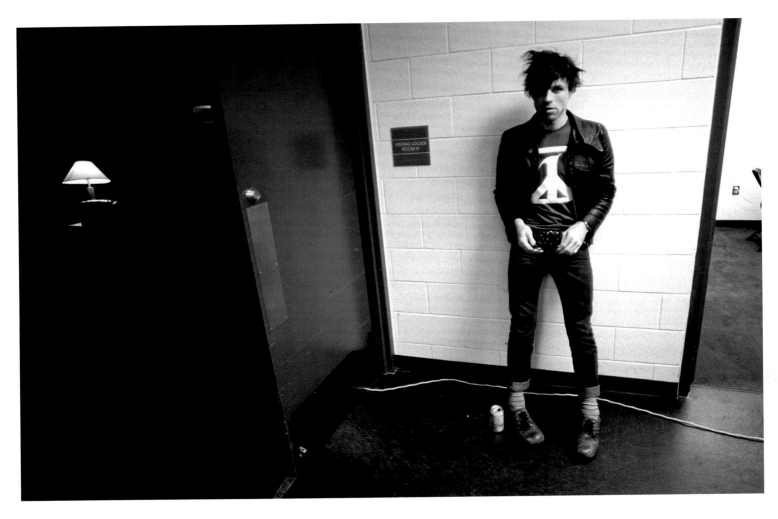

RYAN ADAMS makes his cuffed, skinny-
leg jeans and denim jacket look vintage
yet fresh, with his striped socks
and funky shoes.
Photograph by Neal Casal.

"I was careful about what I wore. From our second
gig on—no shirt, pair of tight, slim jeans, bare feet,
and I had permed hair and a white, painted face.
By the third or fourth gig, I lost the perm and white
face, and I started wearing the same pair of shoes
that you can see in every photo of the Stooges from
mid-'69 to the end of '71. They were these authentic
Anello & Davide Beatle boots. Dave Alexander had
brought them back from England. He and Ron had
skipped their senior year in high school to go to
Liverpool to see what was going on. I used to wear
them over and over, and they have holes in the
bottom, like a cartoon hobo's."

—Iggy Pop, 2012

OPPOSITE

IGGY is the godfather of punk.
Levi's never looked so good.
Photograph by Danny Clinch.

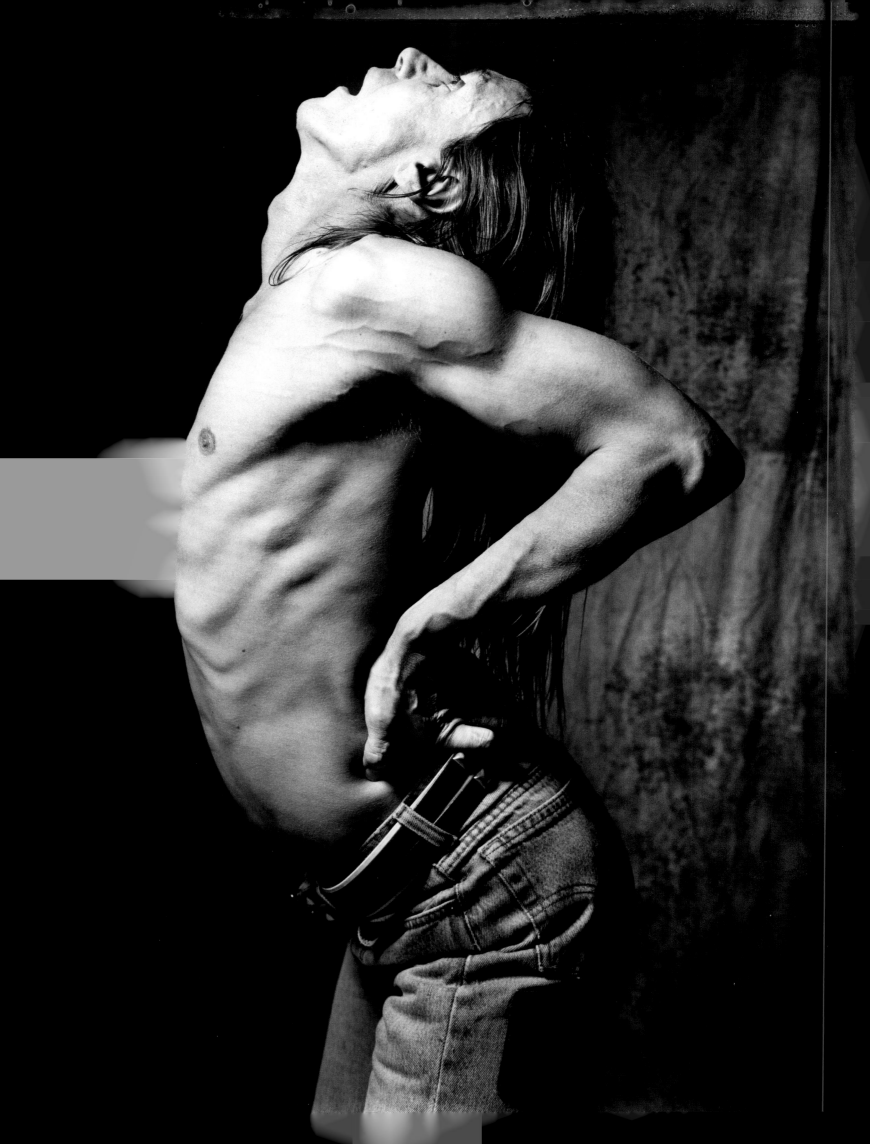

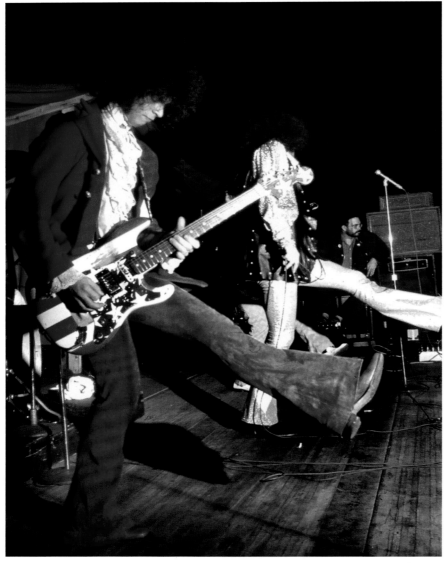

LEFT

WAYNE KRAMER of MC5 playing
his signature flag guitar in 1969.
MC5 used the American flag as part
of their styling.
Photograph by Leni Sinclair.

BELOW

JOHN LENNON in New York City in
1974 wearing his Levi's and Frye boots.
Photograph by Bob Gruen.

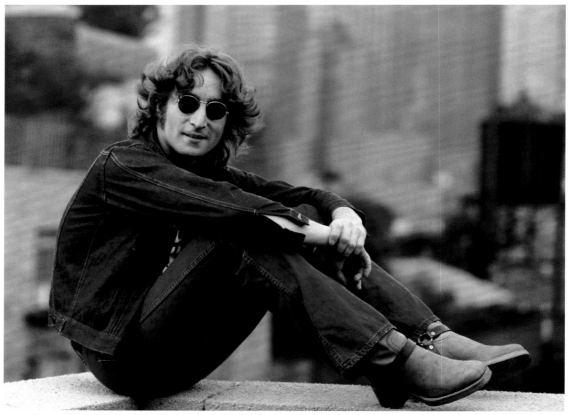

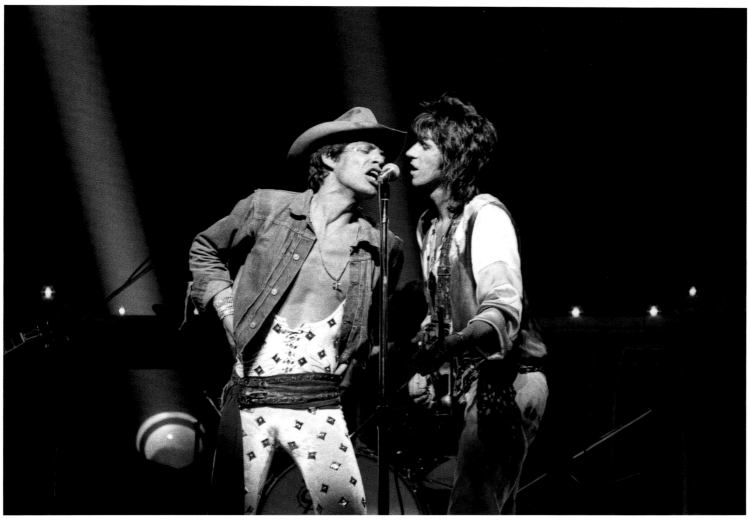

ABOVE

Here, on tour in 1973, **MICK** mixes it up like no one else, combining a denim jacket with his spandex jumpsuit. **KEITH** sticks to a simple style. *Photograph by Robert Knight.*

RIGHT

ANDREW STOCKDALE of Wolfmother has a bit of Zeppelin and Hendrix in his music and style. Check out the T. Rex pin. *Photograph by Robert Knight.*

MARCHING ON.

CHAPTER 12: FROM MILITARY JACKETS TO TRENCH COATS

There's probably no greater irony than the fact that so much rock fashion—the style associated with rebellion—is derived from military wear. The lines of military design are at the heart and soul of every tailored men's and women's collection. In fact, the military employs the very best designers to create its clothing. These specialists have to consider detail, elegance, function, warmth, quality, and durability in their designs. Of course, sometimes the look is for show, so military clothing runs the gamut from functional to highly formal.

All types of outerwear have roots in the military: parkas, trench coats, CPO jackets (a shirt jacket with pockets on the chest), peacoats, and band jackets, to name a few. Wearing a great military peacoat or trench coat, you are never out of fashion.

In 1960s London, the boutiques started selling repurposed vintage military garb. You could also pick up military clothing from army-navy surplus stores in the United States. At the time, mods wore long, fishtail, olive-green parkas. Parkas came back in the late 1970s and early 1980s among fans of Paul Weller's group, the Jam. The shorter, fur-trimmed hooded parka became hot again in the 1990s after Liam Gallagher of Oasis donned one. Both Liam and Noel Gallagher have shown an affinity for other types of military jackets since then, too.

The band jacket became huge in the 1960s, after the release of the Beatles album *Sgt. Pepper*, on which they wore brightly colored custom-made band costumes on the cover. On the funkier side was Jimi Hendrix's vintage band jacket with the cording and frogging on front. That look was referenced by Coldplay during their 2010 tour. Green Day's Billie Joe Armstrong wore a pearl-gray, understated version of the look in our 2012 campaign.

Sometimes artists wear military style to make an ironic statement: John Lennon and the Clash once took up the look, complete with armbands and insignias. Stooges guitarist Ron Asheton wore military jackets in the 1960s to convey his rebelliousness.

The trench coat, a fashion classic, also came from the military, and versions worn by Pete Townshend, Paul Weller, and Marvin Gaye have a timeless look. Whenever there's a utilitarian design with an elegant flair, it's probably a military-derived garment.

OPPOSITE
Another solid look for **JIMMY PAGE**—a vintage double-breasted military great coat, complete with medal. *Photograph by Chuck Boyd.*

"I sold Jimi Hendrix his famous
military coat, the one with all
the braiding that he wore so
much that it just became part
of his image."

—Robert Orbach, manager of the
 boutique I Was Lord Kitchener's Valet,
 London, from *The Look*, 2001

JIMI HENDRIX usually wore
a silk scarf with his vintage
military jackets. This signature
Hendrix look inspired a jacket
in my Spring 2012 collection.
Photographs by Gered Mankowitz.

TOP
The military look, from left to
right: **NOEL GALLAGHER** goes for
a streamlined leather flight jacket,
RYAN ADAMS opts for a peacoat, and
LIAM GALLAGHER wears a vintage
military shirt jacket. All three have
a distinctive look.
Photograph by Neal Casal.

BOTTOM
JOHN LENNON incorporated
a bit of vintage military into
his wardrobe in 1972.
Photograph by Bob Gruen.

THE CLASH—ready for urban warfare.
After *Sandinista!* came out in 1980, the
band took up military garb, including
paramilitary boots and camouflage.
Photograph by Bob Gruen.

GREEN DAY, from the John Varvatos
Spring 2012 advertising campaign.
Billie Joe Armstrong (center) is
wearing a gray linen military jacket
inspired by Jimi Hendrix.
Photograph by Danny Clinch.

ADAM ANT definitely took a page
from Jimi Hendrix's stylebook.
Photograph by Robert Matheu.

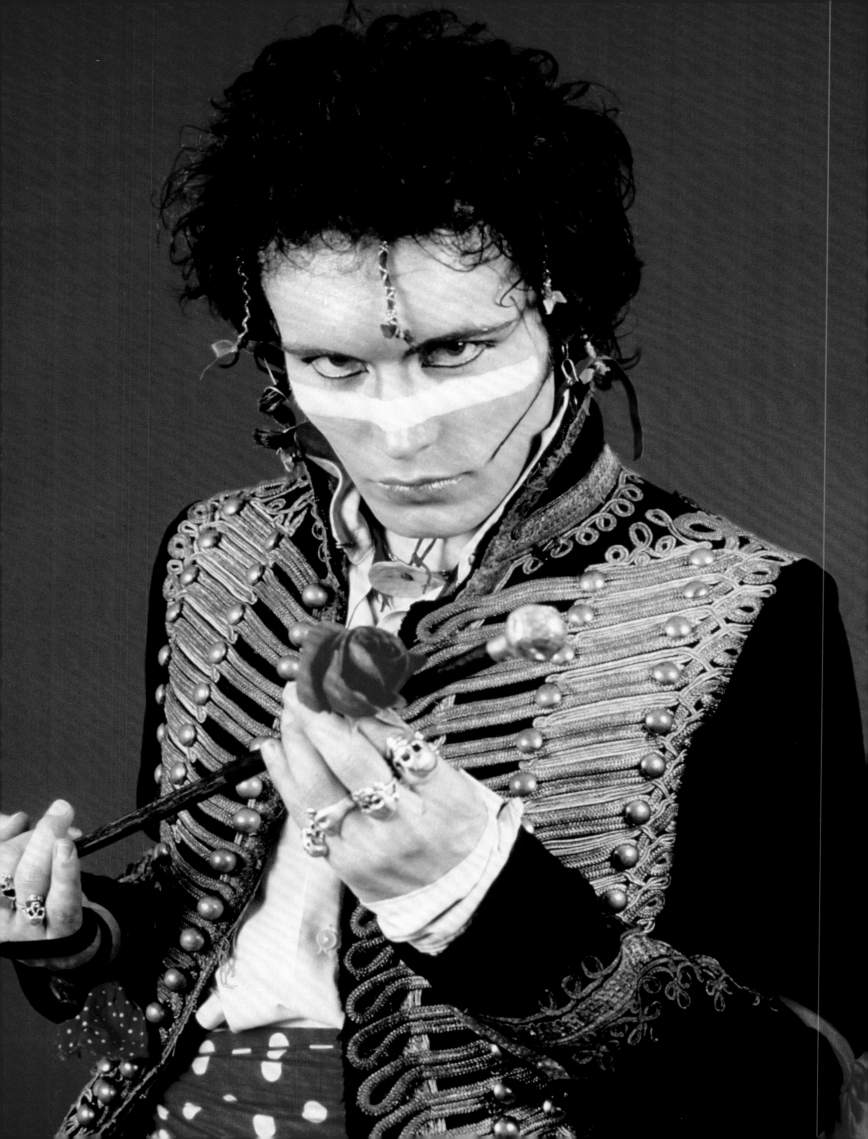

ABOVE

PETE TOWNSHEND in a trench coat, the most widely worn military influence in fashion.
Photograph by Martyn Goddard.

LEFT

LOU REED in a classic trench looks like an undercover agent from a Graham Greene novel.
Photograph by Mick Rock.

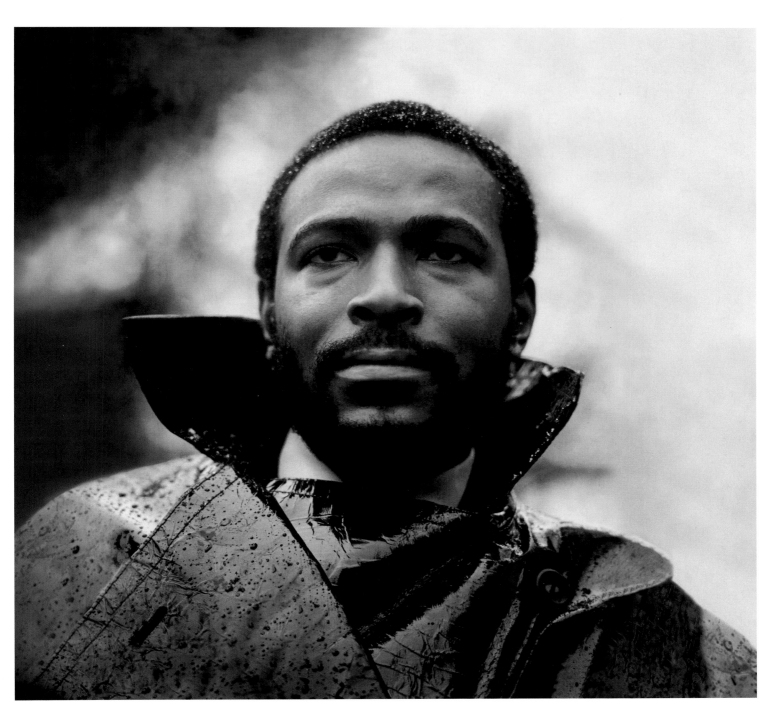

Simple and utilitarian!
MARVIN GAYE looks great
in a trench.
Photograph by Jim Hendin.

SECOND SKIN.

CHAPTER 13: LEATHER JACKETS, PANTS, AND JUMPSUITS

You can't think about rock & roll without seeing leather.

The leather jacket is probably rock & roll's most iconic garment. I remember seeing Elvis Presley wearing a black leather jacket and pants in his comeback special on TV in 1968. But it wasn't until I saw the Stooges' 1970 album *Funhouse* that a particular style of leather jacket really struck a chord with me. Rather than the popular black motorcycle style, the guys wore a slimmer, streamlined leather jacket with a band collar. This style of racing jacket was manufactured by Buco, a Detroit company that had made motorcycle pants and jackets since the 1940s. In 1973, I bought a Buco jacket: I still have it and wear it today. Over the years, I've designed versions of this jacket for my collection.

Like so many other types of outerwear, the first zippered "pilot-style" jacket was developed by the Army Air Corps in 1931. In the late 1930s and into the 1940s, a few manufacturers started making horsehide motorcycle jackets with zippered pockets. During World War II, manufacturing slowed down except for items needed for the war effort. But by the early 1950s, several American companies were making motorcycle jackets, including Harley-Davidson and Schott Brothers, who came up with the Ramones' jacket of choice, the Perfecto jacket, also known as the "Bronx" style. When Marlon Brando wore a One Star Perfecto motorcycle jacket in the 1953 film *The Wild*

One, the jackets became de rigueur for rebellious rockers who considered themselves outside the mainstream.

Since then, the rebel stance associated with the jacket has been an essential element among artists who've adopted the look. Early rockabilly singer Gene Vincent became known for his black leather jacket and pants in the 1950s and early 1960s. When the Beatles first started performing in Hamburg's Reeperbahn nightclubs, they wore leather jackets.

The association of leather jackets and rock & roll was imbedded in popular and fashion culture by the 1970s, perhaps most memorably when Bruce Springsteen wore a motorcycle jacket on the cover of *Born to Run*. The motorcycle jacket became associated with punk, thanks to the Ramones, who always wore their Perfecto jackets with skinny jeans, T-shirts, and sneakers. In London, punks were donning leather jackets defaced with graffiti and customized with chains, studs, and other paraphernalia, many of them sold at Vivienne Westwood and Malcolm McLaren's shop, Seditionaries.

There's a timelessness about the classic racing or motorcycle jacket. Today, you can wear one with a shirt and tie and look a bit dressy.

Leather pants, on the other hand, seem to come and go. Jim Morrison popularized them in the 1960s, and Slash was rarely seen without his in the 1990s. Prince has shown a penchant for

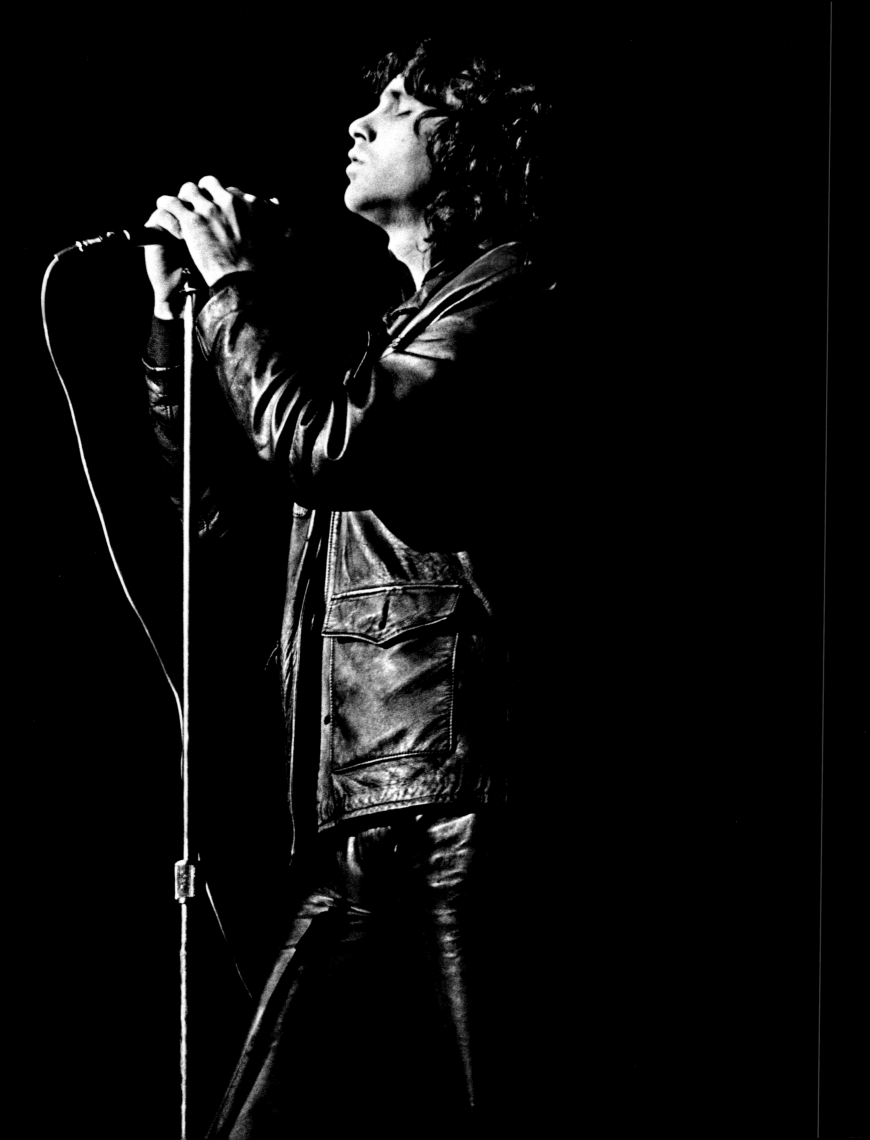

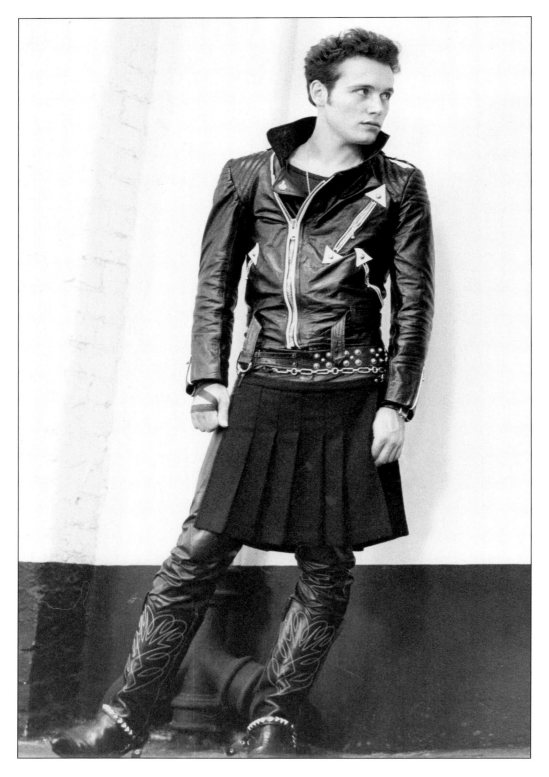

leather trench coats, and Pete Townshend wore a nifty patch-work leather blazer in the 1970s; both of those looks are dated. Leather jumpsuits hearken back to the 1970s, thanks to Suzi Quatro, who looked much better than Elvis did in his fabric ones in Vegas. But I don't think that look is coming back any-time soon either.

Fringed leather shirts became popular after Woodstock, where Roger Daltrey wore an open leather jacket with two feet of fringe whipping from the sleeves, and Grace Slick took the stage in fringed white leather. Buckskin fringed jackets, a popular piece of attire in western films and TV shows in the 1950s, were donned by David Crosby, Carlos Santana, and members of Buffalo Springfield and the Allman Brothers Band. Fringed leather goes back to the nineteenth century when it was worn to wick off rain and shoo away insects by Native Americans and cowboys.

Leather is primal, it's sexy, and it brings out the animal in rock & rollers who wear it.

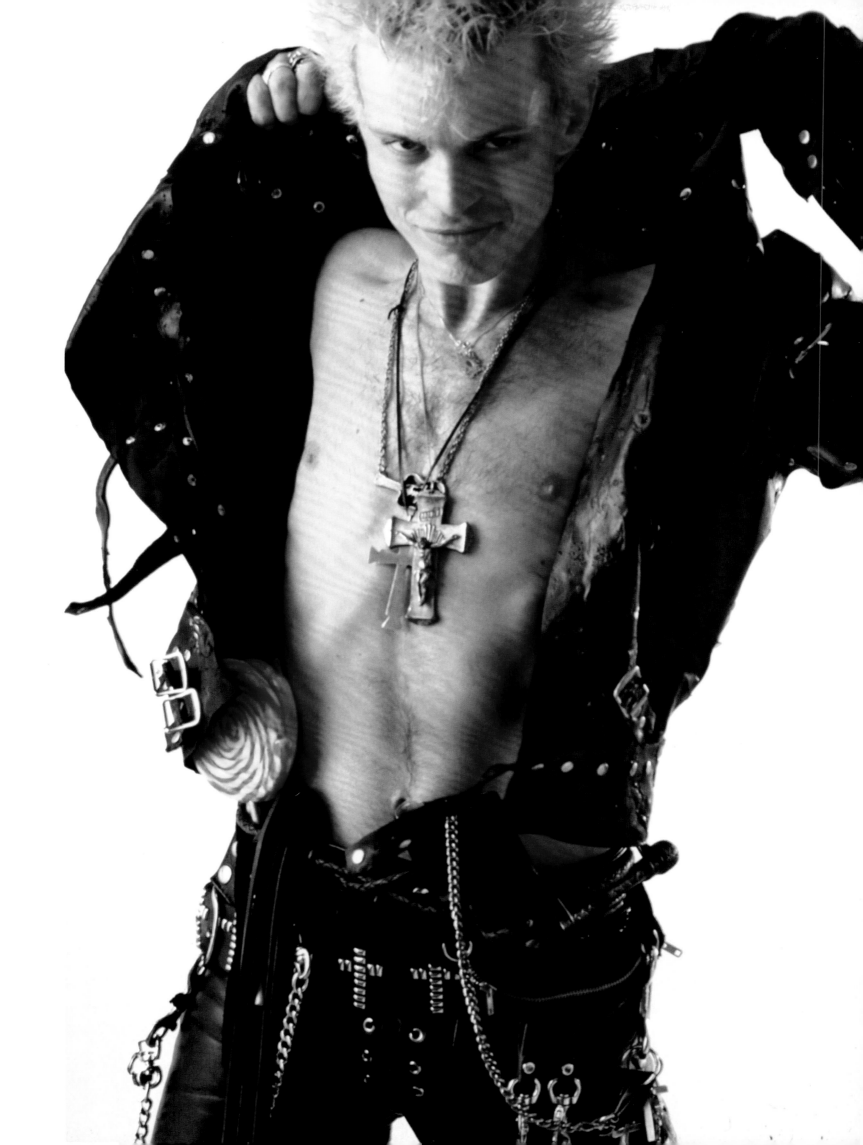

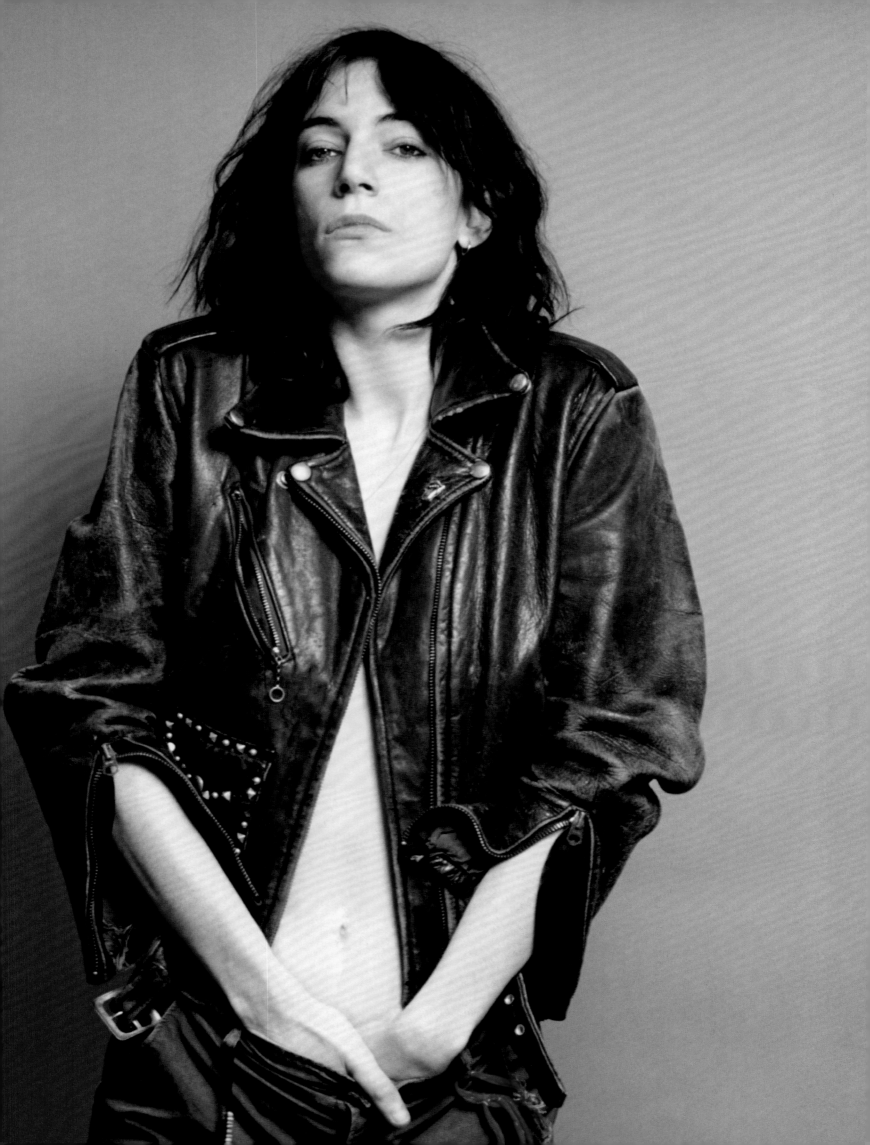

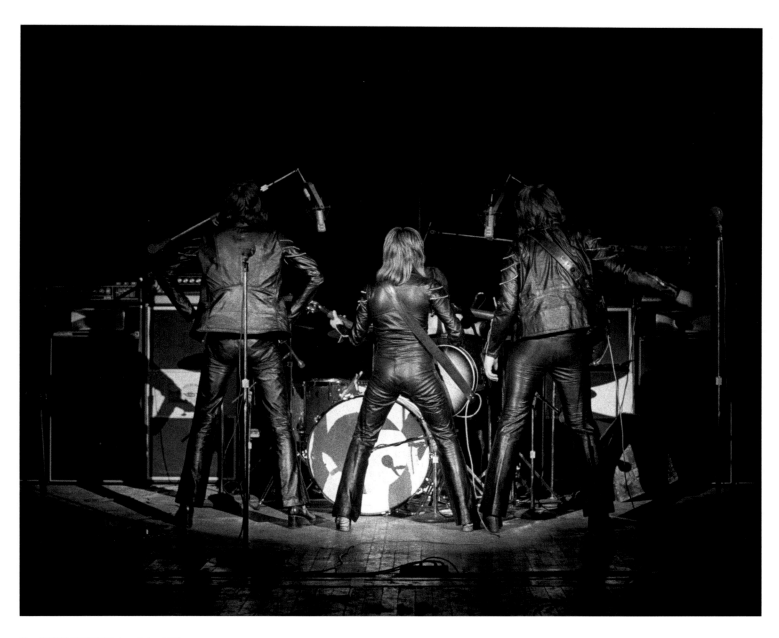

The **SUZI QUATRO** band in 1974.
All leathered up!
Photograph by Bob Gruen.

OPPOSITE

Leather, studs, sex—**PATTI SMITH**,
sans shirt, knew how to pose in this
vintage motorcycle jacket.
Photograph by Lynn Goldsmith.

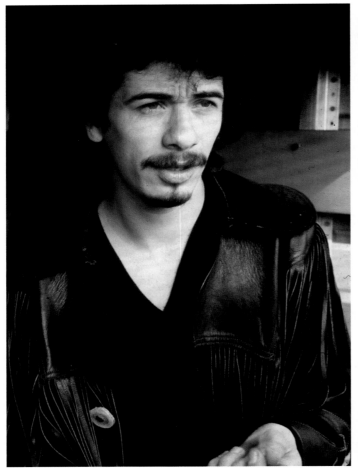

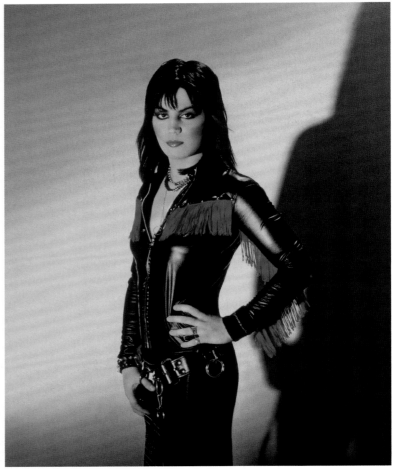

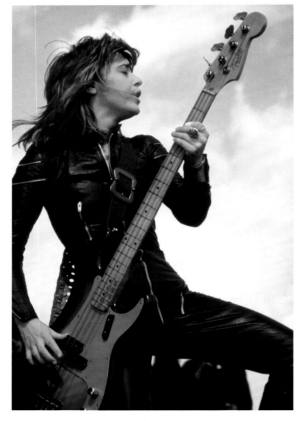

CARLOS SANTANA in a fringed jacket—a style that didn't last, but one that is very much a part of rock history.
Photograph by Robert Altman.

JOAN JETT and leather go together—and you can see the Suzi Quatro influence. Joan's punky belt and bracelet work well with the skintight black jumpsuit—and I love the red fringe.
Photograph by Robert Kiss/Robert Matheu Collection.

SUZI QUATRO in her signature leather jumpsuit in 1974. She inspired so many with this look, including Joan Jett, and even got the name "Leather Tuscadero" for her tough-girl character when she starred on the TV show, *Happy Days*, in the 1970s.
Photograph by Bob Gruen.

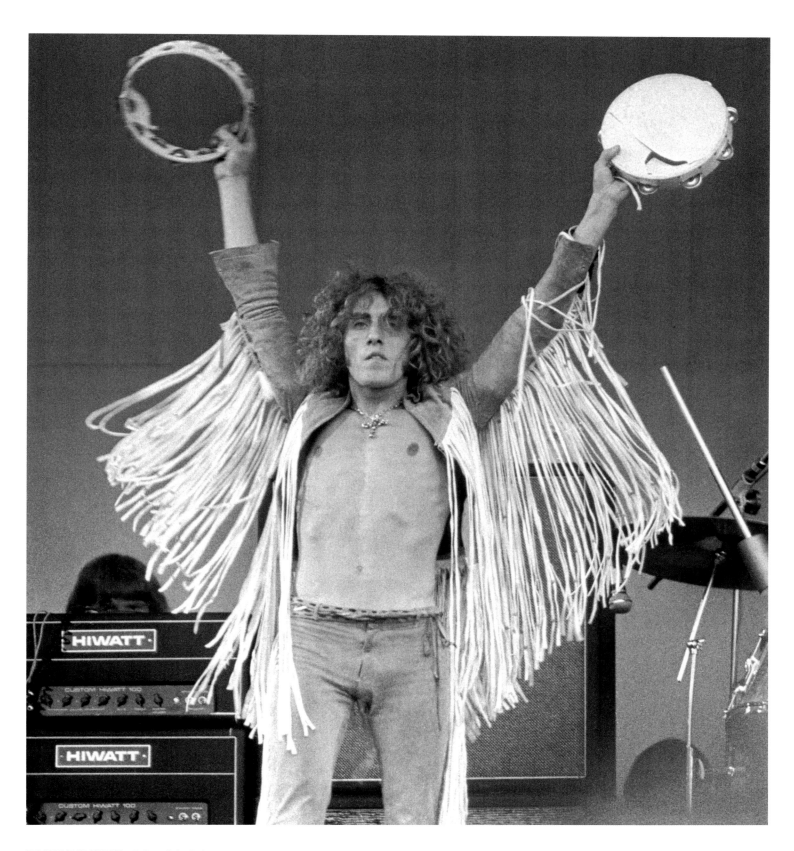

ROGER DALTREY's fringed jacket
blew my mind when I saw the Who
onstage at Cobo Hall in Detroit
in the early 1970s.
Photograph by Barrie Wentzell.

PAGES 212–213
Detroit pop rockers **THE ROMANTICS** occasionally wore black leather, but preferred candy-colored hues, including purple, pink, and—as seen here in 1980— fire-engine red. Not many bands could pull off red leather suits, but somehow it works for the group whose first big hit was "What I Like About You." *Photograph by Robert Matheu.*

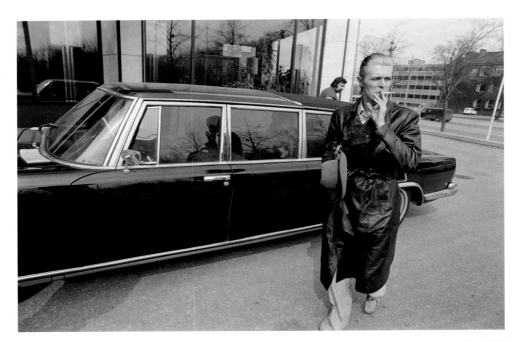

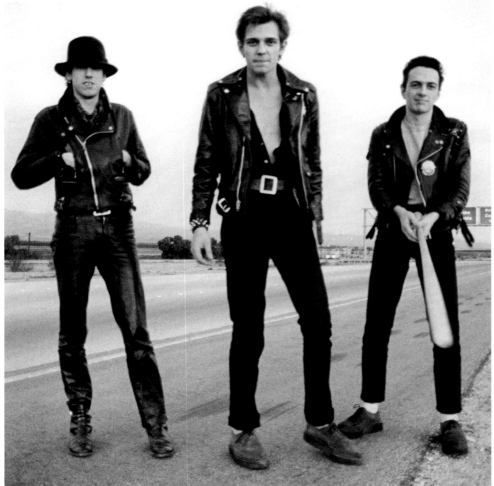

TOP

BOWIE embracing the leather trench in eastern Europe. *Photograph by Andrew Kent.*

BOTTOM

Does it get any tougher and more rock & roll than this? Members of **THE CLASH** were in the audience when the Ramones played London in 1976 and became enamored of the New York punk pioneers' signature black leather motorcycle jackets. *Photograph by Bob Gruen.*

OPPOSITE

Most of the **SEX PISTOLS**' clothes were designed by Vivienne Westwood, including this black leather vest held together with chain links. Note the distressed leather pants and chain belt with dog tag and key. *Photograph by Richard Creamer/ Robert Matheu Collection.*

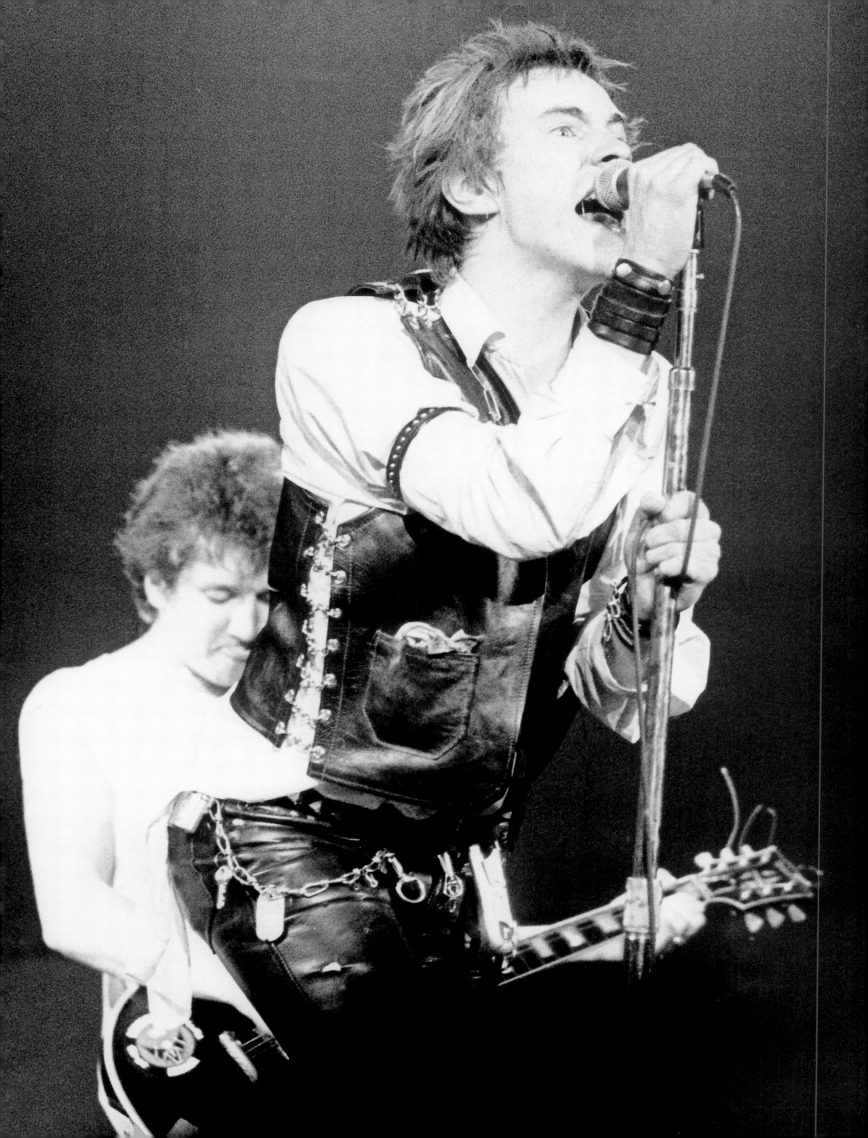

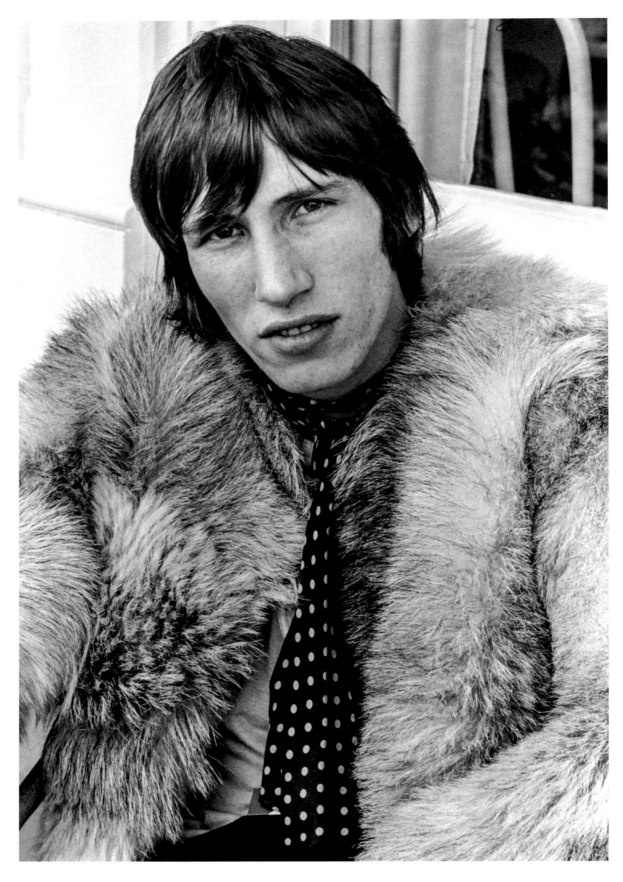

Pink Floyd's **ROGER WATERS** making
an outlandish statement in fur.
Photograph by Baron Wolman.

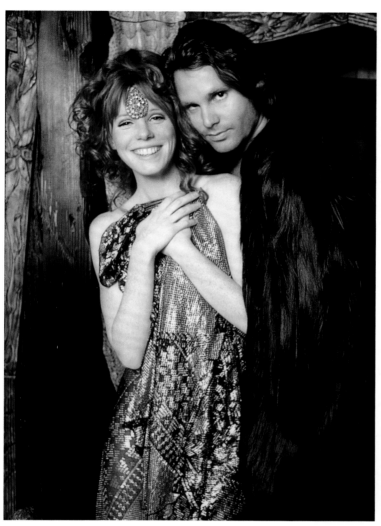

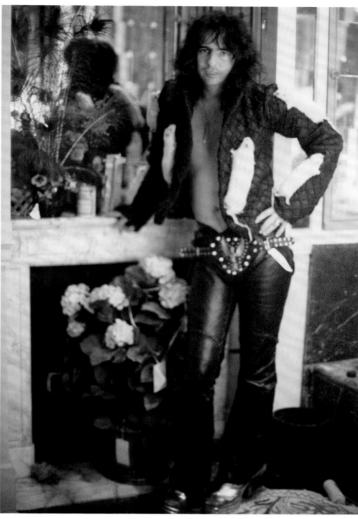

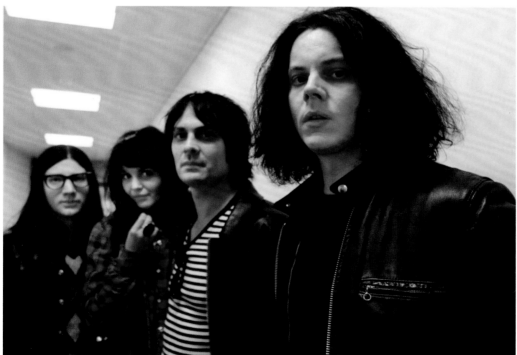

JIM MORRISON and girlfriend Pamela Courson in fur and exotic print—so rock & roll. The metallic fabric and monkey-fur cape were available at Pamela's Los Angeles boutique, Themis, where this photo was taken. *Photograph by Raeanne Rubenstein.*

ALICE COOPER, in 1973, taking leather to another level, adding stuffed rats to his ensemble. *Photograph by Bob Gruen.*

JACK WHITE, hanging with one of his bands, the Dead Weather, wears a Detroit-style leather racing jacket. *Photograph by Andy Willsher.*

JOEY RAMONE in a Schott jacket.
Motorcycle jackets are all about the
fit and zippers.
Photograph by Deborah Feingold.

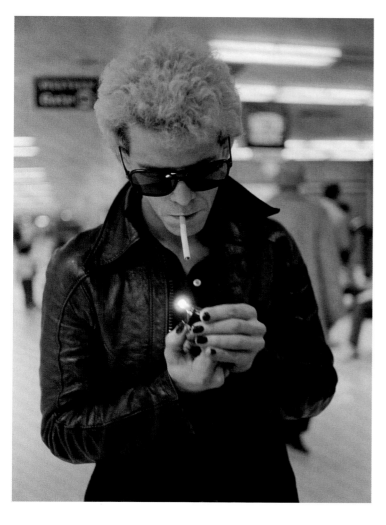

LEFT

LOU REED in his blond stage.
His platinum hair stood in perfect
contrast to his Ray-Bans and
menacing black leather jacket
with oversized collar.
Photograph by Michael Zagaris.

BELOW

RON ASHETON, the ultimate Stooge,
wearing a black leather racing jacket,
a look that inspired me, Jack White,
and so many others.
Photograph by Mick Rock.

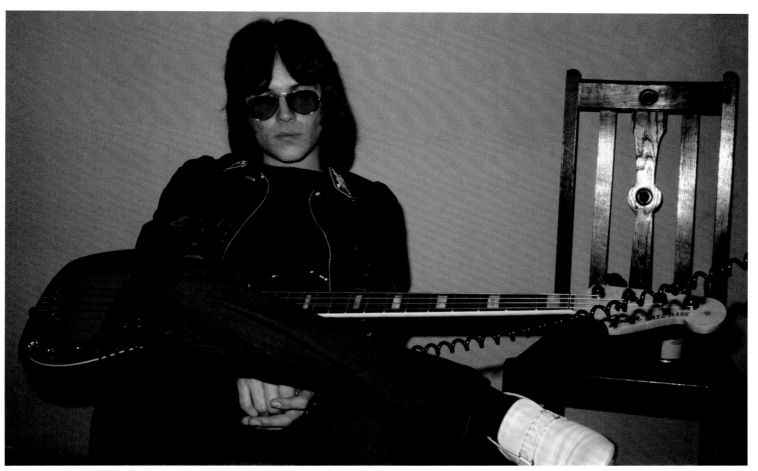

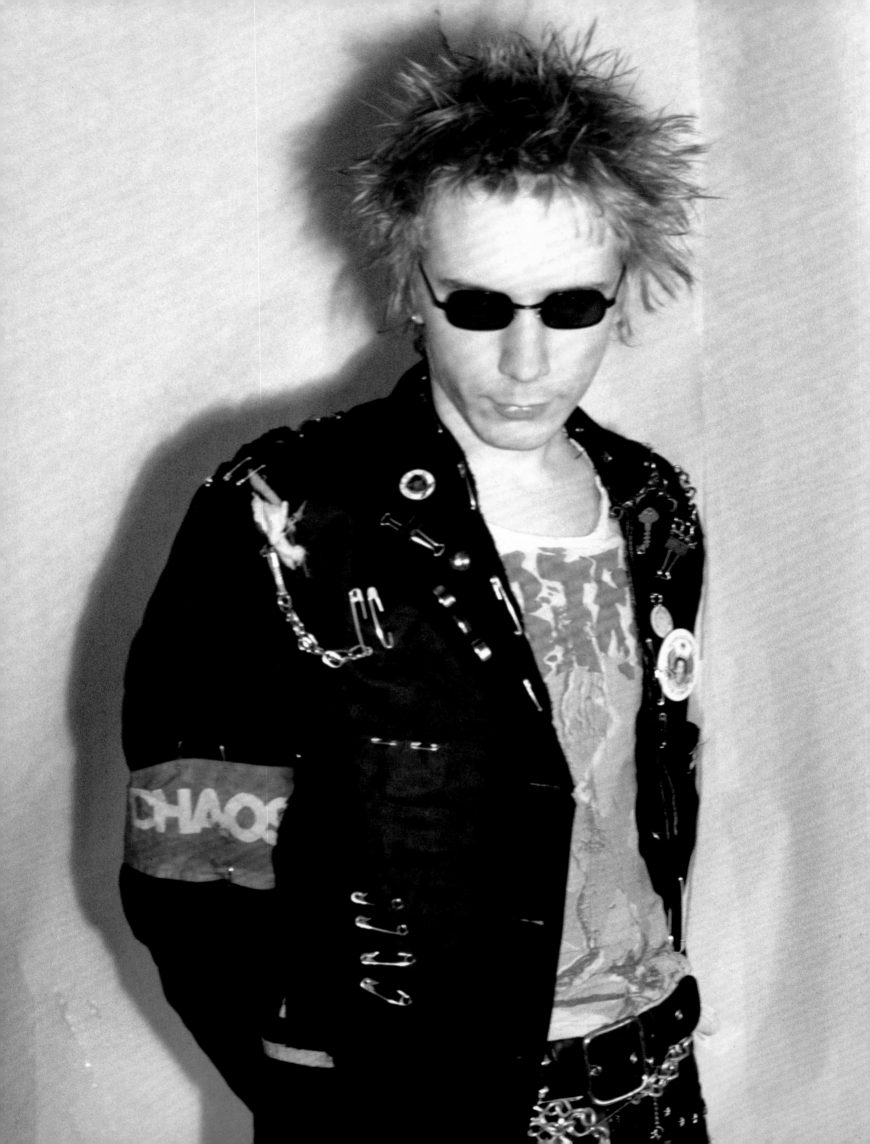

I AM AN ANARCHIST!

CHAPTER 14: PUNK

Along with a refreshing, stripped-down, aggressive musical sound in the 1970s came a new rock & roll style: punk. Punk fashion was not antistyle, though; it was just as much a put-together look as glam. The New York Dolls, in fact, had an impact on what would become the music and style of punk. The Dolls' version of glam—an in-your-face, aggressive attitude—was torn and frayed. And that attitude defined punk.

Bands that played at CBGB and Max's Kansas City in New York City concocted an edgy style that came to define each group: the black leather motorcycle jackets, jeans, and T-shirts of the Ramones; Blondie's retro skinny suits and Debbie Harry's miniskirts; Television's thrift shop sweaters and shirts; Richard Hell's ripped T-shirts with messages marked in Sharpie. In 2008, my company opened a shop in the defunct CBGB on the Bowery, where we feature live performances that have included former members of the New York Dolls, Guns N' Roses, the Jam, and D Generation. It's a great feeling to help keep the punk spirit alive.

In London, the punk scene revolved around the boutique run by designer Vivienne Westwood and her then-husband and pop provocateur, Malcolm McLaren. The couple's rock & roll style evolved over several years. They first opened a boutique, Let It Rock, on King's Road in 1971. Early on, Malcolm urged Vivienne to design suits influenced by the Edwardian-cut draped jackets and drainpipe trousers worn by Teddy boys in the late 1950s and early 1960s. Then, in 1972, Westwood and McLaren changed the name of their shop to Too Fast to Live, Too Young to Die, inspired by James Dean and Marlon Brando in *The Wild One*. They sold customized leather jackets with lots of zippers and secondhand denim jeans. By then, Vivienne had chopped off her hair, spiked it out, and dyed it platinum blonde. The pair traveled to New York City, hung out at Max's and CBGB, where they were floored by the punk style pioneered by Richard Hell and the New York Dolls.

Upon returning to England, Vivienne created a line of ripped and cut-up T-shirts with subversive slogans emblazoned

"The King's Road shop Vivienne ran with Malcolm was unlike anything else going on in England at the time. It was a morass of beige...and their shop was an oasis. If you were 14 in 1974, it took great liberalism and bravery to wear rubber in the street."

—Marco Pirroni, Adam and the Ants, from *The Look*, 2001

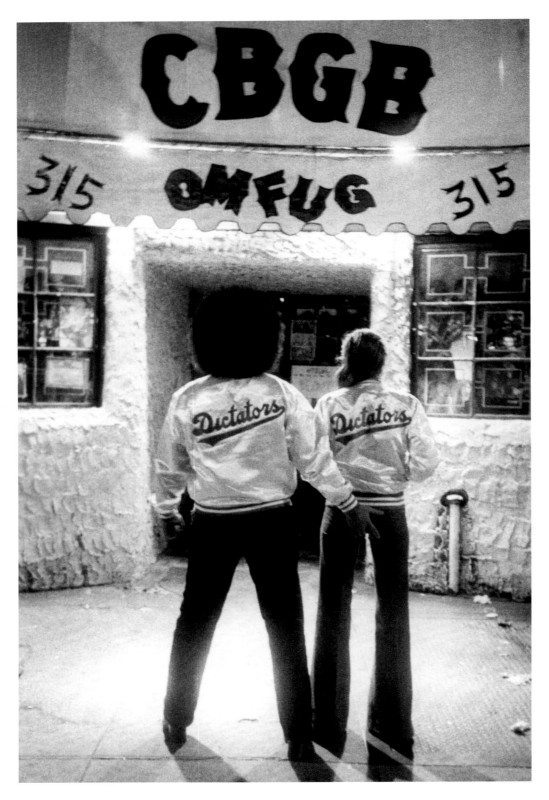

across the front. S&M style, with its rubber, leather, and bondage straps, also became part of Vivienne's designs, and the couple changed the name of the shop to Sex—spelled out in large hot pink letters across the storefront. They sold rubber clothing, bondage trousers, leather miniskirts, stilettoes, and fishnet stockings. Kids who worked there were decked out in the fetish-style clothes, and among them was fledgling bassist/songwriter Glen Matlock. By the time the shop's name changed

again to Seditionaries in 1977, the Sex Pistols—managed by McLaren and featuring Matlock and other shop regulars Johnny Rotten, Paul Cook, Steve Jones, and later, replacing Matlock, Sid Vicious—had been born.

The extreme punk style from London never went mainstream in the United States. But the various elements—the leather clothes, graphic and distressed T-shirts, and chopped, spiky hair—have continued to influence rock style.

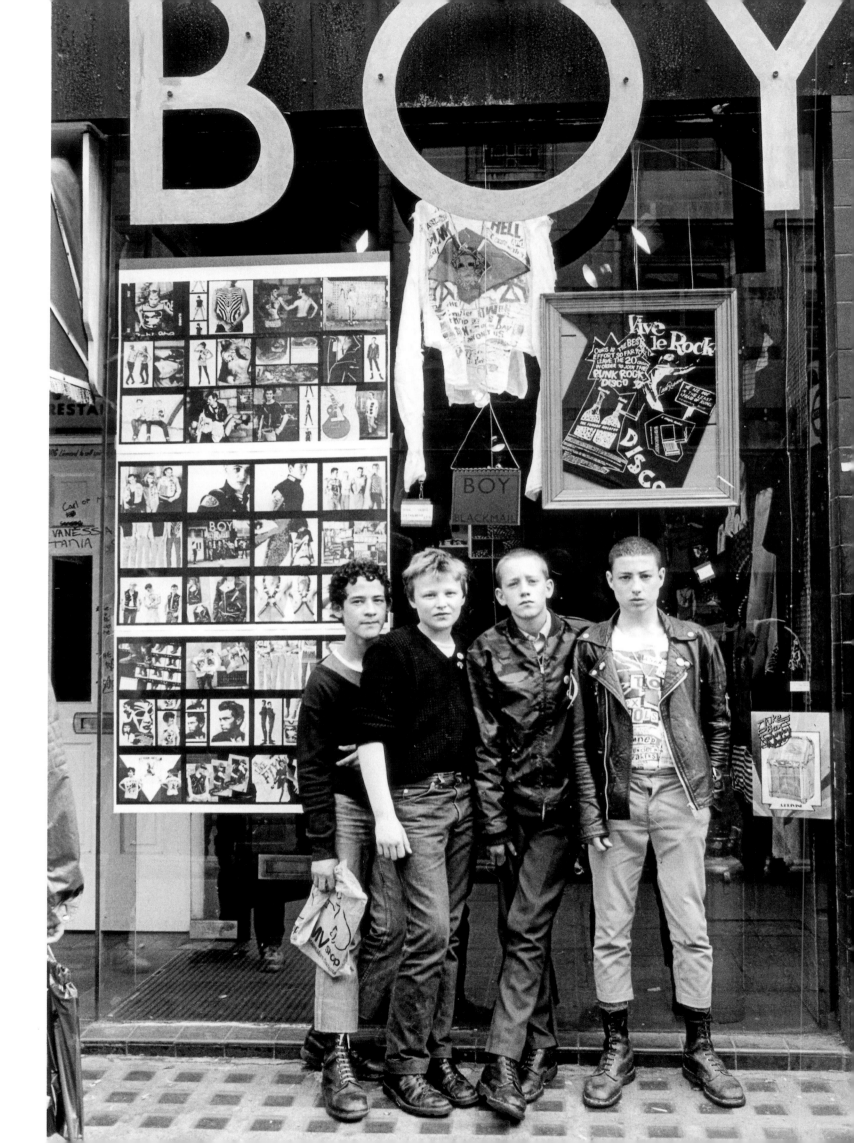

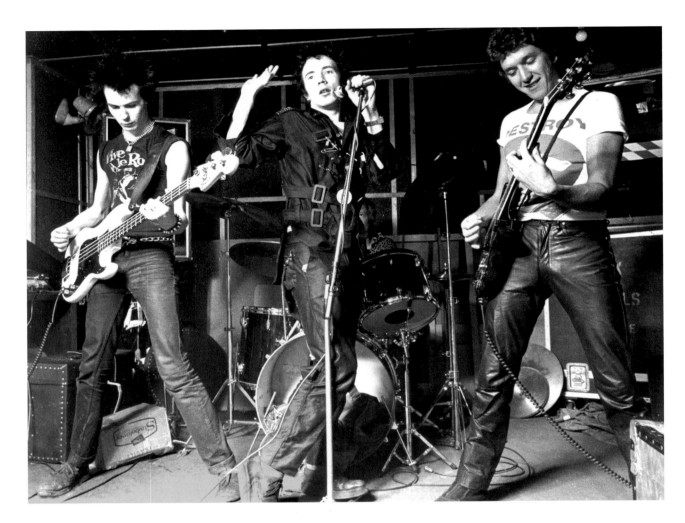

"It was an intense time and there was a lot of violence directed at punks. Vivienne and Malcolm McLaren's shop was one of the few places you could hang around without feeling uncomfortable. The band was formed there from people who used to come in or work there at the weekends. We were never told what to wear, but had free rein in the shop, particularly when it was renamed Seditionaries and we could wear the bondage trousers and the clothes with straps and zips."

—Paul Cook, Sex Pistols, from *Vivienne Westwood*, 2004

THE SEX PISTOLS, with Johnny Rotten (center) in a Vivienne Westwood bondage jacket, and Sid Vicious (left) and Steve Jones dressed down in graphic T's. This was one of Sid's first gigs with the band after replacing Glen Matlock.
Photograph by Janette Beckman.

CLOCKWISE FROM TOP RIGHT

IGGY in his leather and animal print "street-walking cheetah" jacket. *Photograph by Mick Rock.*

SID VICIOUS—power to the Pistols! Sid was the ultimate punk cover boy with his spiked hair, lock-and-chain necklace, and beat-up leather jacket. *Photograph by Lynn Goldsmith.*

BILLIE JOE ARMSTRONG carrying the punk flag into the twenty-first century. *Photograph by Bob Gruen.*

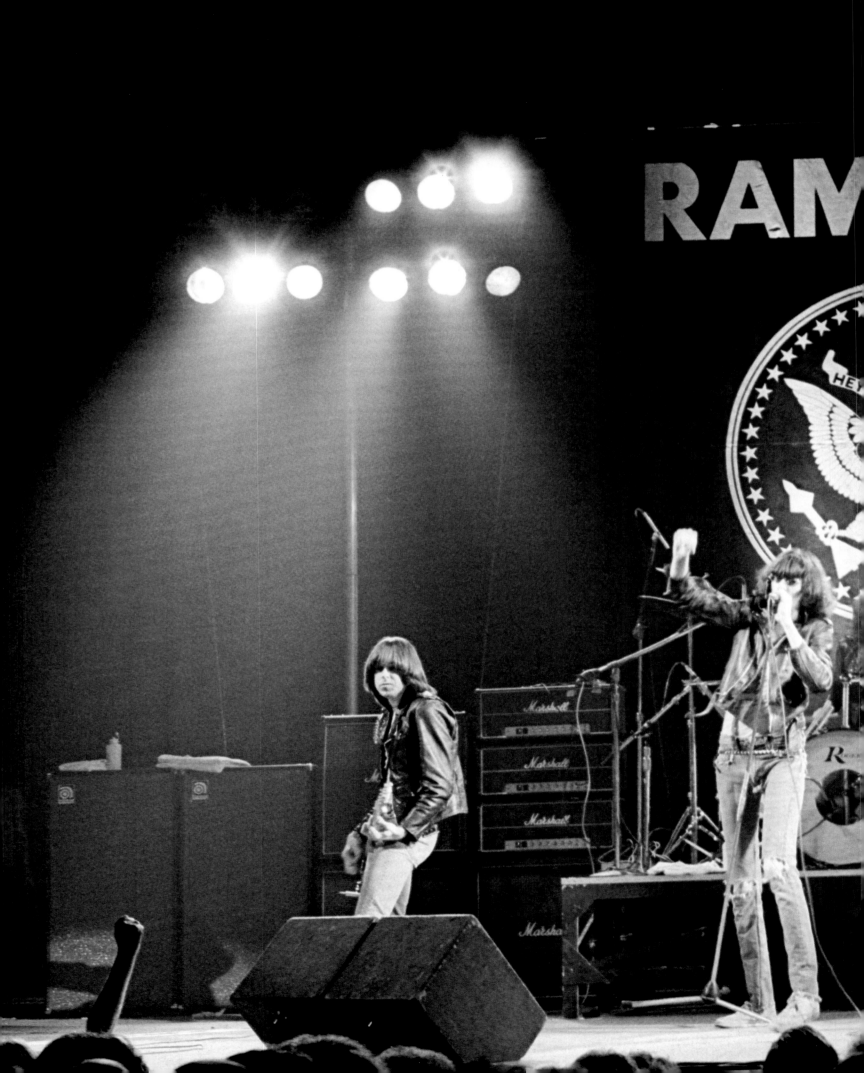

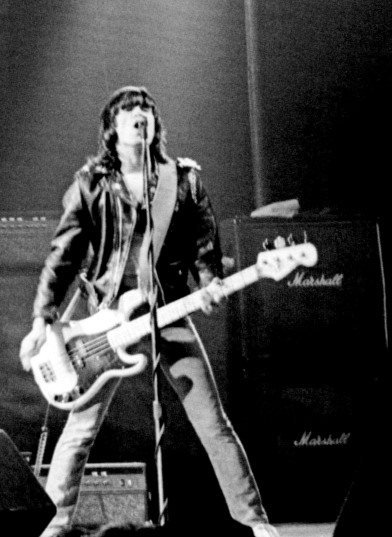

PAGES 228-229

THE RAMONES used to refer to their blue jeans, motorcycle jackets, and sneakers as their "uniform." Their look will forever be the symbol of punk to the world. It continues and transcends generations.
Photograph by Lynn Goldsmith.

RICHARD HELL and **ELVIS COSTELLO**— two punk troubadours hangin'. Though looking natty here, Richard Hell originated the torn T-shirt, most famously the one that said, PLEASE KILL ME, written in Sharpie. Hell and Costello are both stylin' in their Ray-Bans.
Photograph by Roberta Bayley.

The "summit" of the icons of punk:
TOMMY RAMONE, **JOHNNY RAMONE**,
FRED "SONIC" SMITH, **RON ASHETON**,
and **MICHAEL DAVIS** hanging out at a
Detroit club. Their black leather jackets
and—most of all—attitude would influence
future generations of punk rockers.
Photograph by Robert Matheu.

GYPSIES, DIVAS, AND TOMBOYS.

CHAPTER 15: ROCK & ROLL WOMEN

Until recent years, rock & roll was a real boys' club. There were a few women who rocked in the 1950s, like Wanda Jackson, Etta James, and LaVern Baker. In the early 1960s, girl groups like the Ronettes and the Shangri-Las definitely had a unique look and sound. But there were only a few who rocked with a kind of masculine swagger in those days.

Tina Turner, who started her career in the 1960s singing with her husband, Ike, really wrote the book on rock & roll. A ball of energy onstage, she danced and belted out her soulful vocals while dressed to kill. Her stage clothes, her hair, and her makeup were all about the attitude. She owned it. For me, she is one of the hottest women ever in music. Mick Jagger has pointed to Tina as a big influence on his performance style.

Janis Joplin created her own unique look in the 1960s. She was a wild child and onstage projected a blend of vulnerable blues mama and a macho, take-no-prisoners approach. Her unique look mixed exotic gypsy style with a touch of Mae West

via her boas and slinky silk tops. Grace Slick, in Jefferson Airplane, adopted a kind of hippie chic. The white leather outfit she wore at Woodstock made quite an impact on those who could see her onstage—but even more so on the millions who watched the Woodstock movie.

In the 1970s, Janis's gypsy style was carried on to an extent by Stevie Nicks and Heart. Nicks's leather and lace outfits were inspired by glam, too, as was her signature look—chiffon cape, top hat, and platform boots. Seattle's Wilson sisters, Ann and Nancy, charged onto the charts with the hard-rock band Heart; their look borrowed from the gypsy style of Janis and incorporated a bit of Middle-Earth fantasy. In the 1970s, Ann and Nancy sewed many of their stage clothes.

One of the first rockin' all-girl groups to emerge from Detroit in the 1960s was the Pleasure Seekers, comprised of the Quatro sisters, Suzi, Patti, Mary Lou, Arlene, and Nancy. They formed a band after Patti saw the Beatles play at Detroit's

"[In the 1960s] I had a few looks, such as a striped boatneck shirt and a red throat scarf like Yves Montand in *Wages of Fear*, a Left Bank beat look with green tights and red ballet slippers, or my take on Audrey Hepburn in *Funny Face*, with her long black sweater, black tights, white socks, and black Capezios."

—Patti Smith, from *Just Kids*, 2010

OPPOSITE

PATTI SMITH incorporated a bit of masculinity into her look, yet at the same time had a provocative sexuality. This is one of my favorite shots of her. Note the Fred "Sonic" Smith button on her lapel. She and the former MC5 guitarist married in 1980. *Photograph by Kate Simon.*

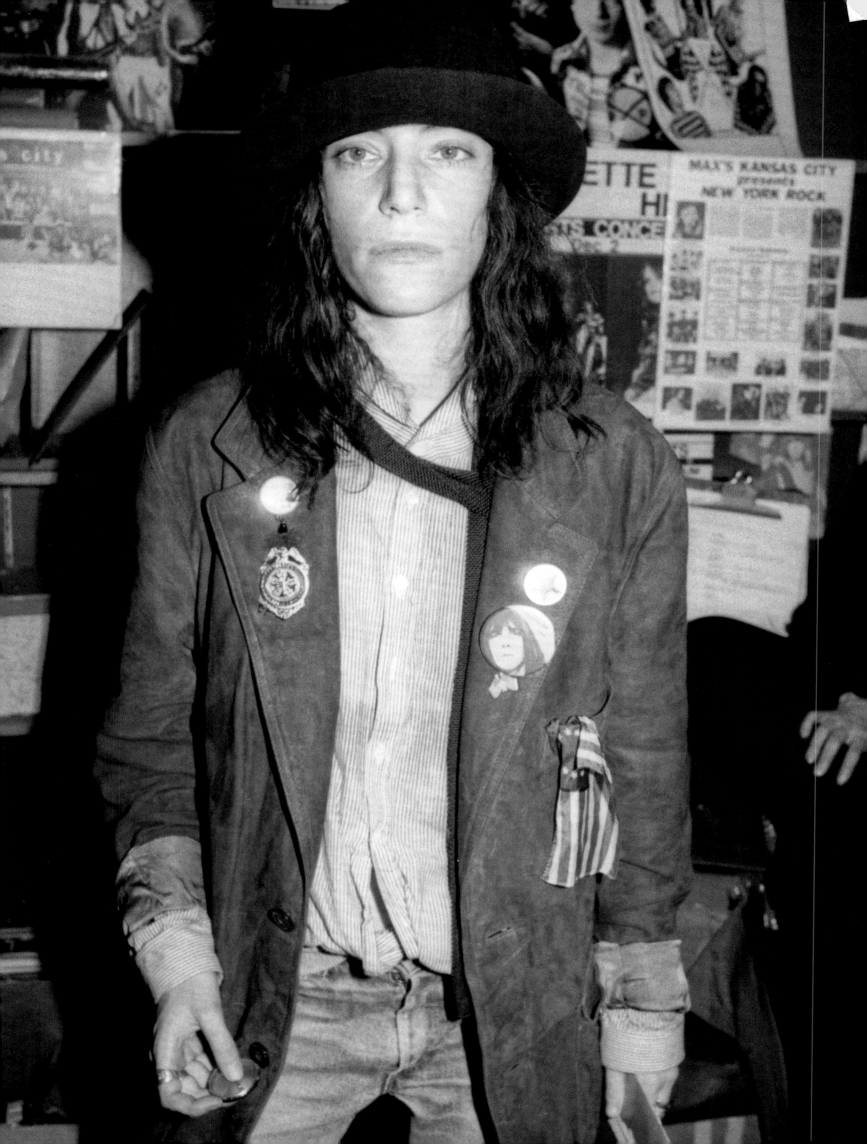

OPPOSITE
NANCY WILSON of Heart wearing a shearling-trimmed coat—an all-time great rock star look. *Photograph by Bob Gruen.*

Olympia Stadium in 1964. Their dad, who manned the organ for hockey games at the Olympia, taught them to play instruments, and they rocked out in garage-band style with electric guitars, drums, and keyboards. "We were quite trendy in our dress," Patti Quatro said of the band. "In the beginning we dressed simple—Levi's, striped T-shirts, English-style blazers. [Then] we...had many costume changes that were a bit risqué at times and inventive at others. We always dressed different than expected." By the late 1960s, they segued into a new group called Cradle that played on bills with MC5. Then Suzi moved to England, where she became a star renowned for her skintight leather jumpsuits.

In the mid to late 1970s, Quatro fan Joan Jett played guitar in the all-girl band the Runaways. They really rocked, with Joan providing a hint of menace, and the group scored a hit with "Cherry Bomb." They had shag haircuts, and they, too, wore leather along with T-shirts and skintight flare-leg jeans, sometimes with a touch of glam.

Meanwhile, in New York, Patti Smith made a big impact on style with her androgynous chic: the cover portrait shot by Robert Mapplethorpe for her 1975 debut, *Horses*, depicted her in a man's white button-down shirt and a loosened skinny tie, worn with black jeans and a black suit coat slung over her shoulder, à la Frank Sinatra in his Rat Pack days. She had a Keith Richards haircut and often performed in T's and men's jackets.

Debbie Harry came out of the same Max's Kansas City and CBGB scene as Patti Smith. Debbie had a kind of 1950s pinup-girl-gone-bad look that combined thrift shop pieces with spandex fabrics and graphic prints. Stephen Sprouse made some of her outfits in the early 1980s.

Debbie Harry definitely had an influence on Madonna, who landed in New York in the 1980s after leaving Detroit. More of a chameleon than David Bowie—one of her influences—Madonna changes her look each time she releases an album or starts a tour. Her style child Lady Gaga continues to push boundaries—every time she walks out the door.

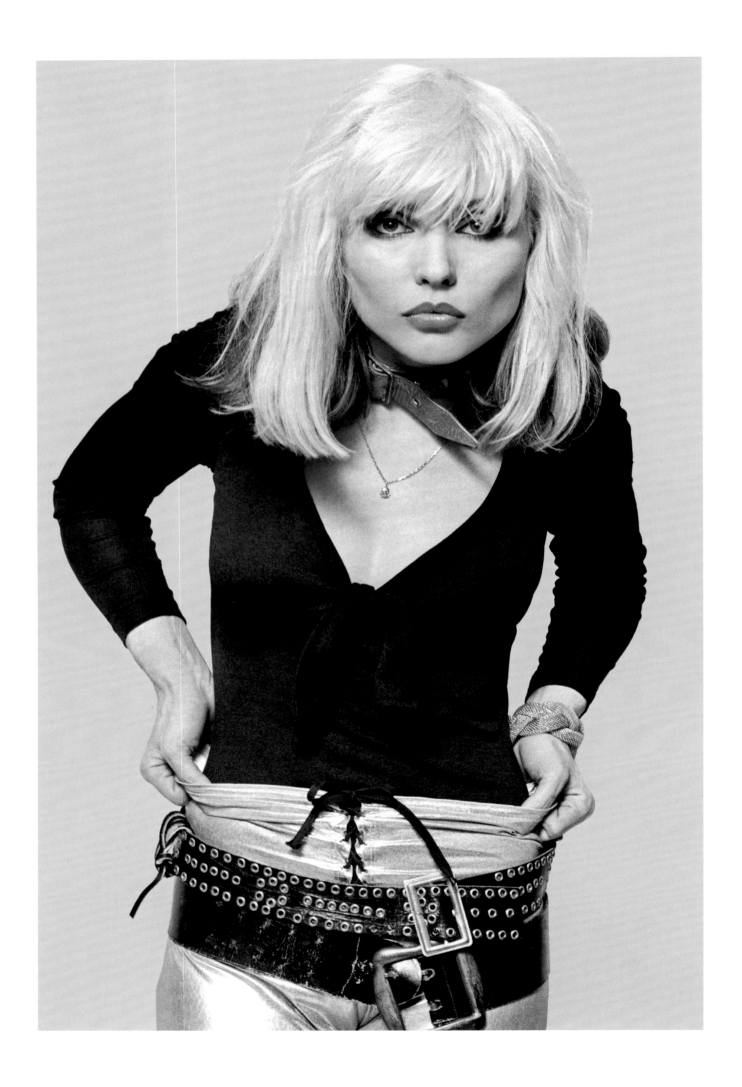

TOP

DEBBIE HARRY, pretty in pink.
Photograph by Bob Gruen.

BOTTOM

When Bob Gruen and **DEBBIE** happened
by a wrecked car on the streets of New
York in 1976, he captured the moment
with this provocative shot. Note the
cowboy boots and long skirt, with the
leather vest adding a twist—a different
look for her.
Photograph by Bob Gruen.

OPPOSITE

DEBBIE had it all going on. She could
wear anything and make it look amazing.
She was brilliant at putting outfits
together and working different versions
of her image.
Photograph by Lynn Goldsmith.

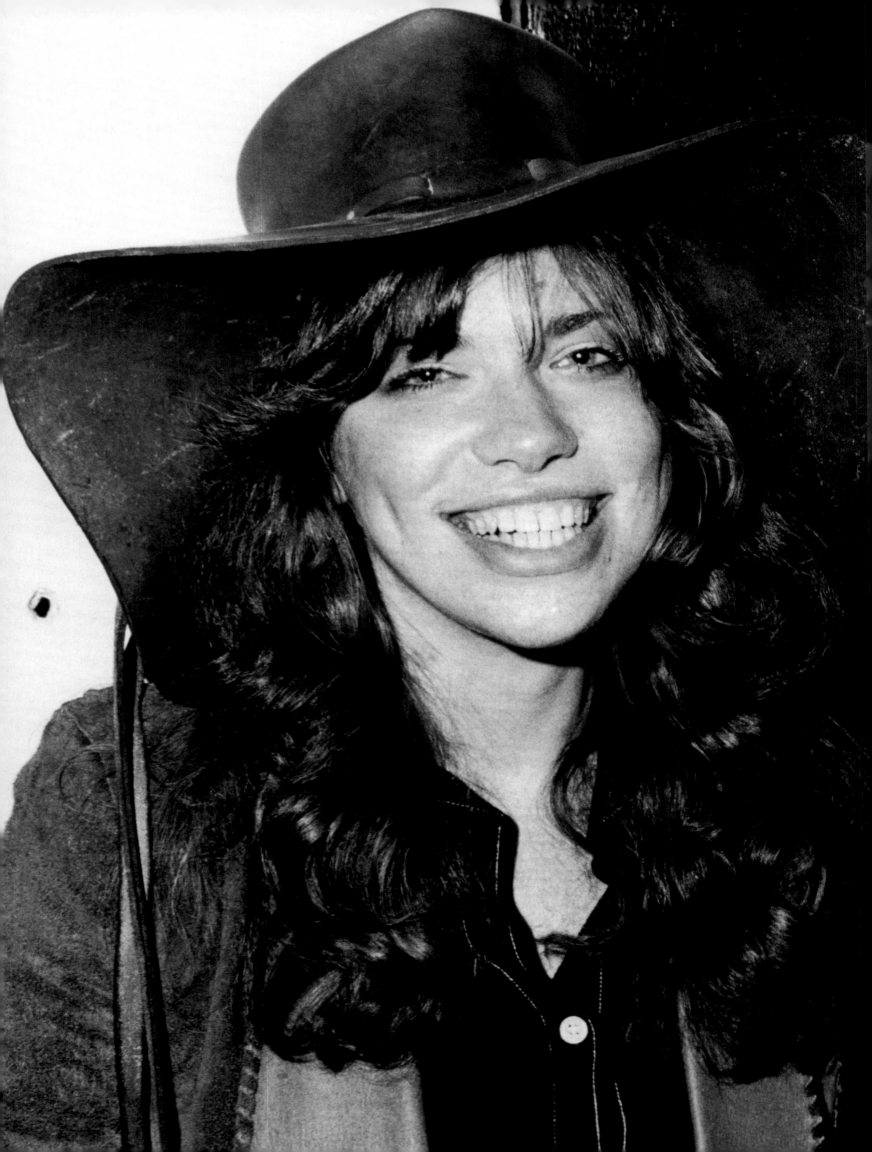

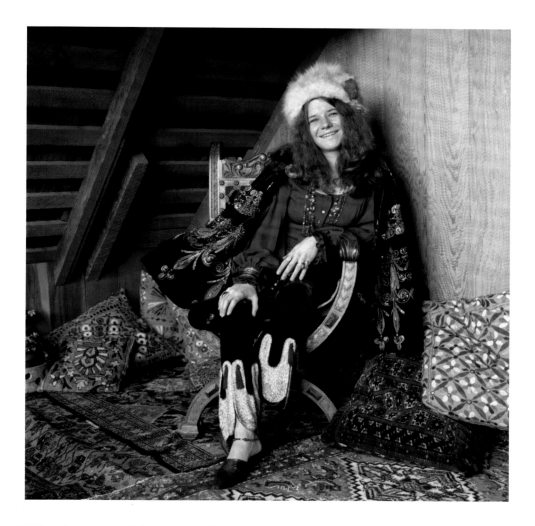

"She invented her own beauty,
just as she invented her
wonderful sleazofreak costumes."

—Ellen Willis, cultural critic,
 on Janis Joplin, from *Out of the
 Vinyl Deeps*, 2011

JANIS JOPLIN had a blues soul. Her
style was about making a statement—it
was an eclectic mix of furs and flowers,
beads and jewels, velvets and metallics.
She redefined the look of the "girl
singer" with her creative mix of exotica
and vintage, and of course a touch of
the blues mama.
Photograph by Baron Wolman.

OPPOSITE

When I think of floppy hats, I think
of this 1971 picture of **CARLY SIMON**.
Photograph by Bob Gruen.

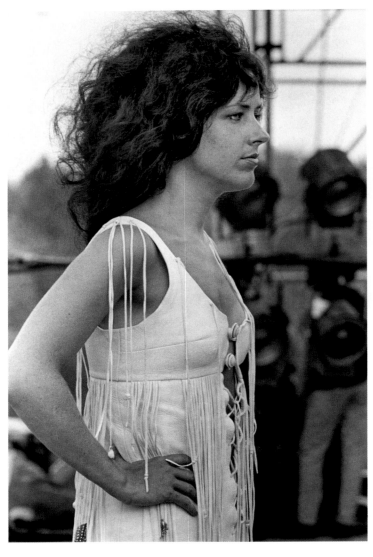

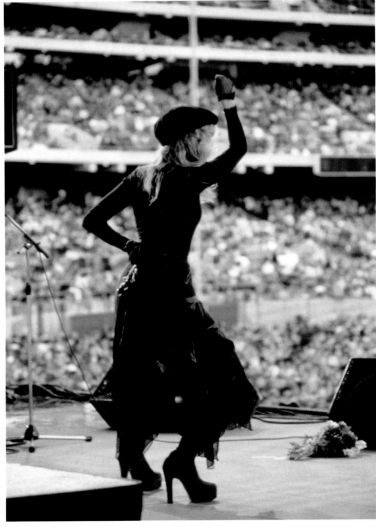

STEVIE NICKS has always intrigued me. Her 1970s style was so unique—like nothing I had ever seen on stage before. The capes, hats, lace, and platform boots were mesmerizing.
Photograph by Baron Wolman.

Jefferson Airplane's **GRACE SLICK** was the ultimate hippie chick, shown here in her amazing leather fringe attire at Woodstock—skin showing skin.
Photograph by Baron Wolman.

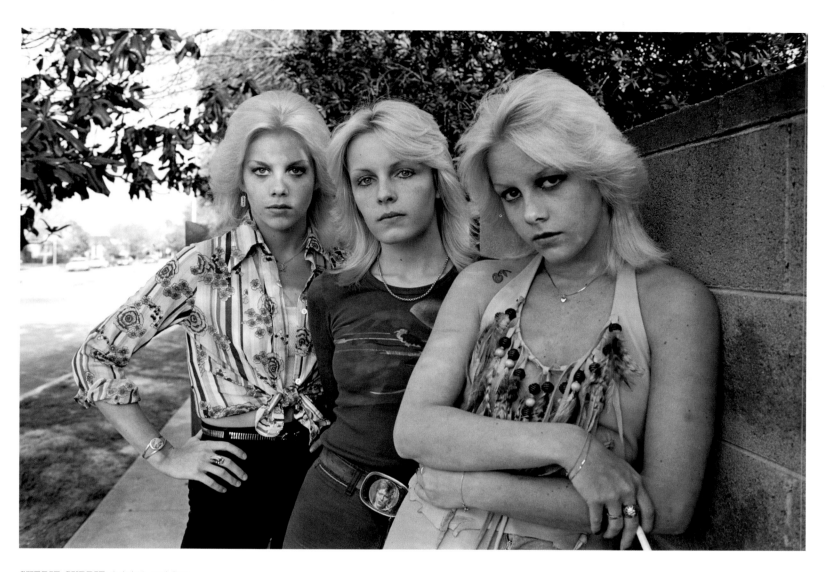

CHERIE CURRIE (right) and her identical twin sister, Marie (left), and Vicki Arnold of Venus and the Razor Blades. I love the hair, tops, and the David Bowie belt buckle. *Photograph by Brad Elterman.*

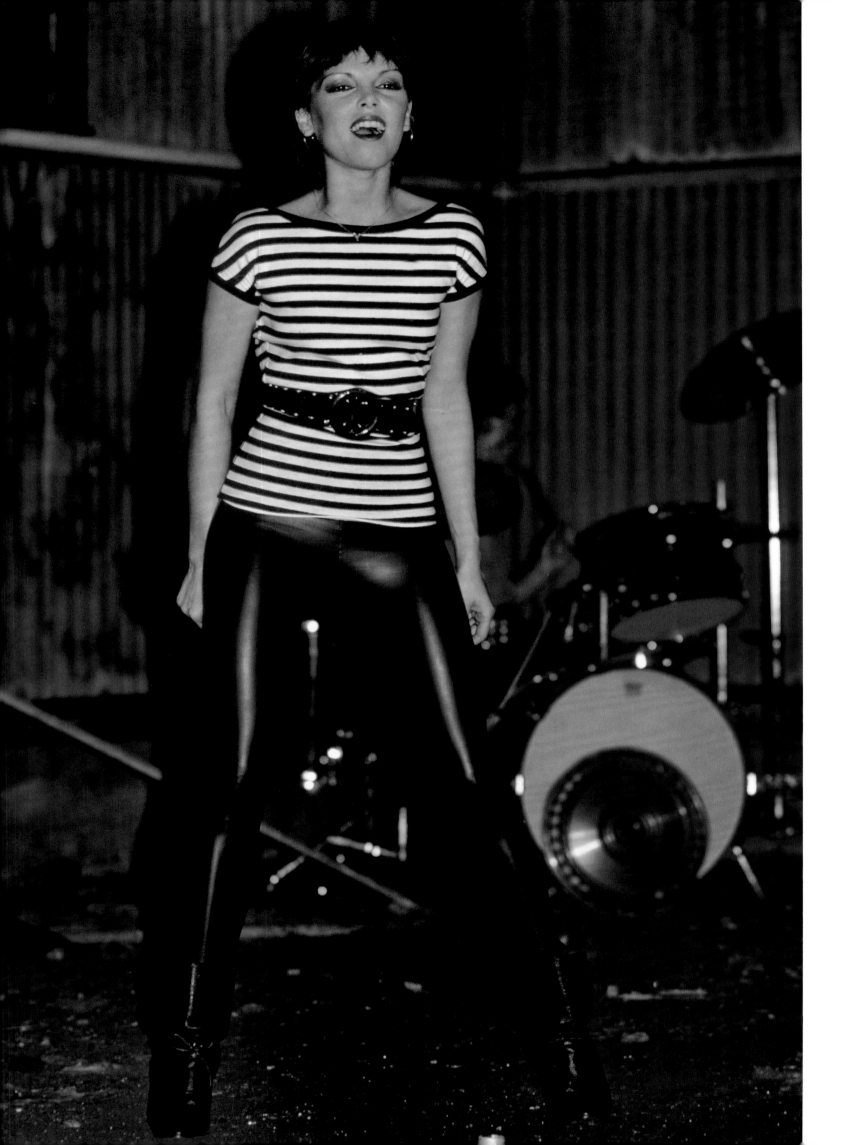

ABOVE
Whether you love her or hate her,
LADY GAGA's style has had a huge
impact on popular culture.
Photograph by Angus Smythe.

OPPOSITE
PAT BENATAR ushered in a new era
of girl rockers. Her signature spandex
pants and pixie haircut made her
an MTV star.
Photograph by Lynn Goldsmith.

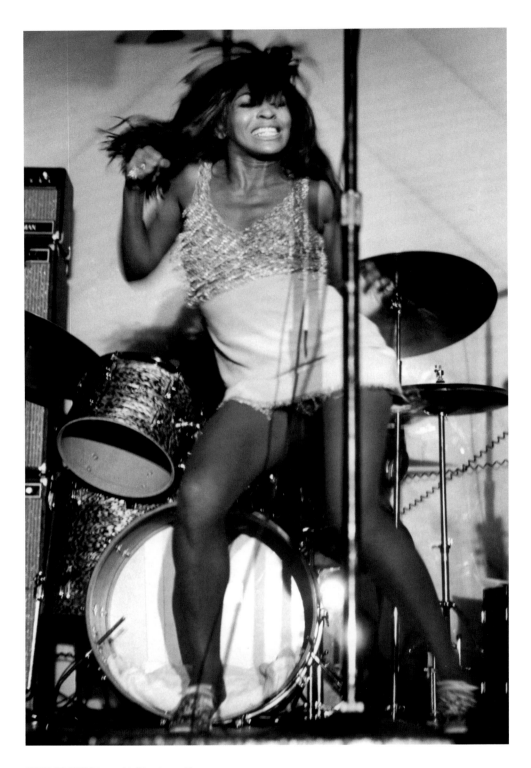

TINA TURNER capitalized on those
famous gams in all her stage wear—the
shorter the skirt, the better. Also
accentuating her nonstop moves, fringe
and sequins added pizzazz.
Photograph by Bob Gruen.

OPPOSITE

This picture says it all. Powerful! Sexy!
Hot! **TINA**'s my favorite female rocker.
Photograph by Lynn Goldsmith.

WEARING THE MESSAGE.

CHAPTER 17: THE T-SHIRT

Signs of fandom. Making a statement. Found objects. In rock & roll, T-shirts do all these things and more. As a teenage rock fan, I started picking up T-shirts at concerts in the early 1970s: packed away somewhere are my T's commemorating a run of Detroit and Ann Arbor shows—Pink Floyd, Black Sabbath, Wishbone Ash, Edgar Winter's White Trash. You get the picture, and so did my friends when I showed up at school proudly wearing proof of what I'd done the weekend before.

It's cool to see musicians wearing T-shirts emblazoned with their heroes. And as you can see from the photos in this chapter, artists can be just as happy to show off their faves as their fans. I still love to wear T's, and have even created a collection of iconic artist T-shirts including the Stooges, MC5, Cheap Trick, Alice Cooper, Jimmy Page, the Ramones, the Yardbirds, ZZ Top, the New York Dolls, and others.

Another element of the graphic T-shirt, of course, is allowing wearers to divulge a hint of their true self: by wearing Marilyn Monroe on his T, for example, Johnny Thunders let us know who his type of gal was, just like Alice Cooper did by wearing a T-shirt with *The Exorcist* movie poster featuring Linda Blair.

Needless to say, a bit of irony can also be conveyed by a T-shirt. In the 1960s and 1970s, people started digging through stacks of discarded T's in thrift shops to see what kind of bizarre promo shirt could be found. Leon Russell did this: he was just as likely to wear a shirt advertising a small-town barbershop as he was the logo for the Fillmore West. Punks, like the Ramones, found some really out-there vintage T's that displayed their sense of humor (and sometimes nostalgia for the 1950s and 1960s). Others like Joan Jett created their own confrontational message boards, like her SEX GODDESS T-shirt. UK punks really delighted in defacing classic rock T's.

Probably the most famous graphic T photograph of all time is the Bob Gruen shot of John Lennon in his New York City shirt. What's really remarkable is that this was a quick, off-the-cuff wardrobe suggestion Bob made to Lennon when he was photographing the former Beatle on top of his building. The shirt was Bob's, and he suggested Lennon throw it on for the photograph. There's something about a T-shirt—its simplicity, its boldness—that made an act like that possible. And now it's an image we'll never forget.

PATTI SMITH wearing a T-shirt
with an image of the man who
inspired her look.
Photograph by Fred Stefanko.

OPPOSITE

IGGY POP, wearing a Jim Morrison
T-shirt, playing with Ray Manzarek
of the Doors.
Photograph by Robert Matheu.

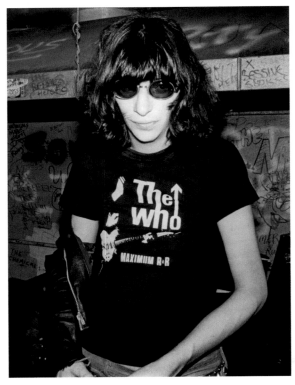

LEFT

JOEY RAMONE wearing one of my favorite rock T's of all time. *Photograph by Bob Gruen.*

BELOW

SCOTT ASHETON, here with his brother, Ron, wearing a Detroit (Mitch Ryder's Band) T-shirt to support his Motor City brothers. *Photograph by Seth Tiven/Robert Matheu Collection.*

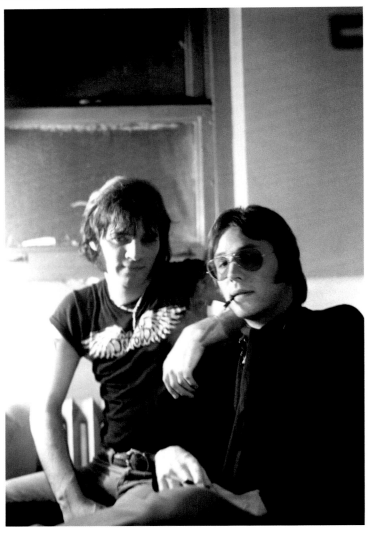

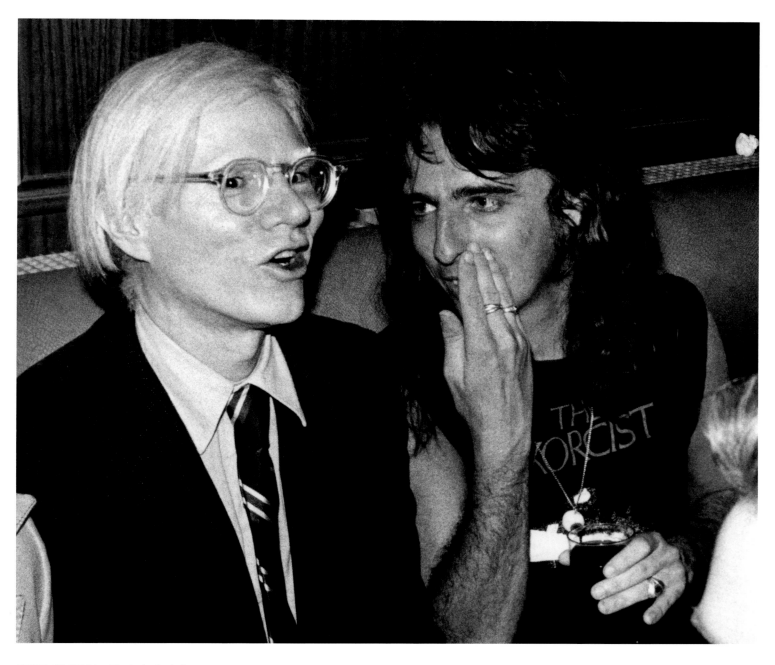

ALICE COOPER with Andy Warhol—
dressed perfectly in a T promoting
The Exorcist.
Photograph by Bob Gruen.

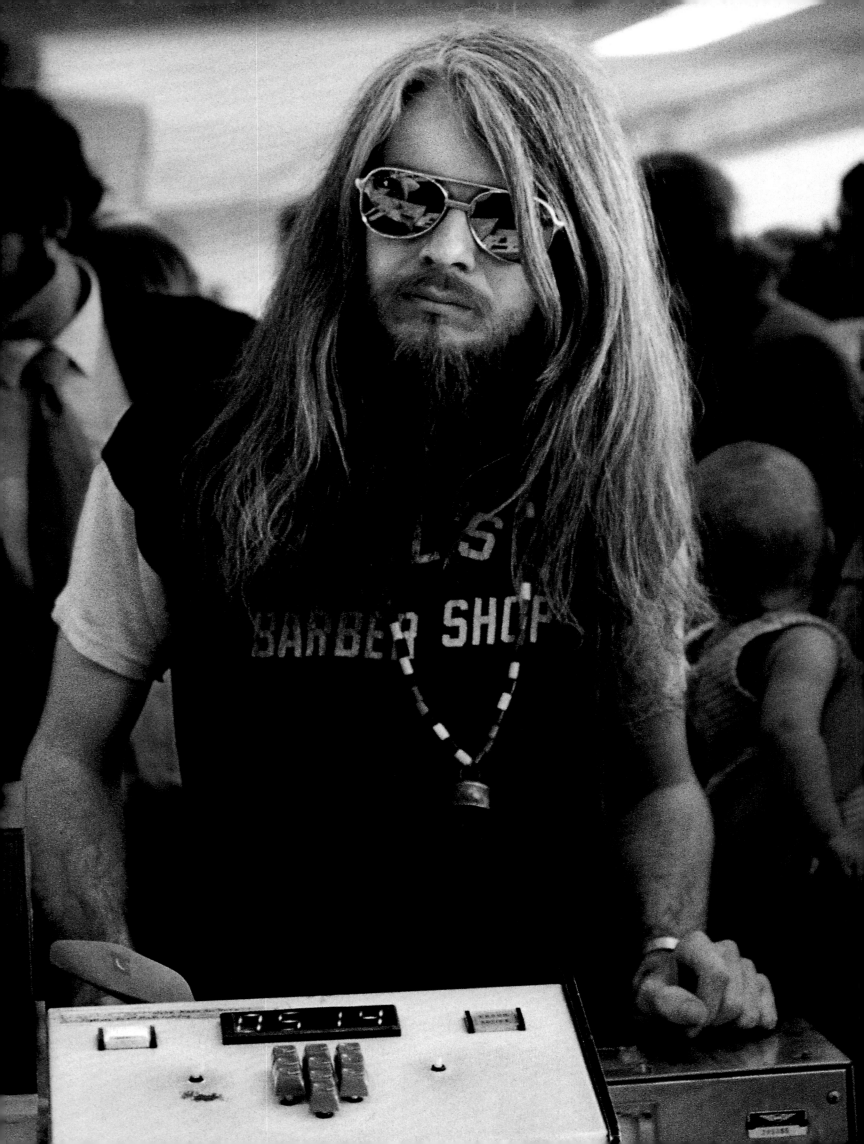

LEON RUSSELL was an early purveyor
of vintage T-shirts.
Photograph by Tom Zimberoff.

The T-shirt reads: PATIENCE PLEASE... A DRUG FREE AMERICA COMES FIRST!

ABOVE

SUZI QUATRO promoting her 1974
Australian tour.
Photograph by Bob Gruen.

RIGHT

JOHNNY THUNDERS loves Marilyn.
Photograph by Bob Gruen.

OPPOSITE

AXL ROSE and his Keith Richards
Drug-Free America T-shirt.
Photograph by Kevin Mazur.

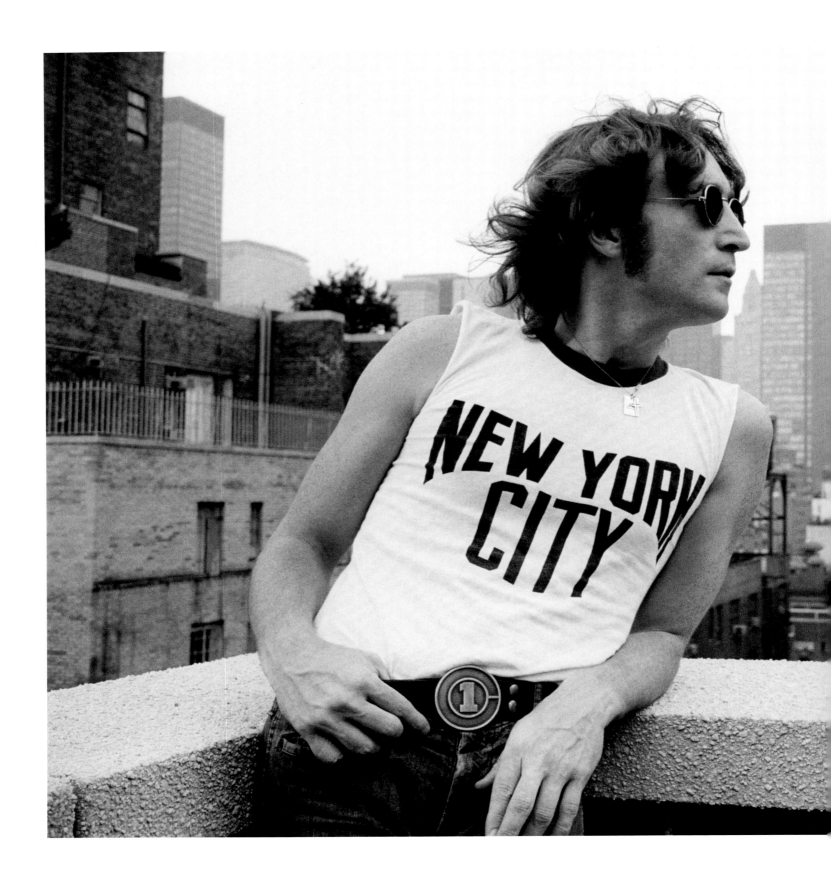

LEFT

JOHN LENNON in Bob Gruen's
New York City T in 1974.
Photograph by Bob Gruen.

BELOW

DAVID JOHANSEN was big on
graphic T's. This one "made the
scene in Greenwich Village."
Photograph by Bob Gruen.

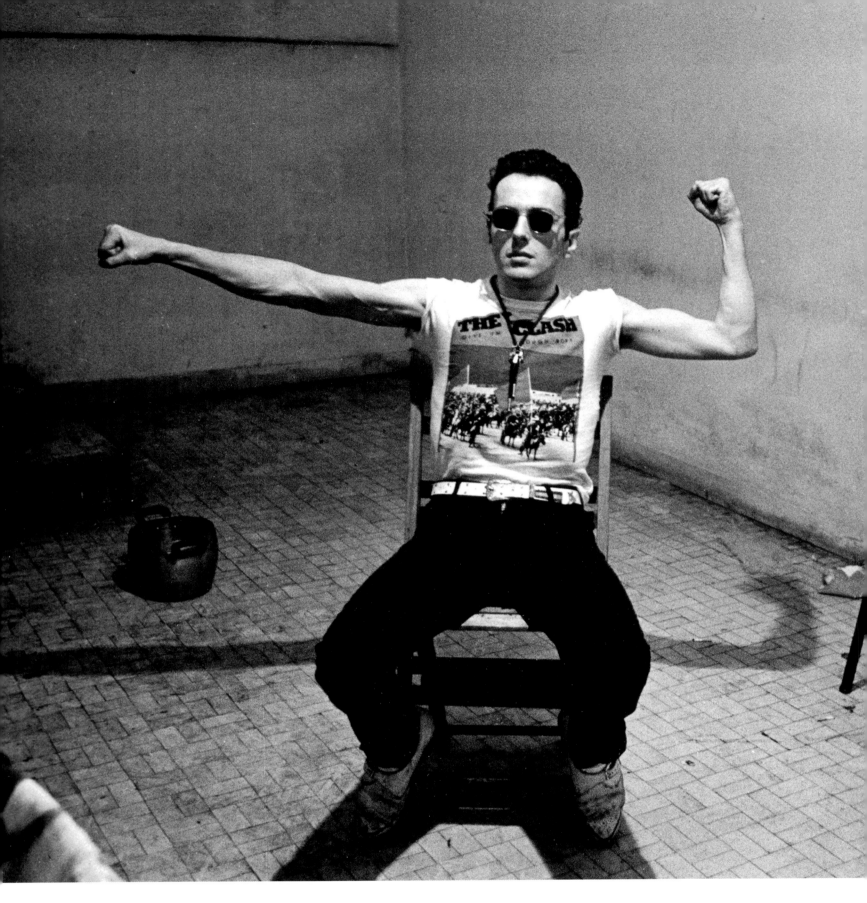

JOE STRUMMER relaxing in his
own Clash T-shirt.
Photograph by Janette Beckman.

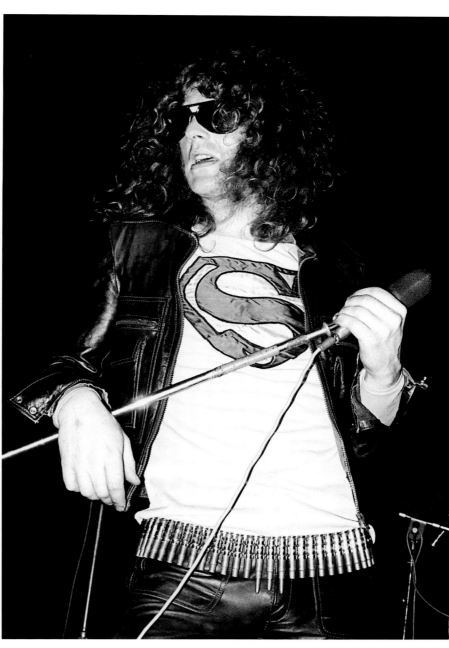

At times **IAN HUNTER** was Superman.
Photograph by Mick Rock.

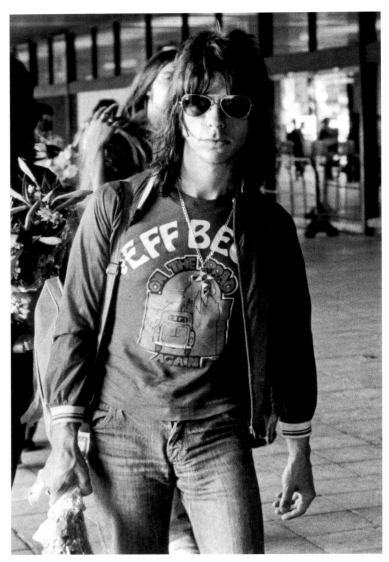

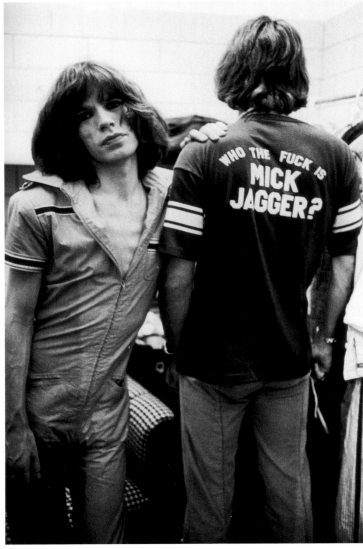

LEFT

JEFF loves Jeff!
Photograph by Bob Gruen.

RIGHT

This photo of **MICK JAGGER**
backstage inspired one of my
Converse advertising campaigns.
*Photograph by Christopher Simon
Sykes/Getty Images.*

What's on **JOAN JETT**'s mind?
Photograph by Bob Gruen.

COURTNEY LOVE—enough said about messages.
Photograph by Bob Gruen.

OPPOSITE

ROBERT PLANT—I guess he knows.
Photograph by Michael Zagaris.

ACKNOWLEDGMENTS

Many thanks to: Holly George-Warren, without whom there would be no book; Stephen N., my partner in crime, and everyone at YARD who helped make this book come to life; everyone at John Varvatos who put up with me and has helped build my brand; Elizabeth Viscott Sullivan at HarperCollins, for her belief in me; and Danny Clinch, whose eye has helped create the John Varvatos ads and whose pictures grace this book.

I'd also like to thank the photographers who captured the magic and were so generous to work with me on this project: Mick Rock, for your friendship and love; Bob Gruen and his team, who dug deep into the archives; Robert Knight, you rock; Lynn Goldsmith, who is always there for me; Robert Matheu, my Detroit brother who helped pull so much great stuff; Timothy White, for the love; Baron Wolman, just amazing; Gered Mankowitz, whose Hendrix photos have always inspired me; Janette Beckman, you are so cool; Ken Regan, it was such an honor. Thanks to Elliott Landy, Raeanne Rubenstein, Ed Caraeff, Mark Hanauer, Ron Pownall, Peter Simon, Stephen Paley, Roberta Bayley, Ian Dickson, Jérôme Brunet, Charles Gatewood, Robert Altman, Andy Willsher, Leni Sinclair, Deborah Feingold, Michael Zagaris, Richard Aaron, Robert Alford, Charlie Auringer, Cass Bird, Chuck Boyd, Larry Busacca, Neal Casal, Richard Creamer, Brad Elterman, Martyn Goddard, GODLIS, Hans Hartwig, Jim Hendin, Dean Karr, Andrew Kent, Robert Kiss, Vincent Lignier, Andrew Maclear, Janet Macoska, Kevin Mazur, Keith Morris, the Michael Ochs Archive, Richard Phibbs, Neal Preston, Michael Putland, Wendy Lynch Redfern, Ron Richardson, Kate Simon, Lucky Singh, Angus Smythe, Frank Stefanko, Christopher Simon Sykes, Seth Tiven, Barrie Wentzell, Tom Wright, and Tom Zimberoff.

Many thanks to my mentor Ralph Lauren and to Ryan Adams, Joe Perry, Chris Cornell, Iggy Pop, Perry Farrell, Franz Ferdinand, ZZ Top, Billy Gibbons, Cheap Trick, Rick Nielsen, Robin Zander, Tom Petersson, Velvet Revolver, Matt Sorum, Slash, Duff McKagan, Alice Cooper, Green Day, the Roots, Paul Weller, Miles Kane, Jimmy Page, Gary Clark Jr., Glenn Hughes, Peter Frampton, the New York Dolls, Alberta Cross, Dave Mathews, Robbie Robertson, Wayne and Margaret Kramer, Robert Plant, Ian Hunter, Steven Tyler, Dave Stewart, Lenny Kravitz, Joan Jett, Dave Grohl, Jack White, Jesse Malin, Kings of Leon, Roger Daltry, Bruce Springsteen, the Faces, Axl Rose, Jakob Dylan, Rick Canny, Bruce Flohr, Shep Gordon, Scooter Weintraub, Jon Rosen, Andy McNicol, Brad Beckerman, Steve Chickery, Mike Toth, and all the other musicians and friends who constantly inspire me.

—J.V.
New York City

BIBLIOGRAPHY

ALLMAN, GREGG, with **ALAN LIGHT**. *My Cross to Bear.* New York: William Morrow, 2012.

CARR, JESSICA CASSYLE. "American Glamour: An Interview with David Johansen." *Alibi*, June 5–15, 2012.

COBB, BEN. "Jack White." *AnOther Man*, March 18, 2010.

COOPER, ALICE. Interview with John Varvatos, 2012.

COTT, JONATHAN. *Dylan.* Garden City, NY: Dolphin/Doubleday and Company, Inc., 1984.

GEORGE-WARREN, HOLLY, AND MICHELLE FREEDMAN. *How the West Was Worn.* New York: Abrams, 2001.

GEORGE-WARREN, HOLLY, AND PATRICIA ROMANOWSKI, EDS. *The Rolling Stone Encyclopedia of Rock & Roll:* New York: Simon & Schuster, 2001.

GIBBONS, BILLY. Interview with John Varvatos, 2012.

GILMORE, MIKAL. "How Ziggy Stardust Fell to Earth." *Rolling Stone*, February 2, 2012.

GORMAN, PAUL. *The Look: Adventures in Pop and Rock Fashion.* London: Sanctuary, 2001.

HENKE, JAMES. "Eric Clapton: The Rolling Stone Interview." *Rolling Stone*, October 17, 1991.

HOLT, SID, ED. *The "Rolling Stone" Interviews: The 1980s.* New York: St. Martin's Press, 1989.

KRAMER, WAYNE. Phone and e-mail interviews with John Varvatos, 2012.

MELLOAN, MARYANNE. *Rock and Roll Revealed: The Outrageous Lives of Rock's Biggest Stars.* New York: Smithmark Publishers, 1993.

PAGE, JIMMY. Interview with John Varvatos, 2012.

PERRY, JOE. Interview with John Varvatos, 2012.

PLANT, ROBERT. Interview with John Varvatos, 2012.

POP, IGGY. Interview with John Varvatos, 2012.

RAMONE, JOHNNY. John Cafiero with Steve Miller and Henry Rollins, eds. *Commando: The Autobiography of Johnny Ramone.* New York: Abrams Image, 2012.

RICHARDS, KEITH, and **JAMES FOX**. *Life.* New York: Little, Brown & Company, 2010.

ROBERTSON, ROBBIE. E-mail interview with John Varvatos, 2012.

ROCK, MICK. *Mick Rock Exposed.* San Francisco: Chronicle Books, 2010.

SIMS, JOSHUA. *Rock/Fashion.* London: Omnibus, 1999.

SLASH. E-mail interview with John Varvatos, 2012.

SMITH, PATTI. *Just Kids.* New York: HarperCollins, 2010.

SOUTHERN, TERRY. *The Early Stones.* New York: Hyperion, 1992.

STAX, ANYA. "The Pleasure Seekers: An Interview with Patti Quatro." *Ugly Things*, Spring 2011.

STEWART, TONY. *Cool Cats: 25 Years in Rock 'N' Roll Style.* New York: Delilah, 1982.

TANAKA, RIN. *Motorcycle Jackets: Ultimate Biker Fashion.* New York: Schiffer, 2003.

TYLER, STEVEN. Interview with John Varvatos, 2012.

WALKER, SAMUEL AMERICUS. *Sneakers.* New York: Workman Publishing Company, 1978.

WENNER, JANN S., ED. *20 Years of "Rolling Stone": What a Long, Strange Trip It's Been.* New York: Friendly Press, 1987.

WILCOX, CLAIRE. *Vivienne Westwood.* London: V&A Publishers, 2004.

WILSON, ANN and **NANCY**, with **CHARLES R. CROSS**. *Kicking and Dreaming: A Story of Heart, Soul, and Rock & Roll.* New York: It Books, 2012.

WILLIS, ELLEN. *Out of the Vinyl Deeps: Ellen Willis on Rock Music.* Minneapolis, MN: University of Minnesota Press, 2011.

WOOD, RONNIE, IAN McLAGAN, and **KENNEY JONES**. *Faces 1969–75.* London: Genesis Productions, 2011.

www.brainyquotes.com, 2012.

www.thoughtfulgestures.com, 2012.

ABOUT THE AUTHOR

JOHN VARVATOS is one of the world's most renowned menswear designers. Born and raised in Detroit, John was exposed to rock & roll from an early age. The spirit, electricity, and edginess intrinsic in the personal style of iconic bands such as Led Zeppelin, the Who, Alice Cooper, Bob Seger, Iggy Pop and the Stooges, and MC5, among others, influenced the evolution of his design sensibility and is a unifying force in every expression of his award-winning brand today. In fall 2008, John opened his Bowery NYC boutique in the space that formerly housed the seminal underground music club, CBGB. He pays homage to the spirit of the legendary club, which closed in 2006, with ongoing performances that have included the likes of Guns N' Roses, the Roots, Paul Weller, the Wallflowers, and more. Since 2009, John has hosted *New York Nights*, a monthly radio show that includes music by and interviews with various artists who have influenced his career in fashion on SiriusXM's Spectrum channel. He lives in New York City.

ABOUT THE COAUTHOR

HOLLY GEORGE-WARREN is the award-winning author or co-author of more than a dozen books, including *The Road to Woodstock* (with Michael Lang), *How the West Was Worn: A History of Western Wear* (with Michelle Freedman), *Punk 365*, *The Rock and Roll Hall of Fame: The First 25 Years*, and *Public Cowboy No. 1: The Life and Times of Gene Autry*, among others. She has written for such publications as *Rolling Stone*, the *New York Times*, *Entertainment Weekly*, and the *Village Voice*. Her liner notes for the Janis Joplin set, *The Pearl Sessions*, received a Grammy nomination in 2012.

Since 2005, we have forged a partnership with YARD's creative director Stephen Niedzwiecki and photographer Danny Clinch to create the John Varvatos advertising campaigns featuring iconic musicians. These images are renowned in their own right and, like many of the photos in this book, doubtless will influence rock in fashion. *Photographs by Danny Clinch.*

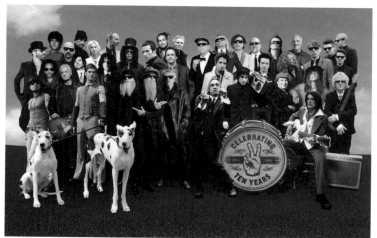

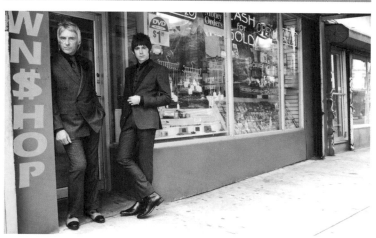
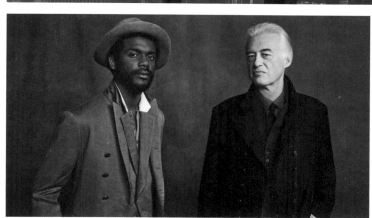

JOHN VARVATOS
ROCK IN FASHION

HarperCollins books may be purchased for educational, business, or sales promotional use. For information please e-mail the Special Markets Department at spsales@harpercollins.com.

First published in 2013 by Harper Design

An Imprint of HarperCollins *Publishers*
10 East 53rd Street
New York, NY 10022
Tel: (212) 207-7000
Fax: (212) 207-7654
www.harpercollinspublisher.com
harperdesign@harpercollins.com

Distributed throughout the world by
HarperCollins *Publishers*
10 East 53rd Street
New York, NY 10022

ISBN 978-0-06-200979-1

Library of Congress Control Number: 2011931360

Book design by YARD
www.yardnyc.com

Printed in China

First Printing, 2013